Graphis is committed to presenting exceptional work in international Design, Advertising, Illustration & Photography. In the following pages, we celebrate the year's best student work from around the globe. We are proud to honor the Platinum and Gold Award winning Instuctors, Students and Schools here and look forward to their future success.

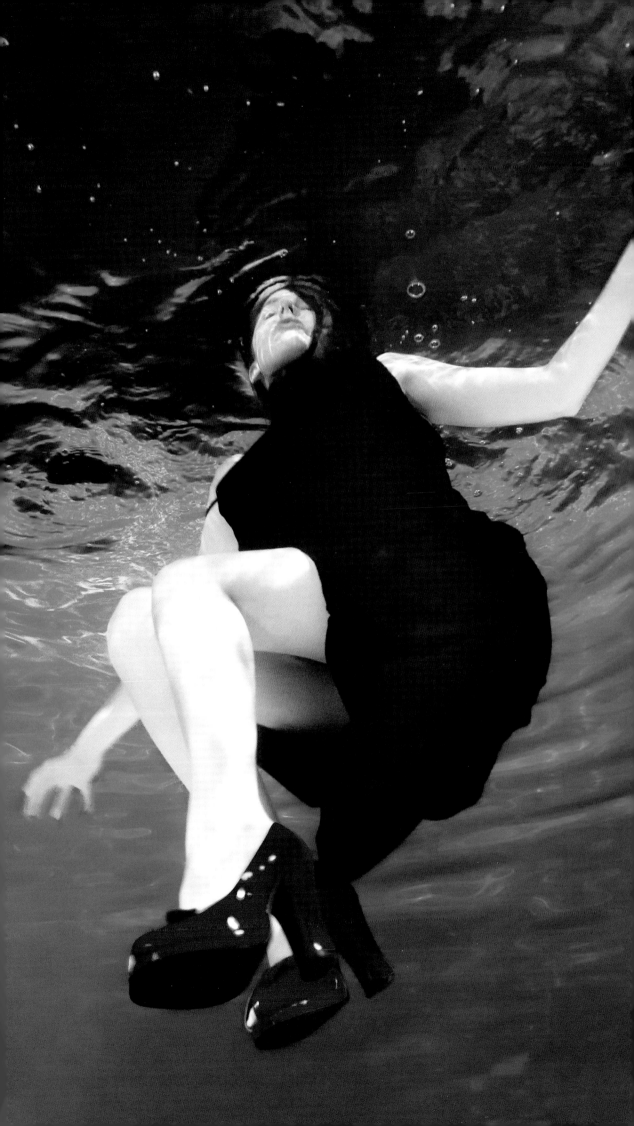

Published by **Graphis** | Publisher & Creative Director: **B. Martin Pedersen** | Design: **Yon Joo Choi and Gregory Cerrato**
Editorial: **Abigail Lapp and Leah Hansen** | Production: **Jennifer Berlingeri and Abigail Lapp** | Webmaster: **Abigail Lapp**
Support Staff: **Rita Jones** | Interns: **Amy L. Bergen, Dana Davis, Diana Lau, Gloria Pak, Elisa Penello, Mariana Uchoa**

Remarks: We extend our heartfelt thanks to contributors throughout the world who have made it possible to publish a wide and international spectrum of the best work in this field. Entry instructions for all Graphis Books may be requested from: Graphis Inc., 307 Fifth Avenue, Tenth Floor, New York, New York 10016, or visit our web site at www.graphis.com.

Anmerkungen: Unser Dank gilt den Einsend-ern aus aller Welt, die es uns ermöglicht ha-ben, ein breites, internationales. Spektrum der besten Arbeiten zu veröffentlichen. Teil-nahmebedingungen für die Graphis-Bücher sind erhältlich bei: Graphis, Inc., 307 Fifth Avenue, Tenth Floor, New York, New York 10016.Besuchen Sie uns im World Wide Web. www.graphis.com.

Remerciements: Nous remercions les par-ticipants du monde entier qui ont rendu possible la publication de cet ouvrage offrant un panorama complet des meil-leurs travaux. Les modalités d'inscription peuvent être obtenues auprès de: Graphis, Inc., 307 Fifth Avenue, Tenth Floor, New York, New York 10016. Rendez-nous visite sur notre site web: www.graphis.com.

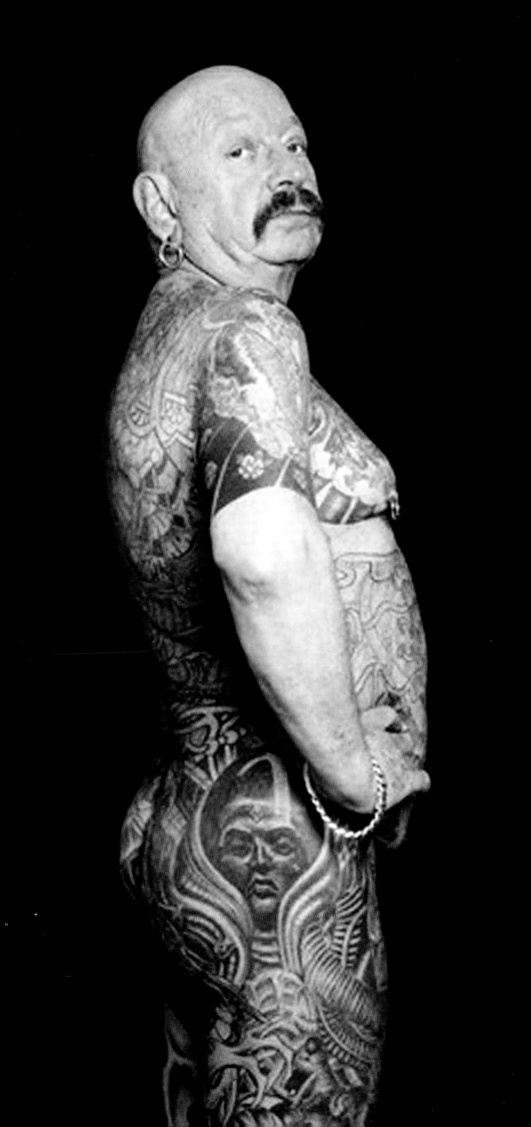

# Contents

741.6 GRA

*Previous Spread:* Alex Benigno, Art Institute of Atlanta I *Opposite Page:* Sara Roderick, School of Visual Arts

# Q&A With Sal DeVito

*Sal DeVito has been teaching Advertising and Design classes at New York City's SVA (School of Visual Arts) for over 20 years. His teaching methods may be unconventional (lighting ads on fire, stamping the word "bullshit" on false facts…), but the results speak for themselves: His students consistently churn out great work, which can frequently be found gracing the pages of Graphis. We sat down with him to discuss how he got into teaching and, of course, that infamous stamp.*

*How did you become a teacher at SVA?*
It was in 1980, I wanted to teach. It was sort of a point in my life where there was a lot of frustration. So I wanted to get into SVA as a teacher. Actually, I tried another school. I tried Parsons the New School, and they asked me to write a course description, and I did that. For them at that time, they wanted me to be more of a "how do you pull a book together, more mechanically." Believe it or not, there were no computers then, so it was, how do you get the type, and how do you get the photos, and how do you do this, and how do you color it. So that's what they wanted me to do, and they asked me to do it. So they actually turned me down, and I would have really preferred working at SVA; one reason is because that was my school. I graduated there in 1971. And I liked how they teach and their style. You know, it's pretty much you can do what you want just to get your message across. So I called them, and it just so happened at that time, they had a summer class coming up where, after the class was already in the catalogue, they had no teacher for the class. He had to go out of town on business or he got another job or something like that. So they put me in that seat, and I had never taught before. But I had my first class—it was a night class. And when I got to that class, I had to let everyone know that I wasn't the other teacher. It was me. And that's how it started; it was my first class. That's where it began.

*What classes do you teach?*
Well after that, I taught evening classes for about five years—continuing ed. After doing some night classes, I still continued to do night classes, but they wanted me to teach a day class, and I did one. But the classes I teach now are junior. I teach juniors Advanced Advertising. They're all ad majors and they're all juniors. And I also teach a Portfolio class, seniors only.

*How many classes do you teach per week?*
Per week, I teach two classes during the same semester.

*How many hours weekly do you spend teaching?*
It's hard to really put a time on it, but if I had to, I'd say about five hours. Sometimes I get emergency calls from students, and I tell them if you're about to do something terrible, a real bad ad, I'm available 24 hours a day. It's like a hotline, a suicide hotline: Just give me a call and I'll talk you off the ledge; I'll make sure you don't do it, that kind of thing.

*How much time weekly do you require for your professional work?*
That's a full-time job.

*Do you feel as much passion for teaching as you do for your professional work?*
Yes, absolutely. And some days, I even feel more passion about teaching. If you get a real bad day at work where everything's going wrong, you're not selling ads, clients are a disaster; and you have a good class, that sort of helps bring the rest of the day up. It certainly helps, especially if someone does something good.

*What would you say is your favorite aspect of teaching?*
I guess seeing it happen… Let me put it this way: I never get tired of seeing a rookie hit a home run. That still excites me.

*What do you do to drive your students to the extraordinary level of professionalism you have attained?*
First of all, my students don't all have an extraordinary level of professionalism, that's for sure, especially when the class begins, when it starts out. It's sort of like boot camp in the beginning. I don't give assignments yet; I just more or less talk about the business and the rules that I expect of them. When they're in my class, I actually write a contract they have to sign. I'm going to read it to you: It says, "I, so-and-so, am in Sal DeVito's Advanced Advertising class ADD3010, which meets on Wednesdays at 12:30 p.m. I clearly understand that if I miss one homework assignment and/or have more than two absences, I can be expelled from the class. I also understand that I will probably regret it for the rest of my life." So that they sign, just to at least show them where I'm at, and then we begin. And what do I do to drive my students? It takes place in my office, so they get to see and smell what it's like here. They get to see the awards when they come in, they see ads hanging up, and that kind of thing. So the area where I teach helps show the level of professionalism.

*What is the curriculum like?*
I give an assignment every week: not television, it's basically print. That's just like most of the other teachers, at or least that's the way I was taught. And I change assignments every week. And they do ads, and it used to be they would hang them up on the walls and I'd tear them down, with a critique of course, and the ones that are left up there are the better ones. Now what I do is I have them each present their ad, just to see if there's any thinking behind it. It sort of helps. It's not rough, I tell them we're all friends, no one's going to hold it against you. I like them to sort of set up an idea before they present the ad. That always helps.

*Do you show students your agency's work?*
Yes, I show them my own agency and other agencies. Mostly other places because, you know, I have so much work here and they usually know about that work, but I do show them both TV and print work. And every once in a while, what I do here, I hire students. Every year, I try to get about two. And that's what motivates, I think, the better people in the class. They've heard the tales, and they've heard the stories of actually getting hired and working for me. A lot of the people who work here, not most of them, but many of the people who work here are from my class, and they're working for me now. And all the rest that I didn't hire are working against me.

*Who are your design and advertising mentors?*
One was a teacher at SVA called Robert Reitzfeld. He's an artist now, but he was someone who really motivated me a lot, and the style of work that I do. And also Allan Beaver, I worked for him; he's a Hall of Fame guy who's an art director, a designer. I worked for him at Levine Huntley, and he taught me a lot and was a good person to be around.

*Who or what influences your professional work?*
I never forget that there's someone else on the other end of that ad, because a lot of people now, or students now, don't realize that. I think they're doing an ad more for themselves or their friends or for other creatives. Don't lose sight of the fact that there are other people at the other end of it. And I'm trying to persuade that person to at least feel something from this ad. And maybe I can say it in a way that hasn't been said before. Which brings me up to another way I teach: One assignment I give that not many instructors gave, but I got this assignment when I was at SVA, is to sell something to the class, not in the form of an

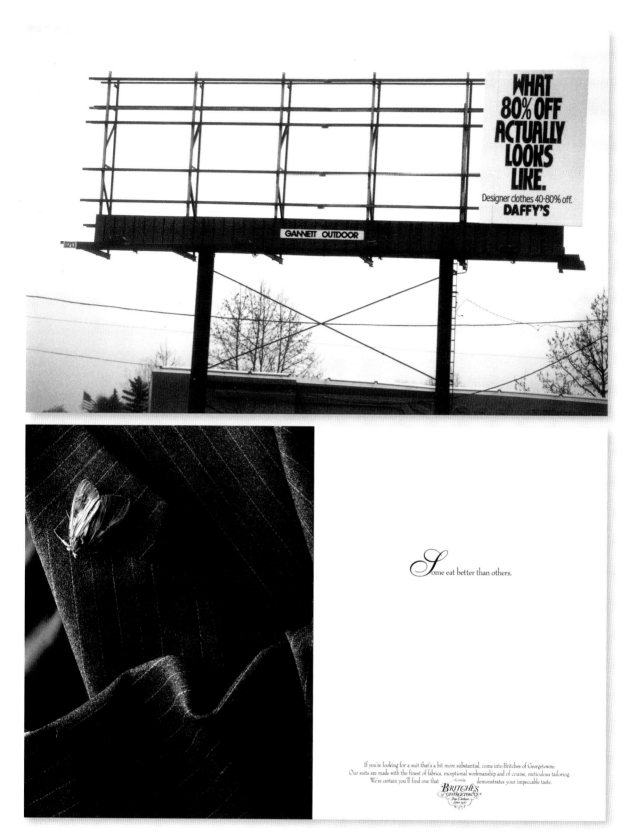

I really don't want anyone falling asleep in the class. I have to keep it exciting, for me and them.

If I have a bad day at work where everything's going wrong, coming to a good class helps bring the rest of the day up.

ad. Just get up like a salesman, and it would have to cost under $10, and get up and sell it to the class. And there are some very interesting solutions to that assignment. You can't really use a cute word phrase when you're doing that. You have to have an idea behind it. And you have to get someone's attention and keep it there. It's almost like doing a 15-second TV spot or a TV commercial. So that's something that I think helps them understand.

I also put a bunch of critiques on the wall that they can use to critique the ads. And I'm going to read these critiques to you… One says "no idea;" another one says "I don't get it;" another one says "dull;" one says "too damn cute;" another one says "good idea, needs better execution;" one just says the word "bullshit," which any time there's some ridiculous fact they have there that's not true—I actually have a bullshit stamp that I put on an ad, I just stamp it right on there, they love it when that happens—one of them just says "ridiculous;" "I've heard it before;" and "sounds just like advertising." I have those around sometimes, especially when they're just getting to know me. I keep that up for a good five or six classes.

*How has teaching affected your professional work?*
What's interesting is when I first started teaching, I was kind of unhappy, and I wasn't me yet. I wasn't me when I asked to work at SVA. And by that, I mean I didn't have 30 years in this business, or 20 years in this business. And I didn't actually have the reputation; I didn't win any awards at that time. But teaching, what I get out of it is I'm reminded of the advertising basics every time I teach, because I keep saying it and reminding the students what it's about. So it sort of helps in one way or another.

Also, I'm kind of a low-key person, but the energy that can come out of me in the class can be very exciting and sometimes even scary. Ways that I motivate people, and things that have happened in my class, I have set ads on fire. Not my agency, but at SVA when I was teaching there at night, with a garbage can in front of it, though. But I did set ads on fire, and I have thrown ads out the window. I do that, again, I say, to save your life because I don't want this ad to come back and hurt you someday. Once, I had a class where I actually came into the class and put a five-dollar bill on the wall, a 10, a 20, a 50 and a 100. I told the class, this is like an award show: I'm going to have some of my people at the agency come in and look at the work and see if any ad deserves any money, and how much. No one won the 100-dollar bill, luckily, but they did get $20 and someone got a 10, that kind of thing… Anything that can sort of wake people up, because I really don't want anyone falling asleep in the class. I have to keep it exciting, for me and them.

*How do you manage to balance everything?*
That question, I put two words down: I don't.

*When you do manage free time, what are your other interests or hobbies?*
I'm satisfied with just getting my mind off it for a while if I can. When I was younger, I did martial arts—that was at a time when I was in my 30s and 40s, but now that's changed. So it all depends on the stage of my teaching career. Now I'm satisfied just grabbing some friends and having a few drinks, and laugh. That's important to me. Again, I don't mind watching TV or some movies at home and just getting away from it all.

---

Sal DeVito, Executive Creative Director: *Sal DeVito is the co-founder and Executive Creative Director of DeVito/ Verdi in New York. Before DeVito/Verdi, Sal was Associate Creative Director at Levine Huntley Schmidt and Beaver. Prior to that, he was a Senior Art Director at Chiat/Day New York. Under his leadership, DeVito/Verdi has created award-winning campaigns for Time Out New York, Canon, Daffy's, Meijer Stores and American Civil Liberties Union. DeVito/Verdi's latest campaign for the National Thoroughbred Racing Association won the Grand Prize at the 2006 Mercury Awards. Sal, a winner of all major advertising awards, also teaches advertising at the School of Visual Arts, where he received the Distinguished Artist-Teacher Award in 2001.*

---

### List of Student Winners

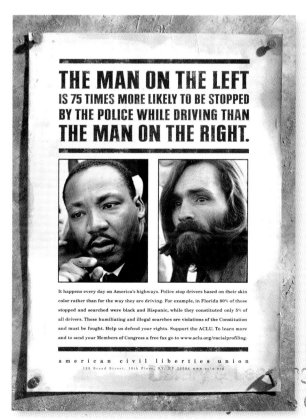

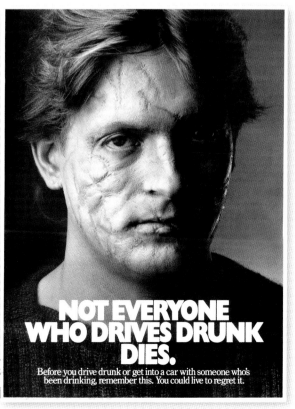

*Over the course of his professional advertising career, Jack Mariucci won hundreds of awards. Now, as an Advertising and Design professor at New York City's SVA (School of Visual Arts), he's educating the next generation of prize-winning advertisers. His students are some of the most consistent winners in the Graphis New Talent Annual. We chatted with Jack Mariucci about his passion for teaching and how he motivates his students to produce such fantastic work.*

*How did you become a teacher at SVA?*

It all started with Richard Wilde in 1991. He asked me to go to lunch with him, and during lunch he asked me if I would ever consider teaching. I said no, and if I did teach, it would probably terrify the hell out of his young students and put them off of advertising altogether. Plus the workload I was carrying made it virtually impossible to have any free time. Then again, he asked me in '92, and again I said no, then finally '93 came around, and if you know Richard, he is very persistent. He asked me out to lunch, this time at a better restaurant, and I said I would go with him on one condition: there would be no mention of me becoming a teacher. He agreed. I think he had a little smirk on his face when he said that.

Everything went well until the second bottle of wine was poured. I was feeling no pain when he hit me with this idea—"What if I sent ten of my best advertising students to your office after working hours? Would you consider giving them one advertising assignment to see if teaching is something you might be interested in doing? Then if you still feel like you don't enjoy teaching or it's too much for you to handle with your workload, I'll never bother you again." I must have agreed, because the next day at around 5:30 in the evening, there were ten glassy-eyed kids standing outside my door. That's how it all started and I'm thankful that it did. The one thing that came out of Richard's tenacity, besides the great wines that were served at our lunch, was that I had no idea how much I enjoyed teaching.

*What classes do you teach? What grades—freshmen, sophomores, juniors, seniors, grad students?*

I teach five classes per week which include beginner, (sophomores) advertising, advanced (juniors) and portfolio (seniors). Plus two advertising classes that put a stronger emphasis on design.

We found that many students who are majoring in advertising do not place enough importance on design. In this course, we start at the idea stage, where we reject the bad ones and improve on the good ones until we find a great one. That's when we turn the great ideas into a great ad: a skillfully designed computer-generated piece that will play a prominent part in their portfolio. The object is to make body copy their friend, where to look for the right photo or illustration, how to find a home for their logo and avoid boring background, how to choose the right font, and, most importantly, how to make sure an ad doesn't look like an ad. Let me put it this way: design should embellish the page. You must teach them to be ruthless. Throw out, eliminate, burn, destroy any unwanted element that doesn't make your idea stand out from the rest.

*What do you do to drive your students to the extraordinary level of professionalism you have attained? What tools do you use to motivate them?*

Teaching advertising is a process without any aids. What I mean by that is there's no book or set of tools that can teach you ideas. You can read all the books that are written on advertising; all they communicate is work that was done in the past. For me, the award annuals are the most useful. They give you a glimpse at the best work that is being done at the time. It's also a way to compare yourself with the gold standards set by other art directors and writers. The future is where you must lead your students. Great ideas are still the King Kong of the our business, except today there are many more outlets to display their work. In today's new world of media, advertising agencies and their clients demand art directors and writers to think beyond the 8" by 10" page. They need to be ready to integrate a single idea into a multimedia campaign, including TV, print, Internet, and find alternative ways to advertise. Give them the opportunity to actually create the changes, which will set the pace in our industry and break new ground for clients.

Since I'm a product of Doyle Dane Bernbach, my teaching stems from Bill Bernbach's philosophy of advertising. To quote Bill Bernbach, "You can say the right thing about a product and nobody will listen. You've got to say it in such a way that people will feel it in their gut. Because if they don't feel it, nothing will happen." Teaching advertising is a process that's painstakingly slow. It's like potty training. If you put them on the toilet seat enough times, they will eventually get the hang of it.

I start my students out slowly with easy assignments and then work them up to ones that are more complex. Every week I give my students a new assignment and strategy. Then, when they come to class with what they think is the perfect solution to the problem, I start to break it down with a sharp ax explaining what is relevant or pitiable about their work. At first, a few get the hang of it, and come in with adequate ideas. And in a few weeks the ones that are passionate enough about staying in advertising start to show up with better and better work. Advertising is hard work that demands countless hours. If the student is not prepared to put in the time, then I suggest they get a hobby. The ultimate goal of a teacher is to instill drive and enthusiasm in their students, and watch them succeed.

*Do you show students your agency's work?*

No, I don't show them my agency's work. Showing them my work is bullshit and a big ego trip. I want them to become individuals and have their own sense of being. Every student has their way of looking at life. All that I'm interested in is that they shape his or her ideas into their own personal mode of thinking. Not mine. Otherwise you have a monotonous sameness of accepted wisdom that tends to bore the hell out of me.

*Do you show the work of other agencies?*

To give them a better understanding of what's happening

# The future is where you must lead your students. Great ideas are still the King Kong of the our business.

around them in advertising,

*Who are your design and advertising mentors?*

Growing up at DDB, there were plenty to choose from: Helmut Krone, Sid Meyers, Len Serowitz, Bill Talben, Bert Steinhouser, and Lester Feldman. And some of the best writers in the business: Phyllis Robinson, Bob Levenson, Dave Reider, Leon Meadow... I learned from them all. It was like having ten of the best teachers sitting on your lap. How could you go wrong?

My biggest influence came from Bob Gage. He was my first boss. Gage was an innovator in the early days of commercials. He was the guy who was doing dissolve quick cuts and putting humanity into commercials way before anyone else. That's when my love for TV overshadowed print. Besides watching him do great advertising, he taught me passion for my work and most of all, how never to give up, how to come up with the best advertising despite the confinements you're put under by clients and agencies. He would always say, "Coming up with a great idea once was easy. But can you come up with a second great concept when the first one was killed?" That stuck with me through my whole career and that's what I try to instill in my students.

*Who or what influences your professional work?*

My students...today anyway. I learn from them every day that I teach. Their unique freshness of ideas and design has infiltrated the way I look at advertising. They have taken me out of the big type and cute headls that was once part of the way I looked at advertising. I guess you could say that SVA is paying me to learn.

*How has teaching affected your professional work?*

This may sound like a cliché, but teaching has enabled me to think younger. Being around young minds tends to bring out the kid in you. I listen to their music; I may not agree with it, but I do try to listen. I watch what they watch on TV and observe how they interact with each other. This

allows me to take a peek at what's going on in their generation. And I then try to translate that into my work and teaching methods. I look at ideas much differently today than I did 30 years ago. What took me weeks in some cases to accomplish takes students days with the aid of their computers. In all cases, great ideas are the objective. But how you look at them has changed. Today's advertising students rely on the Internet, which gives them quicker access to the world around them. They don't have to wait for information, it's handed to them by the minute. As the target audience for advertising gets younger and younger, and more and more advertising appears online, advertisers reflect the mood of this faster-paced generation. Ads should have less copy and stronger visuals. But let's not forget, even with all the new technology and the different media outlets that surround us, the aim stays the same—a big idea that promotes and sells the product. When all's said and done, you still need to sell the product.

*When you manage free time, what are your other interests or hobbies?*

My main interest is wine. I've been collecting it for 45 years and I'm a member of Tastevines, a Burgundy wine organization that began in France.

*Did your time at Doyle Dane Bernbach overlap with your time teaching and how did you work that out?*

Two years... It's pretty much what I explained earlier: I had this great lunch with Richard when he conned me into teaching. He would send students up to my office after working hours, and I had a big boardroom next to my office, so I would give them an assignment and then they would come back the following week with it completed. And that's where my basic love, or real love, for teaching started. This went on for two years, and then I retired from Doyle Dane Bernbach, and I started up my own agency, a small agency, and that's how it's been since I started.

*What was the transition like going from just professional work to teaching?*

There was no change basically. Leaving a great agency and then being able to teach at a great school. How much of a transition could there be?

---

Jack Mariucci: *Before Jack was a teacher, he was a student. Early in his career he worked with the men and women who changed the face of advertising. Hal Riney. Bob Gage. Phyllis Robinson. Helmut Krone. And the legendary Bill Bernbach.*

*Jack learned their lessons well. In 1986 he was elected a director of DDB Needham Worldwide, and held the top creative post in the firm's flagship New York office until his retirement in 1994. During his tenure there, that office alone won more creative awards than any other agency in the world. His personal campaign credits include*

*Volkswagen, American Tourister, Polaroid, Avis, Clairol, Hershey, Nabisco, Sony, IBM, Weight Watchers, Citicorp, and the famous Michelin baby commercials. He's won hundreds of awards for creative excellence and marketing effectiveness, including the prestigious Stephen E. Kelly award. In 1992 Adweek magazine named him the Best Creative Director in the East, and that year his global campaign for Seagram, entitled "Cognac, L'Art de Martell," was placed in New York's Museum of Modern Art. Jack and his wife, Marie, live in Holmdel, New Jersey, and Jupiter, Florida.*

---

### List of Student Winners

---

# Teaching advertising is a process that's painstakingly slow. It's like potty training. If you put them on the toilet seat enough times, they will eventually get the hang of it.

**BETTER GRIP.**

In the wet, in the dry, when lateral g-forces send other tires packing, a Michelin performance tire hangs in there. Our rubber compounds are different. Our treadblocks are different. And all the high tech stuff you can't see is different. Which makes our grip, traction and control very different, too. The XGT° Series. With speed ratings from 112 to over 149 mph. You could try other tires. But you might be in for a big letdown.

Examine new Polacolor ER through the eyes of Phil Marco and Eric Meola.

To quote Bill Bernbach, "You can say the right thing about a product and nobody will listen. You've got to say it in such a way that people will feel it in their gut. Because if they don't feel it, nothing will happen."

*Recognizing a need for businesspeople to possess an understanding of the design process, MBA (Master of Business Arts) programs at many universities now include design-related electives. New York City's Pratt Institute delves even deeper with a specialized degree: the MPS (Master of Professional Studies) in Design Management. The curriculum is modeled after a traditional MBA (Master of Business Arts), but focuses on the special needs of leaders managing teams in creative industries. We sat down with Mary McBride, chairperson of the program, to discuss how it operates, and why this burgeoning field is so important.*

*When was this program first offered?*

The program began in 1996.

*What motivated the inception of the MPS program?*

We saw an unfilled need design leaders needing skill in business. They needed vocabulary, concepts and tools. Our goal was to fully enable design to enter the strategy conversation.

*In your opinion, why is it important for businesspeople to understand the design process?*

If business and design do not fully communicate, strategic opportunities and business risks can go undiscovered. Especially as business moves toward more fully sustainable methods and materials, design management is essential.

*What is the curriculum of the program?*

The curriculum is designed to develop strategic management skills in six study areas related to design management: operations management; financial management; marketing management; organization and human resource management; management of innovation and change; and management of local, regional and global suppliers, distributors, markets.

*What types of case studies do the students work with?*

Students work with Harvard, Darden, MIT developed cases that are relevant to specific curriculum and provide students a credible practice field.

*What exposure to professional designers do the students in this program get?*

The program is designed for working professionals and delivered by working professionals for from the world of business and design: Professional designers from around the world form the class. Program participants learn from each other across the design disciplines. Design and business professionals also teach the core program.

*Do the MPS students also study advertising?*

Advertising and Promotion is one of our courses as is Strategic Marketing.

*Do MPS students connect with design students and/or business/MBA students from other schools?*

We are a member of Net Impact, a group of MBA students; and we have a relationship with JIDPO (Japan Industrial Design Promotion Organization) in Japan, grantors of the prestigious G-mark.

*If so, how is the classwork structured?*

Classes meet every other weekend for two full days or twelve hours. They attend for a full week at the beginning and the middle of the program. An integrative experience at the end of the two-year program provides the opportunity for several brief, intensive courses, including behavioral simulation and negotiating modules.

*What should business students learn from designers?*

Courses provide students with an integrated focus on the role of design in the creation and management of strategic and sustainable advantage.

*What should designers learn from business students?*

By the time Design Management students graduate, they are prepared for leadership roles in the design management and strategic management fields. They have developed a strong skill set in the discipline of business and the management of design; can identify and manage critical business challenges strategically; and can use design to create strategic and sustainable advantage.

*Do the professors for MPS classes come from professional design and business backgrounds?*

The program is delivered by working professionals who bridge the disciplines of design and business management.

*In your opinion, what value would business/MBA students find in design courses?*

Business students lacking the design experience would be better prepared to guide design and lead creative people.

Mary McBride: Mary McBride, Chairperson of the Master of Professional Studies in Design Management program. She leads SPC International's strategic leadership and stewardship practice. She is an internationally renowned speaker. Her professional business experience spans several areas including marketing, strategic planning, design management, operations analysis and organizational development. As partner in SPC International and a citizen of the US and Ireland, Mary consults on innovation and leadership worldwide and is an executive coach to international business leaders in a variety of industries. Mary's experience spans publishing and entertainment, financial services, technology, retail store development, apparel and packaging, product design and merchandising. She has also worked extensively in the NGO and public sector with organizations as diverse as community service agencies, arts organizations, hospitals, schools, foundations, city, state, and international agencies. Mary received her business training at NYU's Stern Graduate School of Business and also earned an MA and PhD from NYU specializing in Marketing Communications and Systems Analysis. Mary focuses on the development of leaders and their organizational systems and management structures for peak performance. She was Director of the Management Decision Laboratory at NYU's Stern Graduate School of Business and is currently a Clinical Professor at NYU. Mary also acts as the visionary leader and Director of the Pratt Institute graduate program in Design Management, the first graduate program for creative professionals interested in strategic management and design driven economies. Mary has been nominated for the esteemed Aspen Institute Faculty Pioneer Award, dubbed the "Oscars of the business school world." The award recognizes MBA faculty who have demonstrated leadership and risk-taking in integrating social and environment issues into academic research, educational programs and business practice.

Pratt Institute: *Founded in 1887, Pratt Institute is the largest independent college of art and design in the northeastern United States, offering undergraduate and graduate degree programs in the schools of architecture, art and design, information and library science, and liberal arts and sciences. Pratt is located on 25 landscaped acres in the Clinton Hill section of Brooklyn and has a Manhattan campus in renovated eight-story building on West 14th Street in Chelsea. www.pratt.edu.*

*Pratt Institute photograph by Bob Handelman, 2007.*

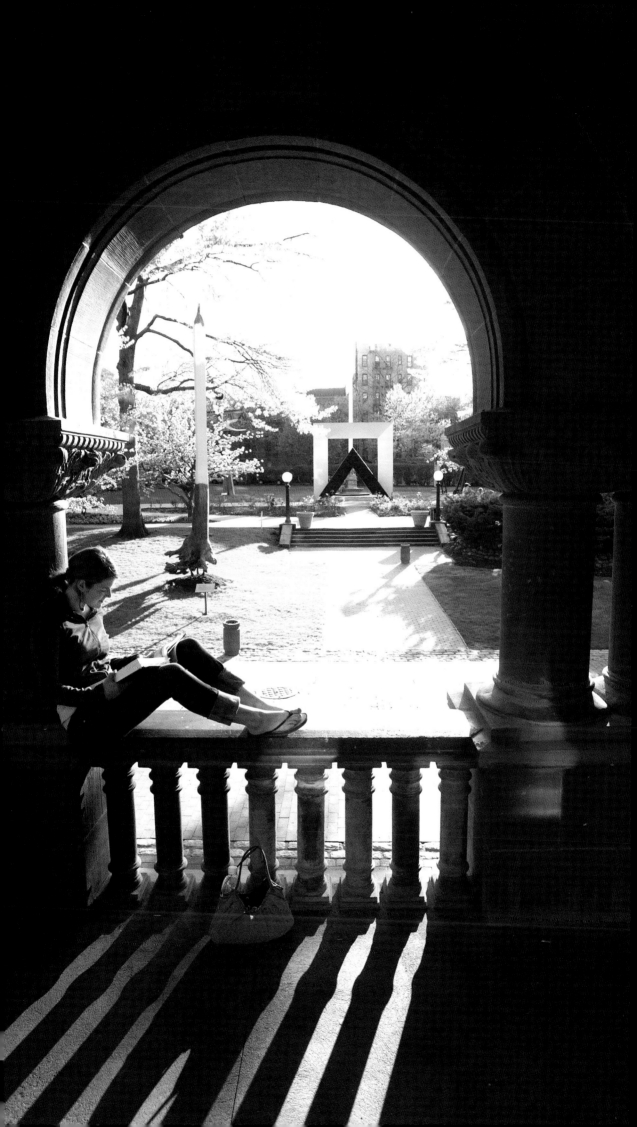

# PlatinumWinners

School:
**School of Visual Arts**
**Richard Wilde, Chair**

Instructors:
**Frank Anselmo**
School of Visual Arts
30 Winning Projects
**Christopher Austopchuk**
School of Visual Arts
8 Winning Projects
**Louisse Fili**
School of Visual Arts
6 Winning Projects
**Michael Ian Kaye**
School of Visual Arts
6 Winning Projects
**Jack Mariucci**
School of Visual Arts
32 Winning Projects
**Adrian Pulfer**
Brigham Young University
14 Winning Projects
**Timothy Samara**
School of Visual Arts
6 Winning Projects

Students:
**Cindy Eunhaee Chun**
School of Visual Arts
Beverage, pg. 25
Cameras, pg. 34
**Ian Bae**
**Brian McLaughlin**
School of Visual Arts
Delivery Systems, pg. 38
**Jeong Jyn Yi**
**Sara Roderick**
School of Visual Arts
Museums, pg. 47
**Yanghee Kang**
Pratt Institute
Calendars, pg. 121
**Jonathan Han**
School of Visual Arts
Editorial, pg. 130-133
**Eun Joung Park**
School of Visual Arts
Logos, pg. 162
**Jason Giles**
Pennsylvania State University
Poster, pg. 195
**Ali Dick**
Portfolio Center
Products, pg. 218

*Pages 16, 19, 91, 231: Award photographs by Henry Leutwyler | Page 18:* Lauren Brown, Art Institute of Atlanta

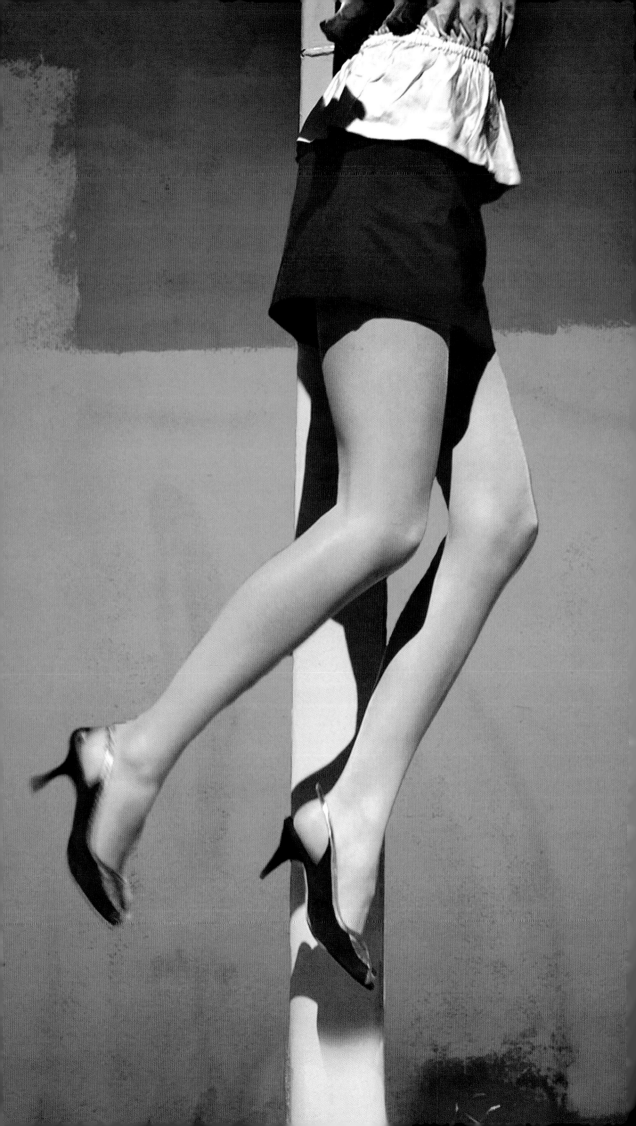

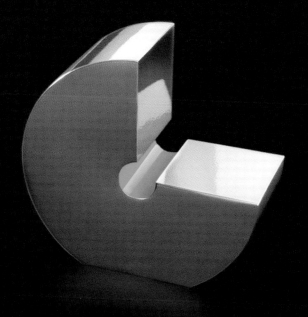

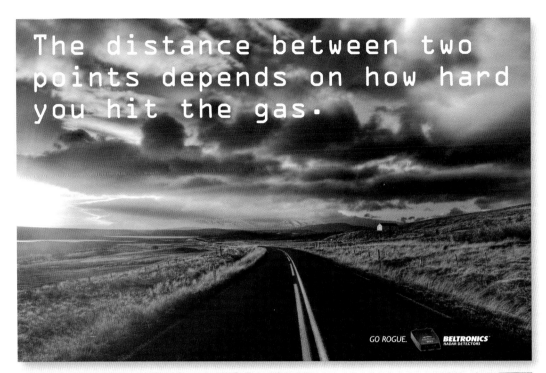

The distance between two points depends on how hard you hit the gas.

GO ROGUE. **BELTRONICS** RADAR DETECTORS

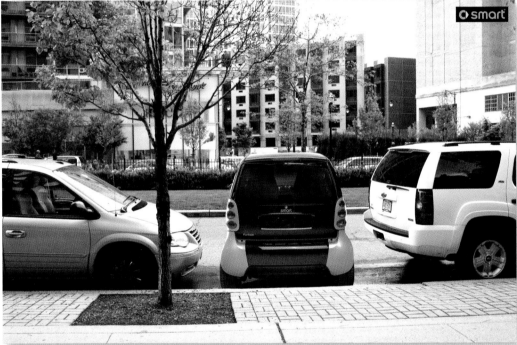

smart

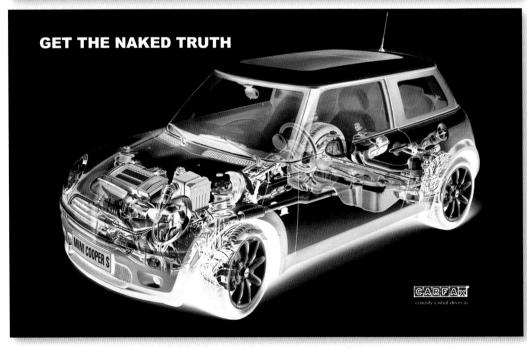

GET THE NAKED TRUTH

MINI COOPER S

CARFAX
curiosity is what drives us

**Jack Mariucci** School of Visual Arts **Julissa Ortiz**
**Frank Anselmo** School of Visual Arts **Yong Wook Kim**
**Jack Mariucci** School of Visual Arts **Carolina Macias Vega**

# AT A CERTAIN AGE
## SITTING IN THE FRONT
## ISN'T AS APPEALING.

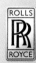

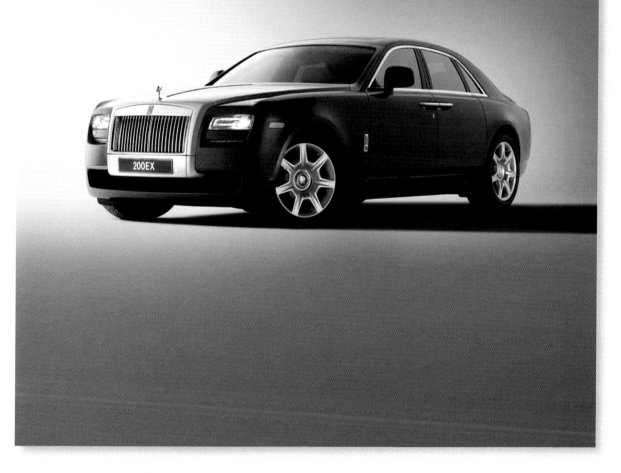

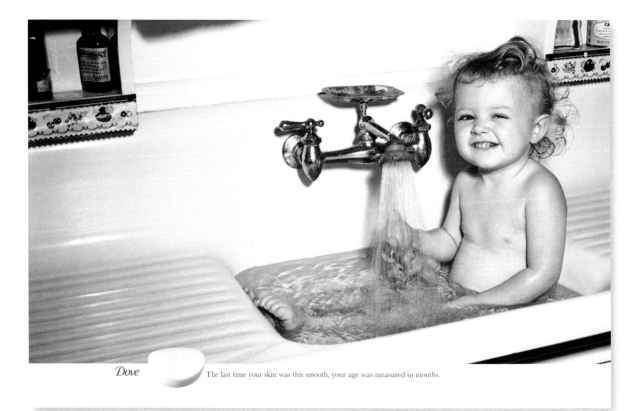

*Dove* The last time your skin was this smooth, your age was measured in months.

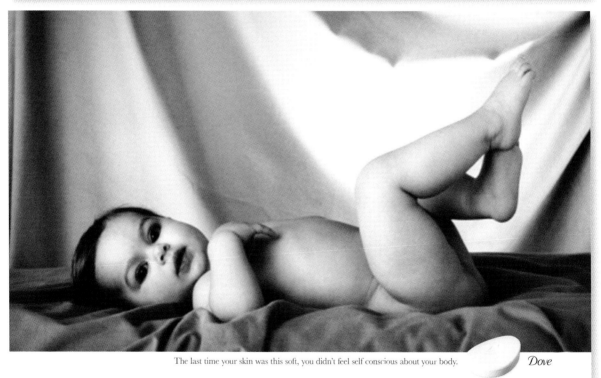

The last time your skin was this soft, you didn't feel self conscious about your body. *Dove*

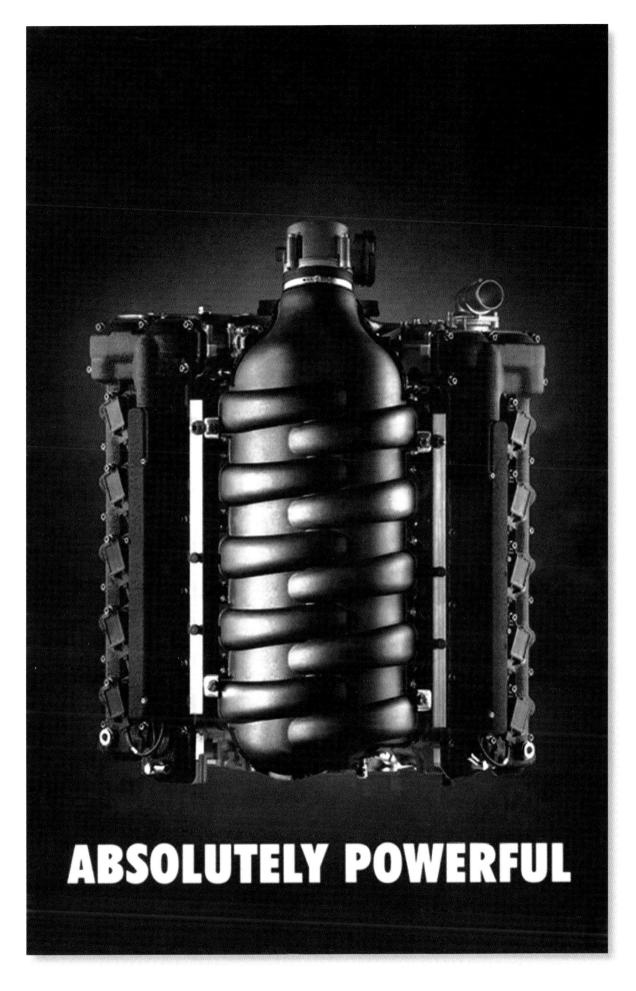

# ABSOLUTELY POWERFUL

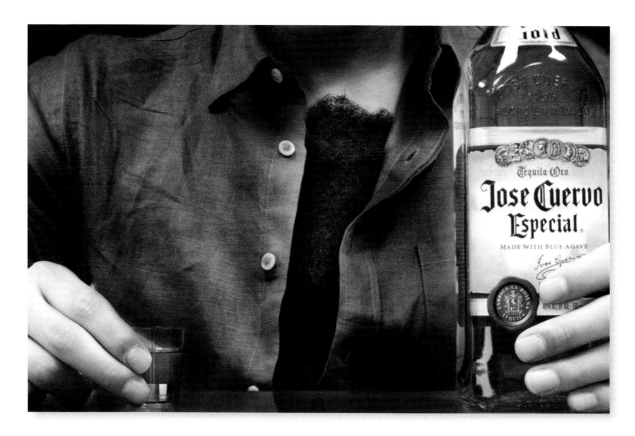

**Frank Anselmo** School of Visual Arts **Alain Baburam**

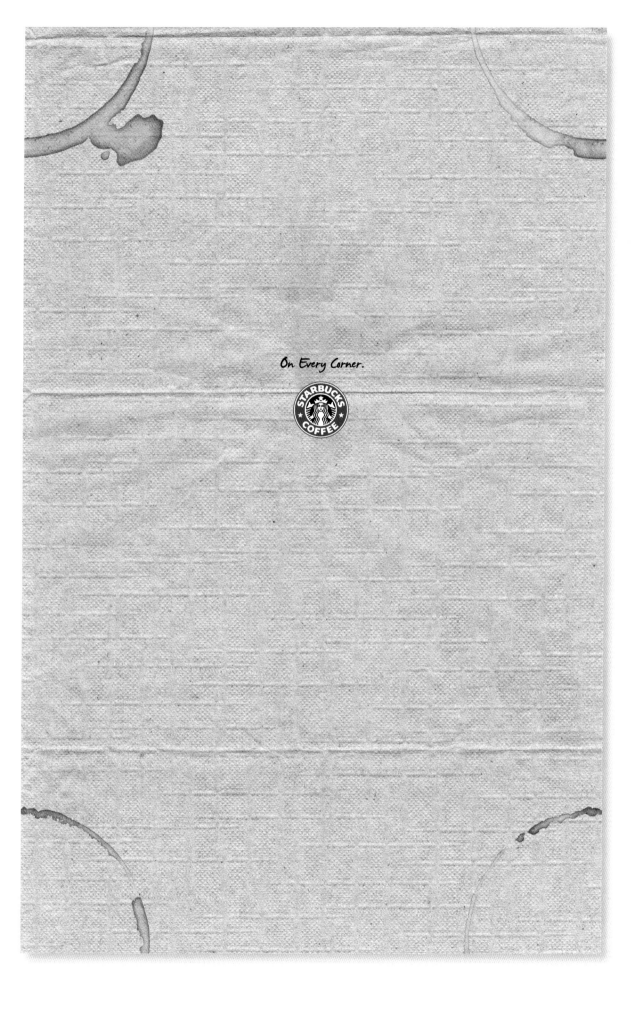

On Every Corner.

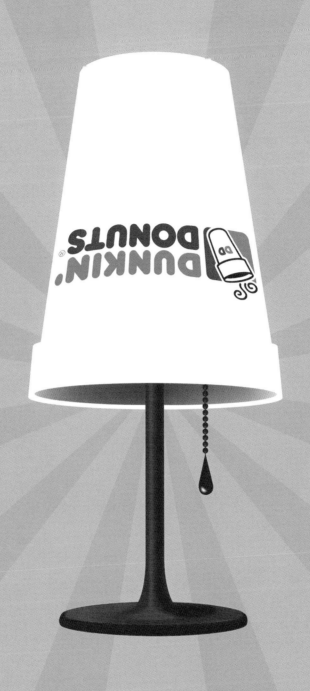

RISE & SHINE

**Frank Anselmo** School of Visual Arts **Czarine Yee**

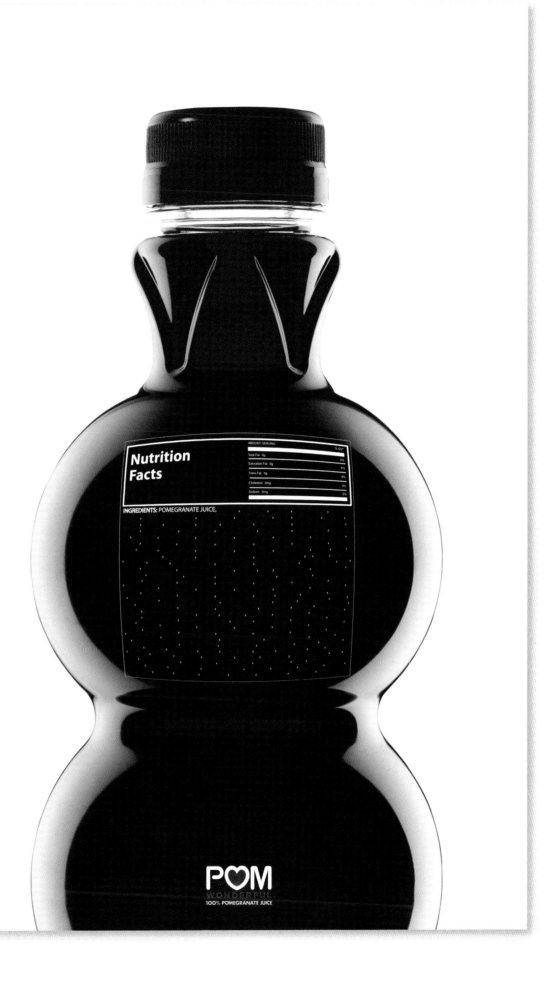

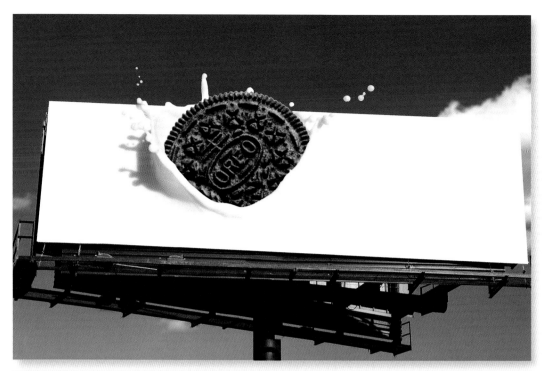

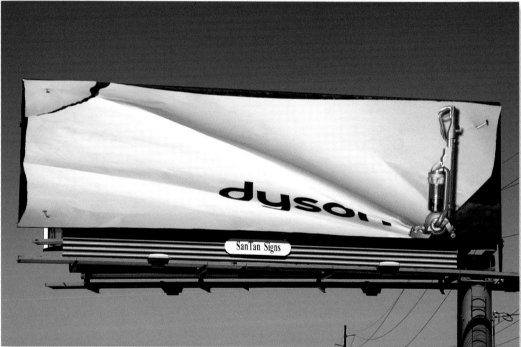

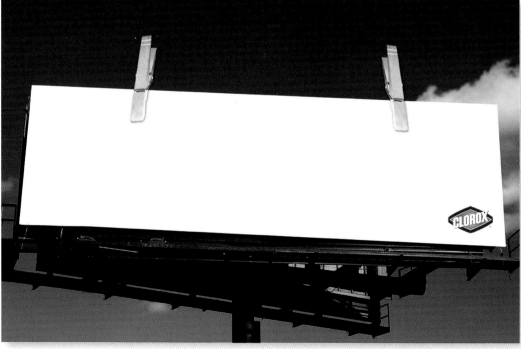

**Jack Mariucci** (top, bottom) **Sal De Vito** (middle) School of Visual Arts **Carolina Macias Vega**

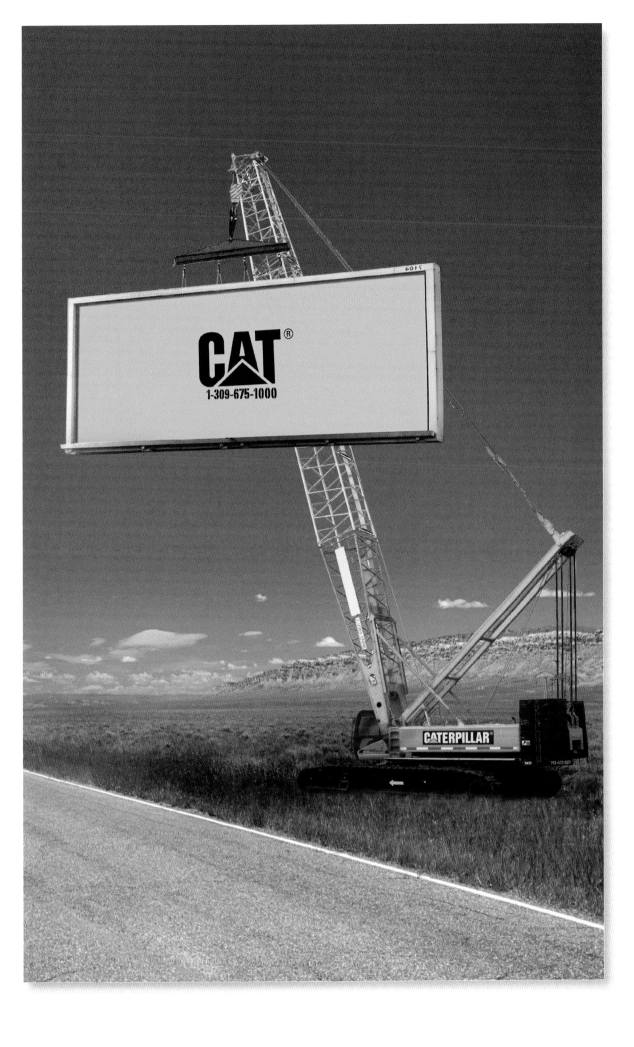

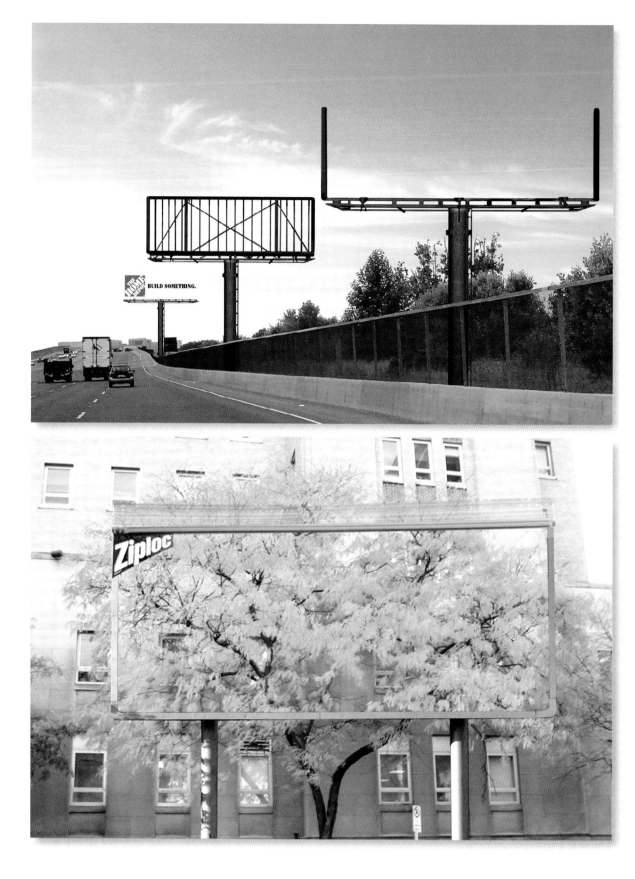

BUILD SOMETHING.

Ziploc

Frank Anselmo School of Visual Arts Cindy Eunhaee Cho, Hyojoo Kim
Maggi Machado, Stephanie Price Miami Ad School Pablo Jimenez, Colleen Layman

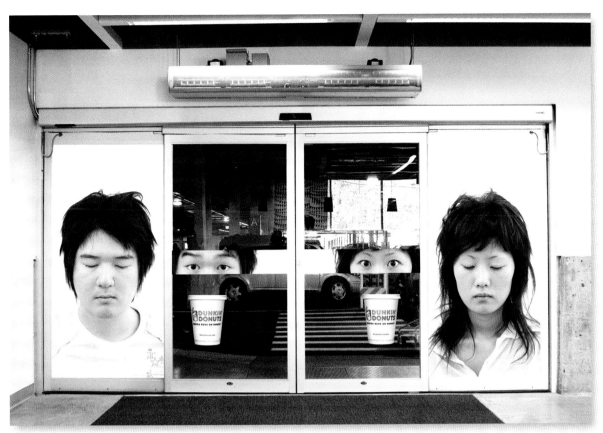

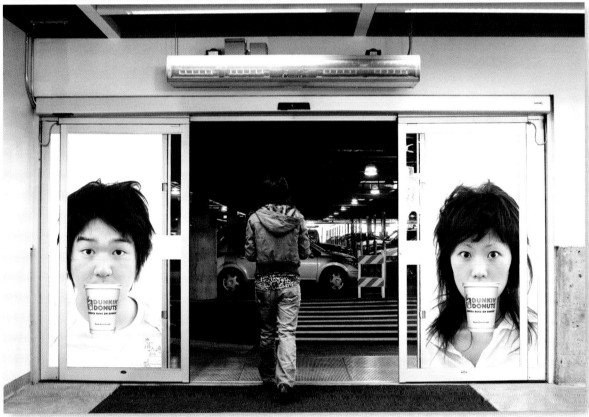

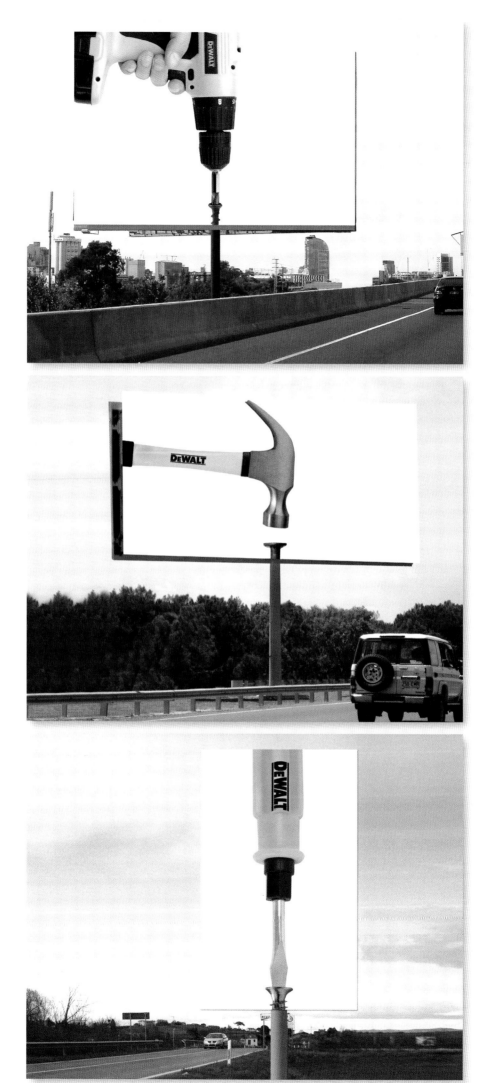

**Frank Anselmo** School of Visual Arts **Marianna D'Annunzio**

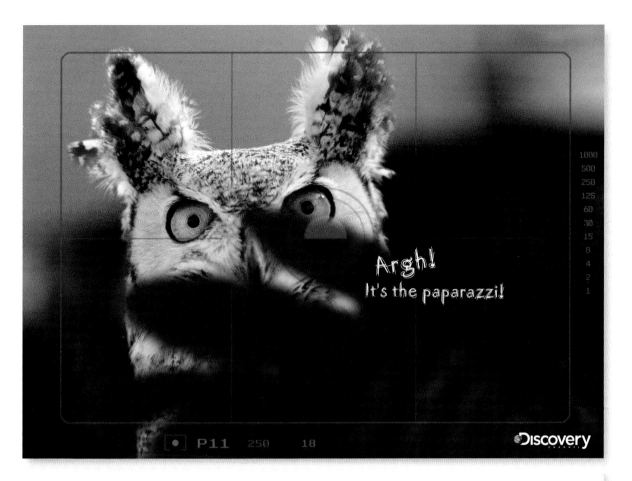

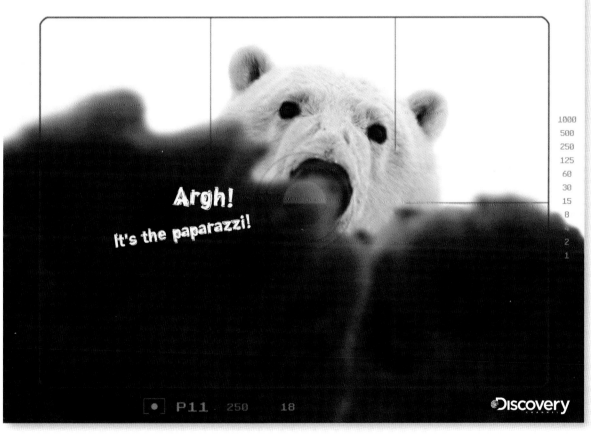

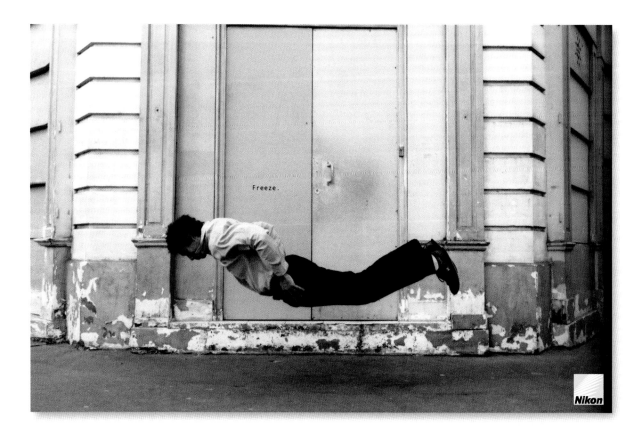

Freeze.

**Jack Mariucci** School of Visual Arts **Cindy Eunhaee Cho**

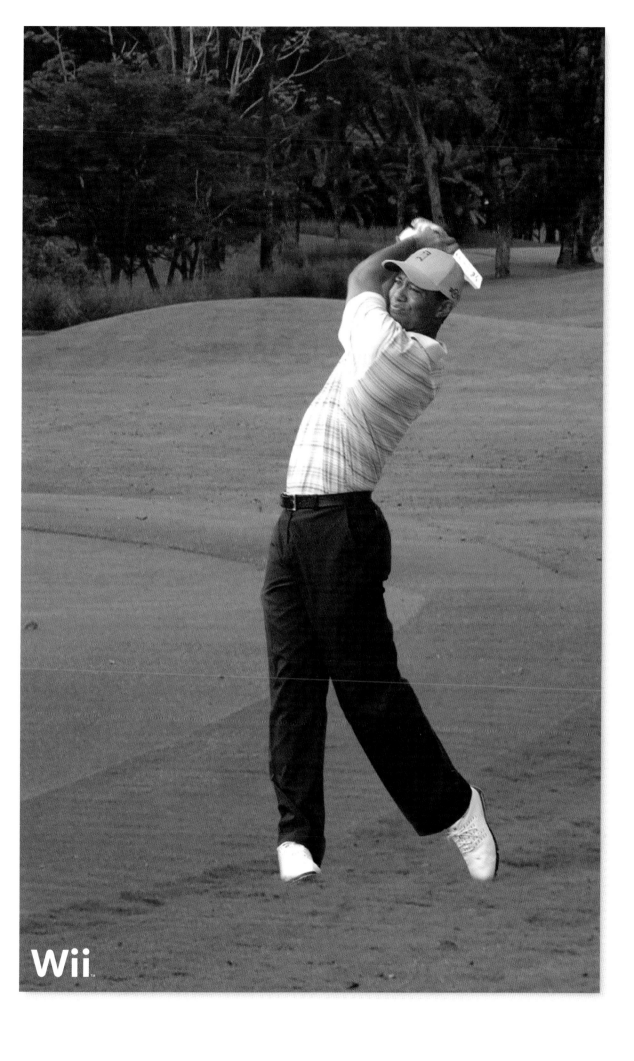

Wii™

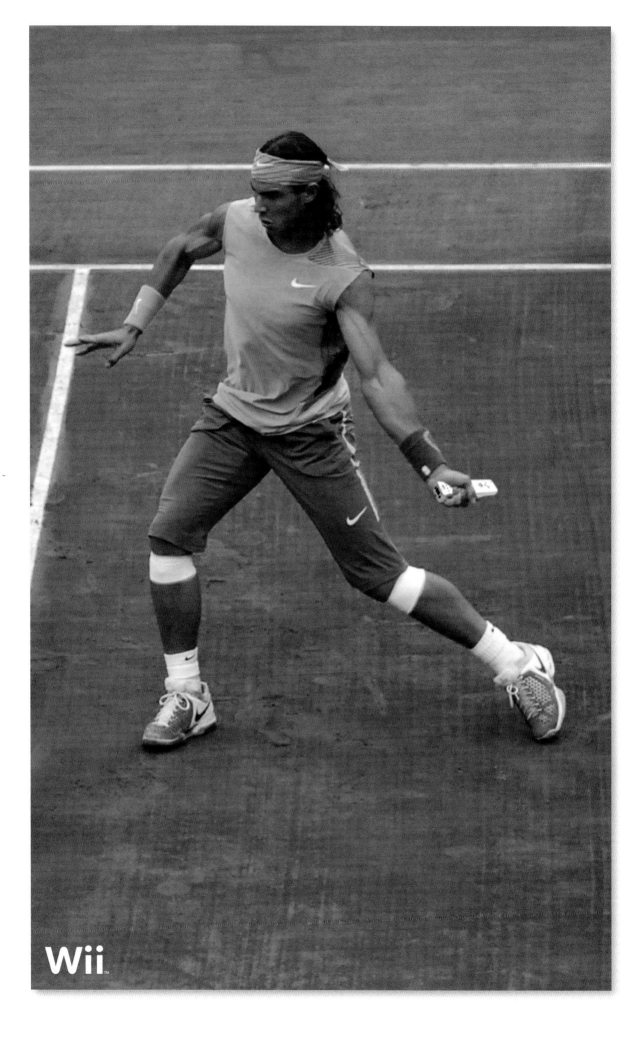

Wii.

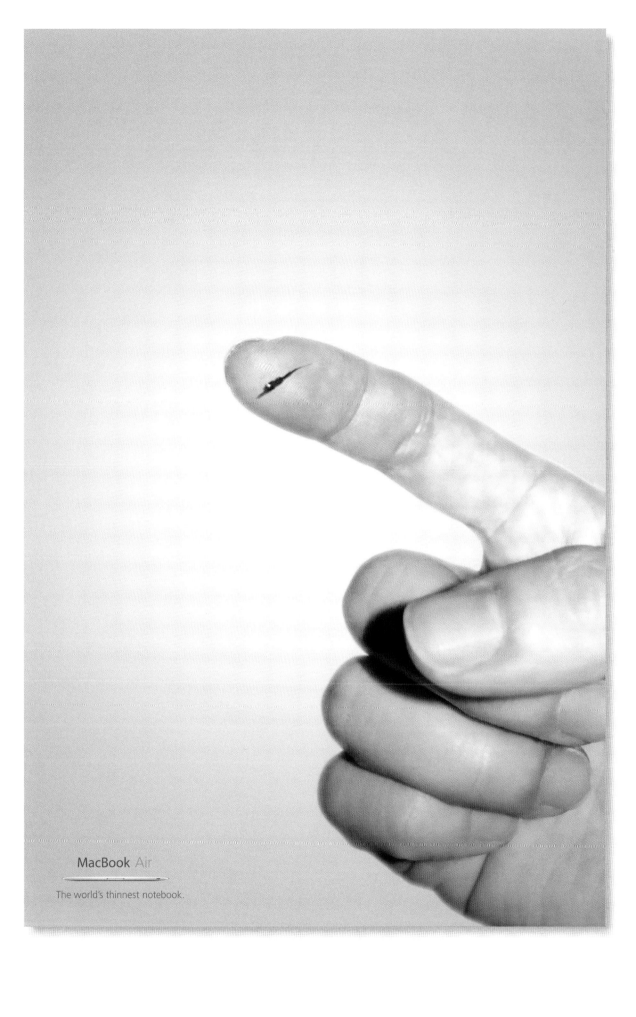

MacBook Air

The world's thinnest notebook.

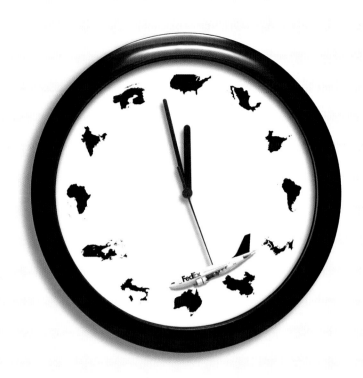

**Frank Anselmo** School of Visual Arts **Ian Bae, Brian McLaughlin**

wonderbra

WET PAINT

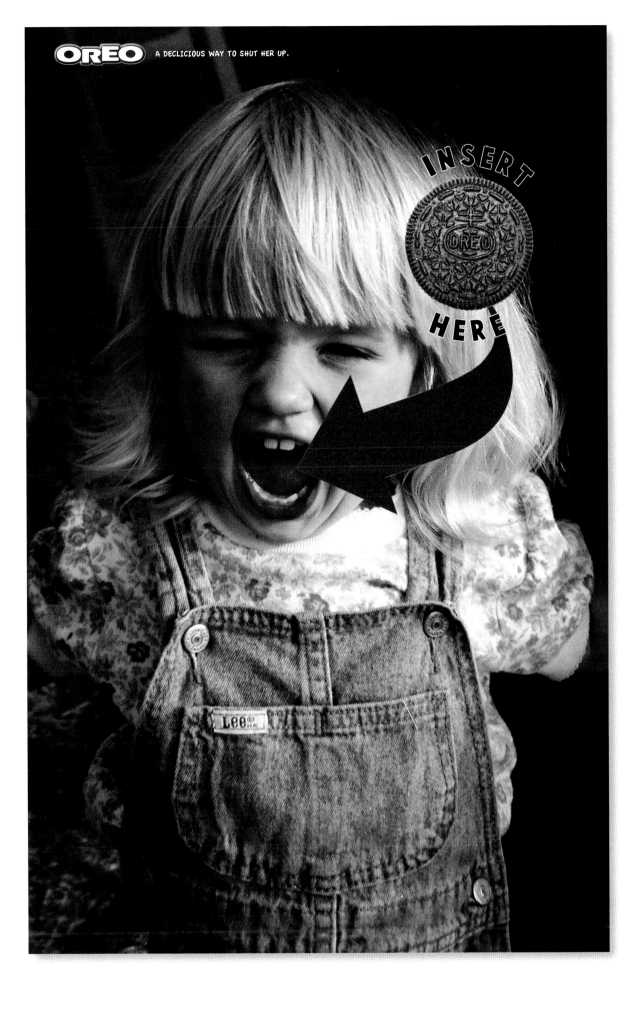

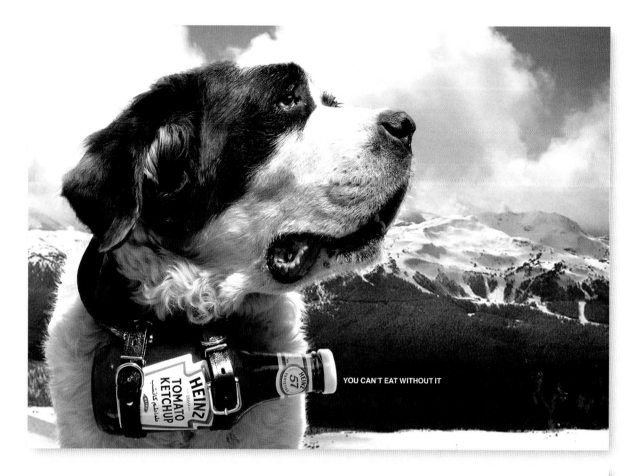

YOU CAN'T EAT WITHOUT IT

Made
Fresh
Daily

Miami Ad School **Michael Youssef**
**Frank Anselmo** School of Visual Arts **Kenji Akiyama**

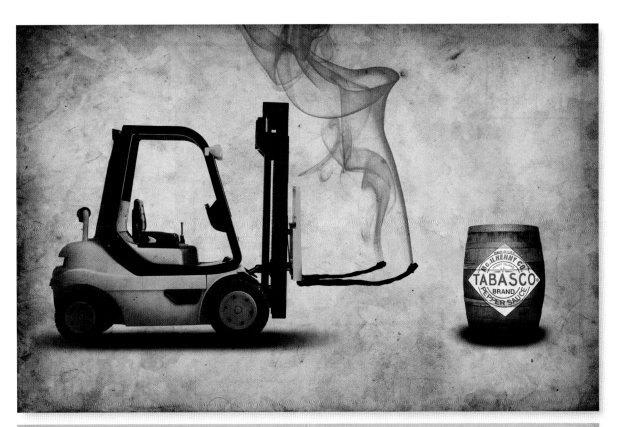

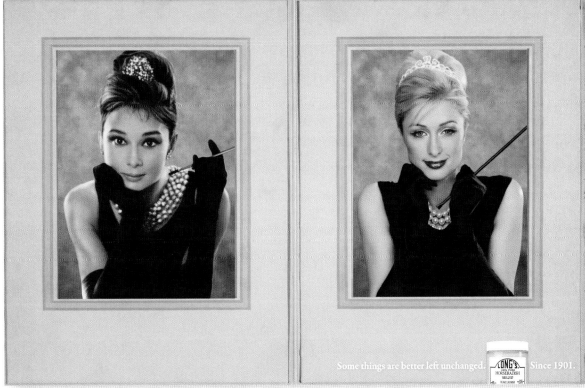

Some things are better left unchanged. Since 1901.

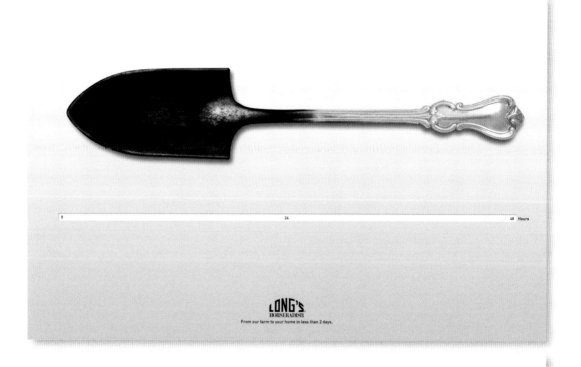

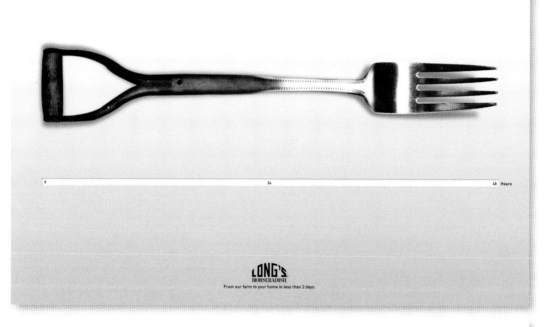

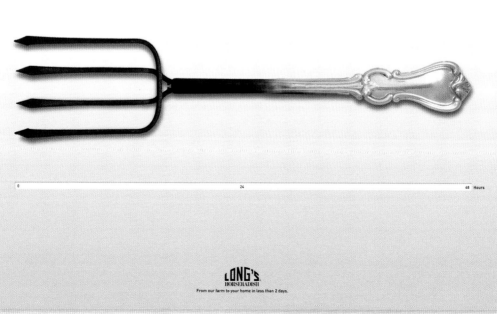

**Frank Anselmo** School of Visual Arts **Jyn Yi, Sara Roderick**

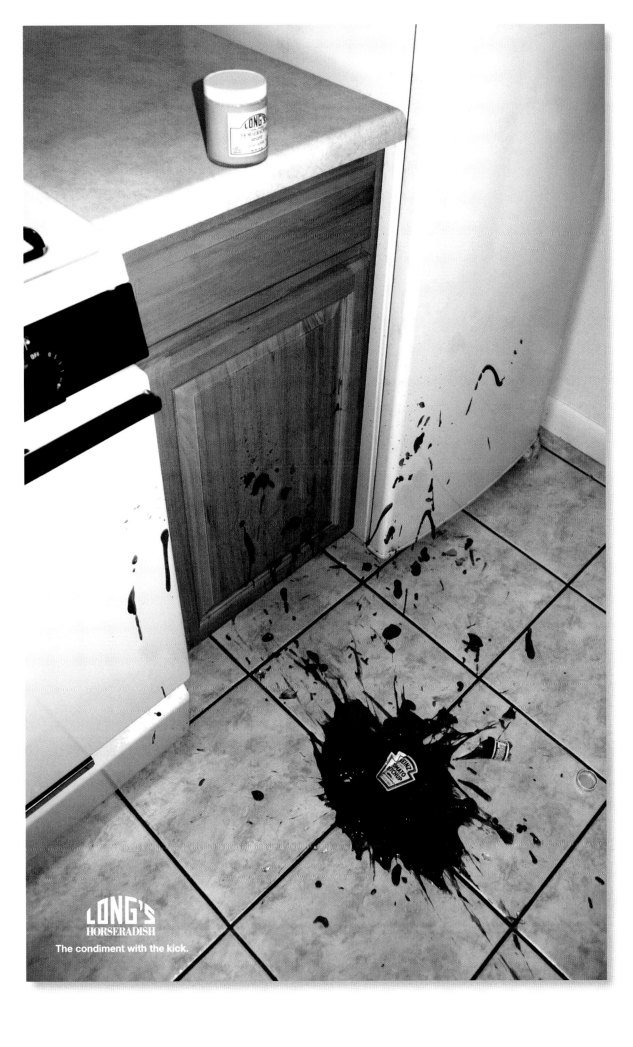

LONG'S
HORSERADISH

The condiment with the kick.

JAPAN HAS ITS OWN WWII MUSEUM.
YOU CAN FIND MOST OF IT AT THE BOTTOM OF THE PACIFIC.

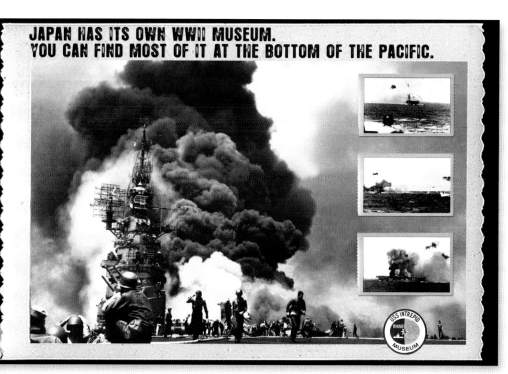

OTHER MUSEUMS CAN'T STAND UP TO OURS.
IT WOULDN'T BE A FAIR FIGHT.

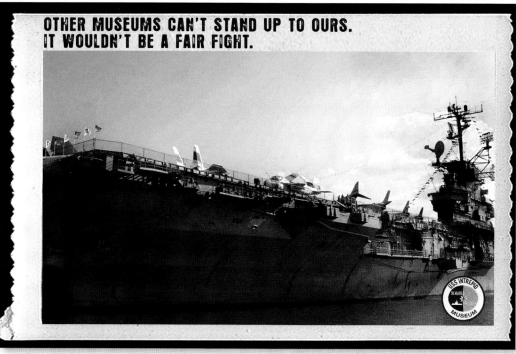

SOME OF THE MEN ON THIS SHIP HAVE SEEN THE WORLD.
FROM 239,000 MILES AWAY.

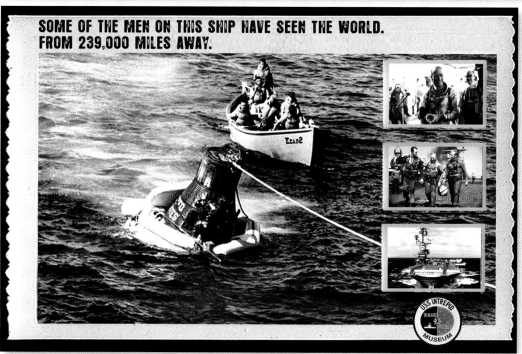

**Sal DeVito** School of Visual Arts **Sara Roderick**

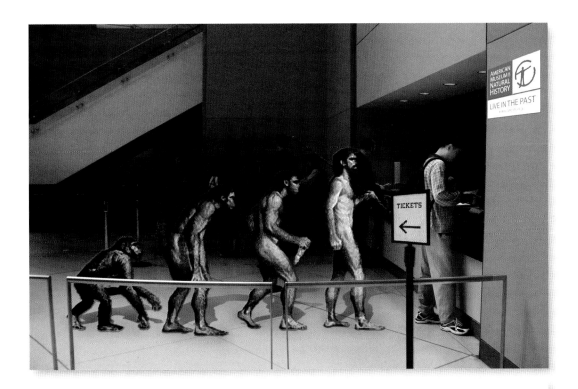

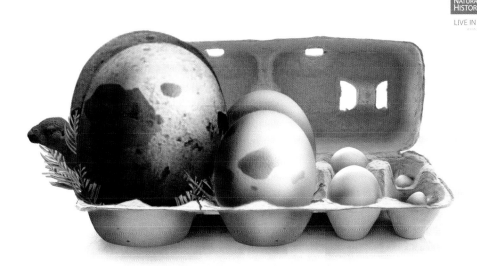

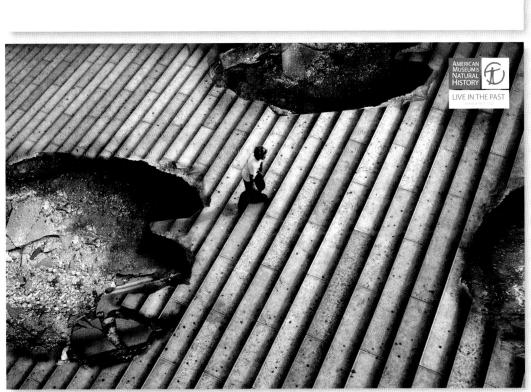

**Jack Mariucci** School of Visual Arts **Jyn Yi, Sara Roderick**  Museums|Advertising**47**

She carried 3,000 men and
91 planes on her back
and is still standing 68 years later.
That's no old lady.

INTREPID

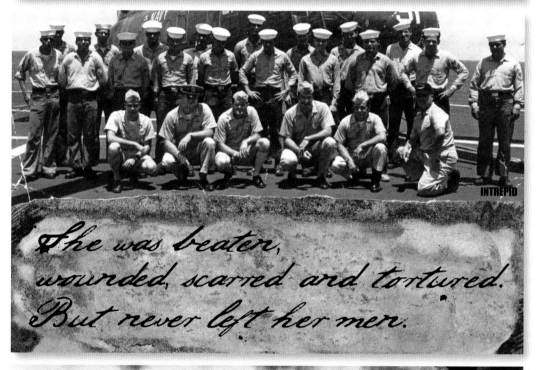

INTREPID

She was beaten,
wounded, scarred and tortured.
But never left her men.

INTREPID

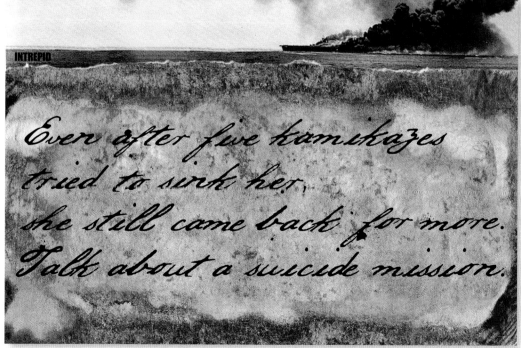

Even after five kamikazes
tried to sink her,
she still came back for more.
Talk about a suicide mission.

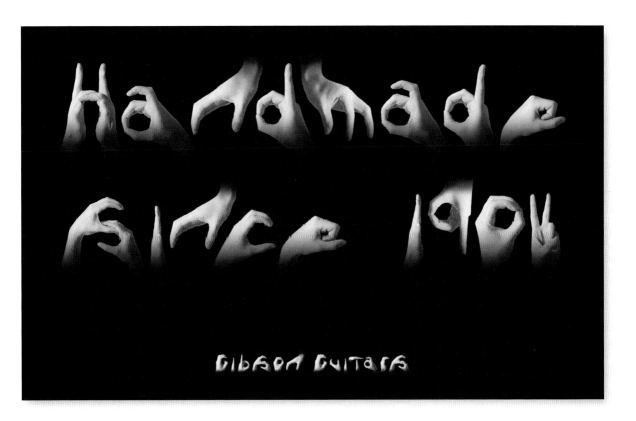

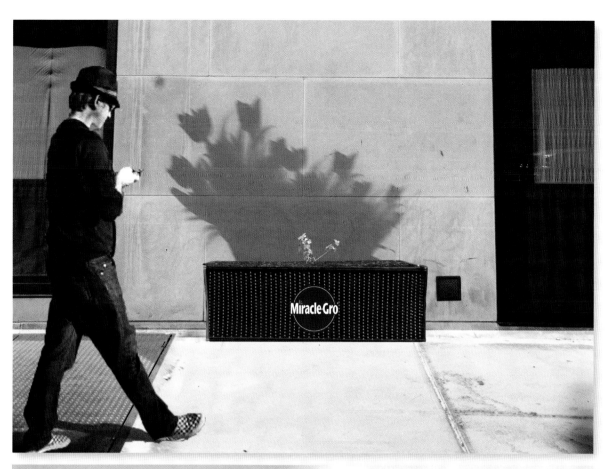

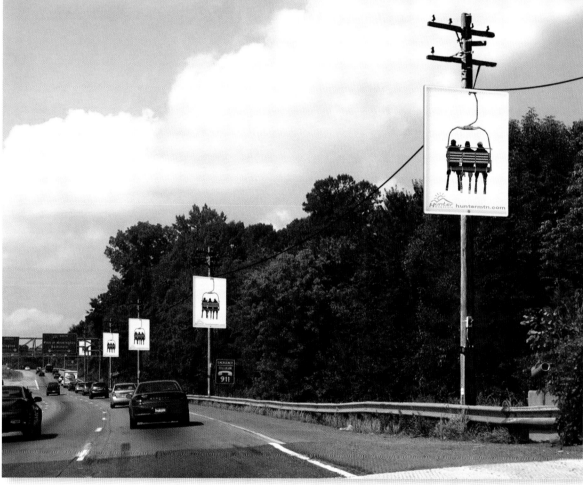

**Jack Mariucci** School of Visual Arts **Stella Jo Hsin Wang**
**Frank Anselmo** School of Visual Arts **Hyojoo Kim**

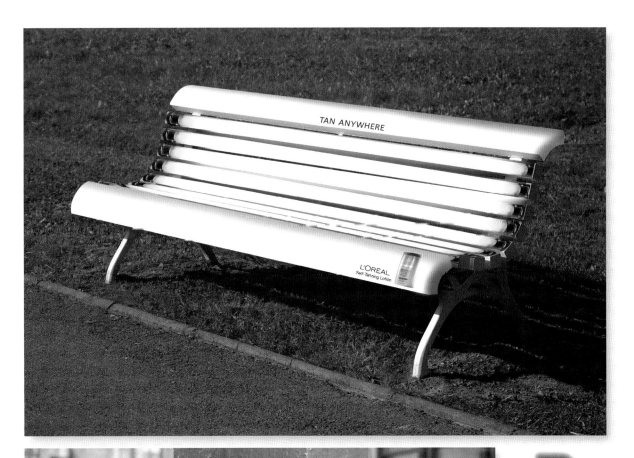

TAN ANYWHERE

L'ORÉAL
Self-Tanning Lotion

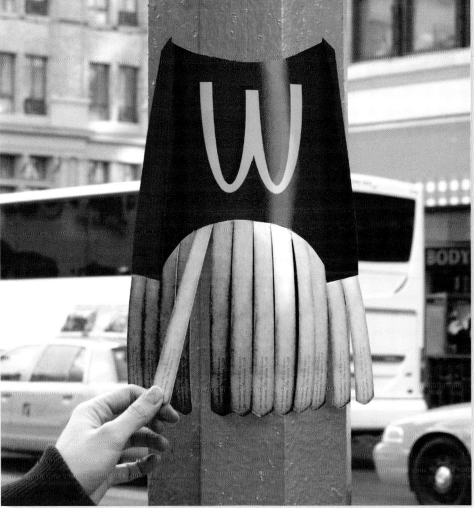

Free medium fry with this coupon.
1 per customer. Offer expires 11/09

**Vinney Tulley** School of Visual Arts **Hee Kyung Helen Shin**
**Frank Anselmo** School of Visual Arts **Tiffany Hyerim Joung**

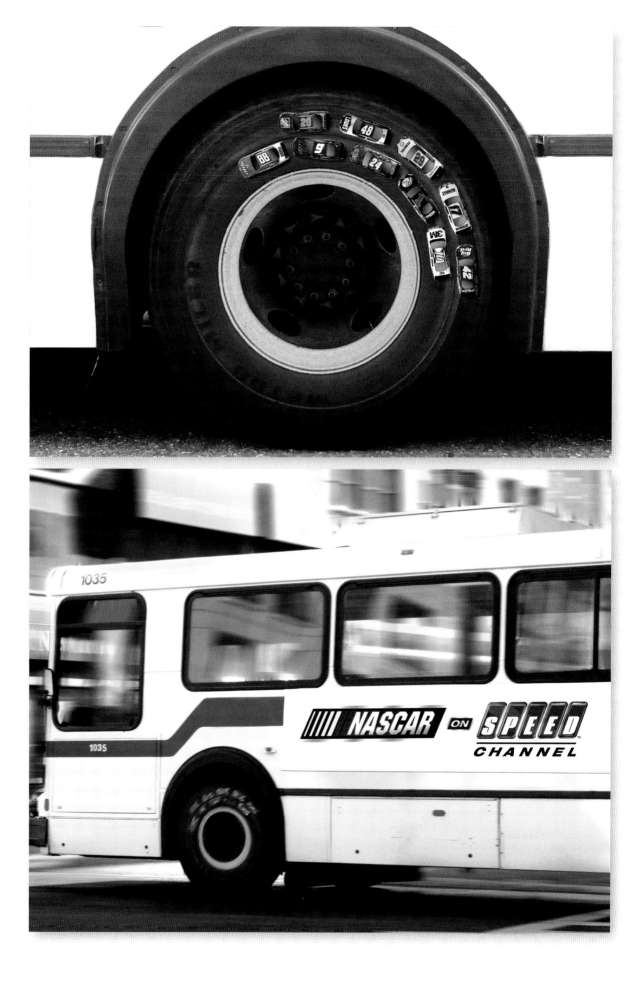

Frank Anselmo School of Visual Arts Mariana Castellanos Isaza, Stella Jo Hsin Wang

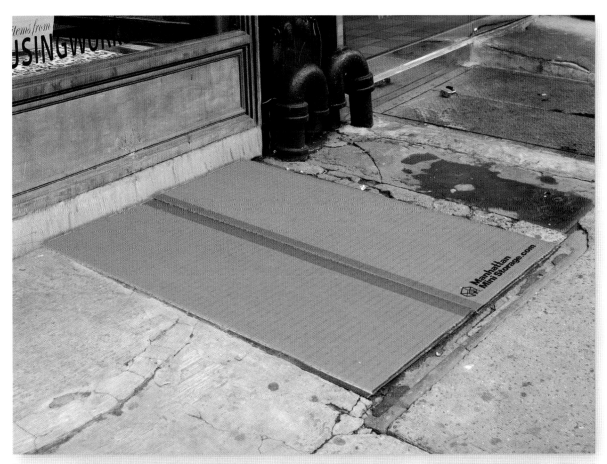

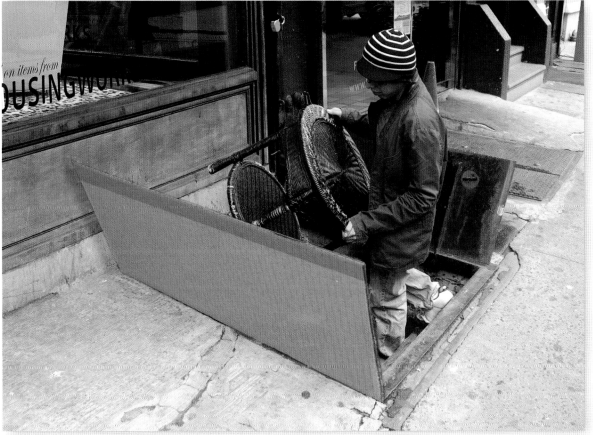

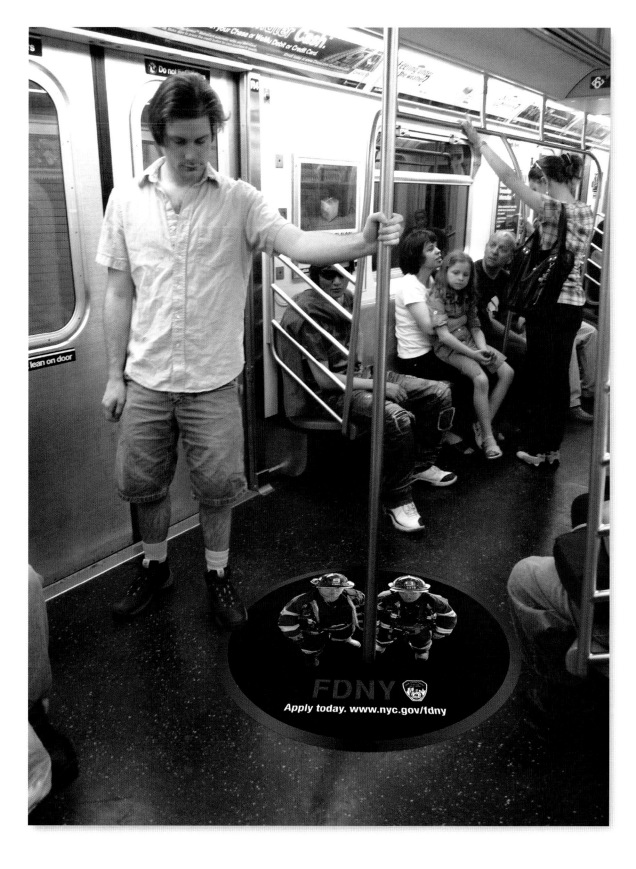

**Frank Anselmo** School of Visual Arts **Czarine Yee**

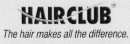

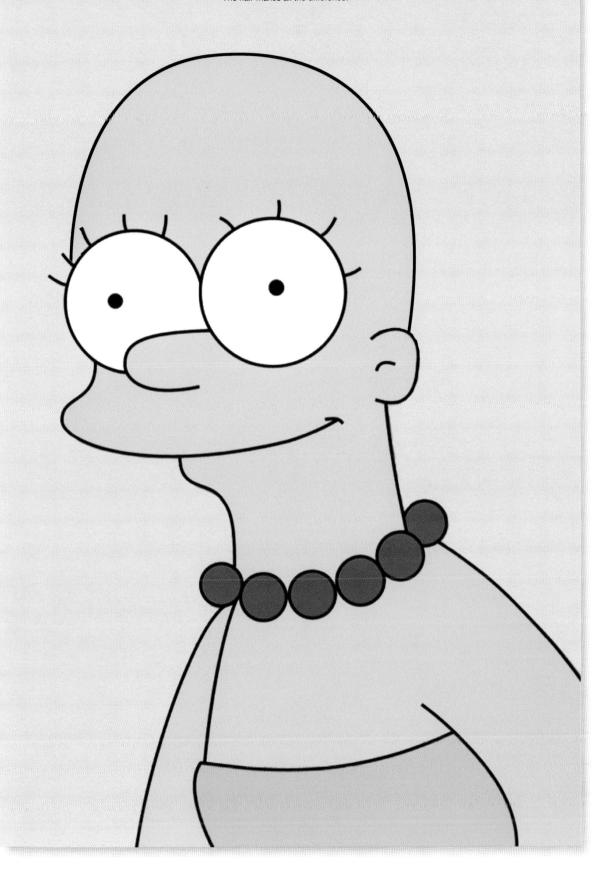

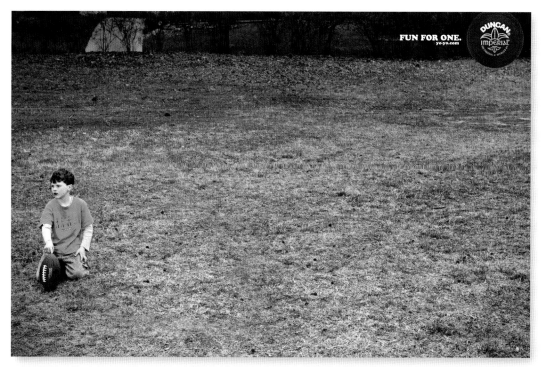

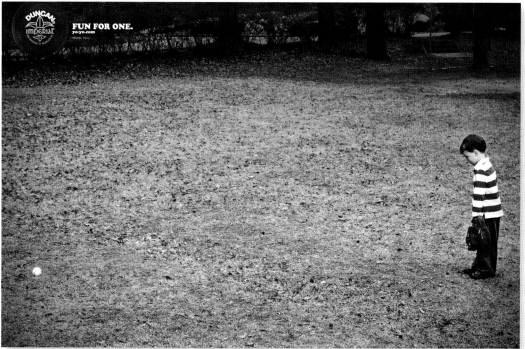

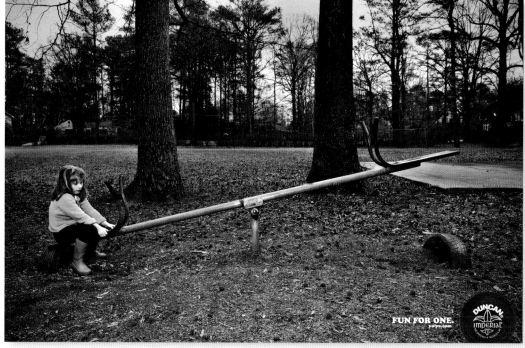

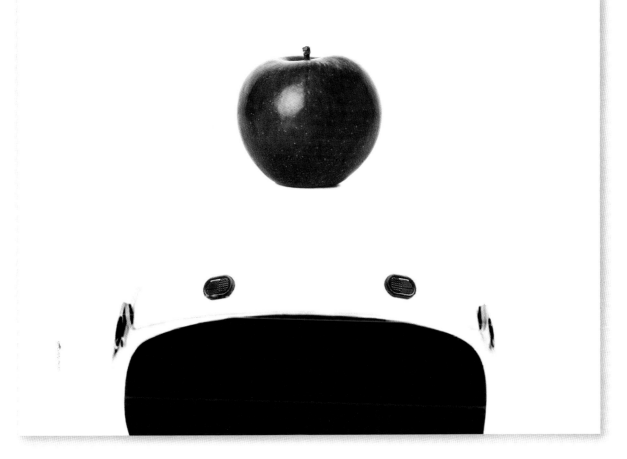

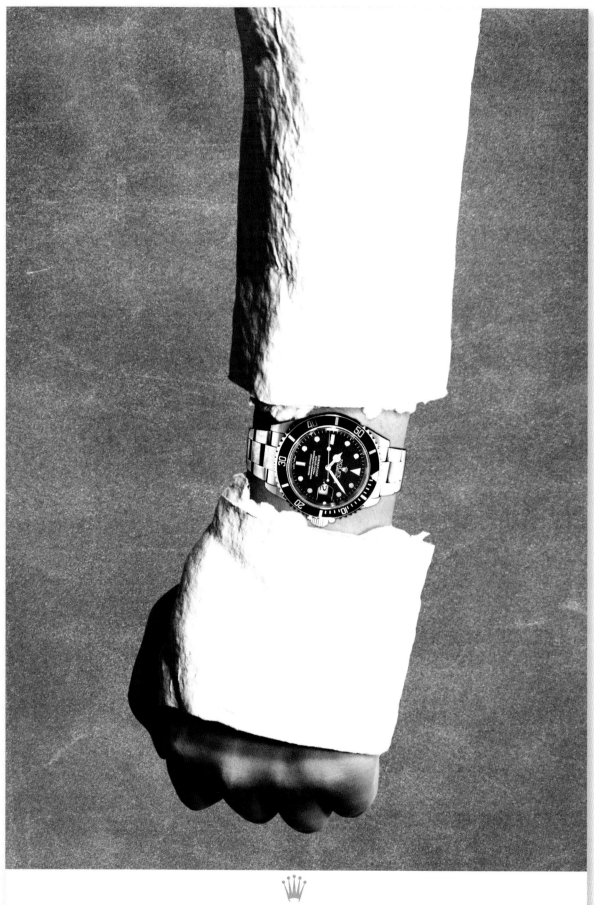

ROLEX

**Jack Mariucci** School of Visual Arts **Kenji Akiyama**

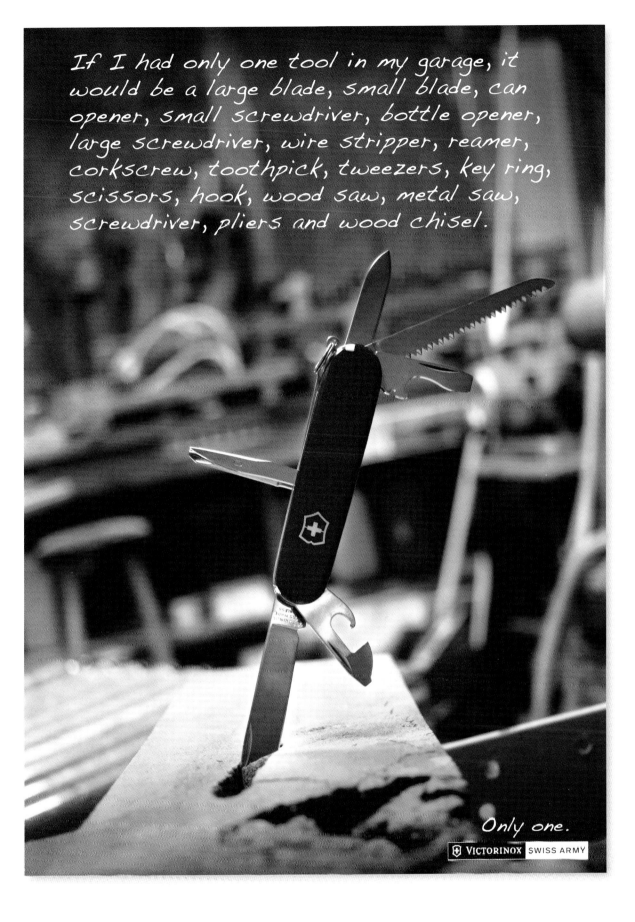

If I had only one tool in my garage, it would be a large blade, small blade, can opener, small screwdriver, bottle opener, large screwdriver, wire stripper, reamer, corkscrew, toothpick, tweezers, key ring, scissors, hook, wood saw, metal saw, screwdriver, pliers and wood chisel.

Only one.

VICTORINOX SWISS ARMY

If I could take one thing on a deserted island, I would take a corkscrew, toothpick, screwdriver, nail file, scissor, saw, hook, magnifying glass, pliers, key chain, wire stripper, toothpick, hex wrench, fish scaler, can opener, bottle opener and ballpoint pen.

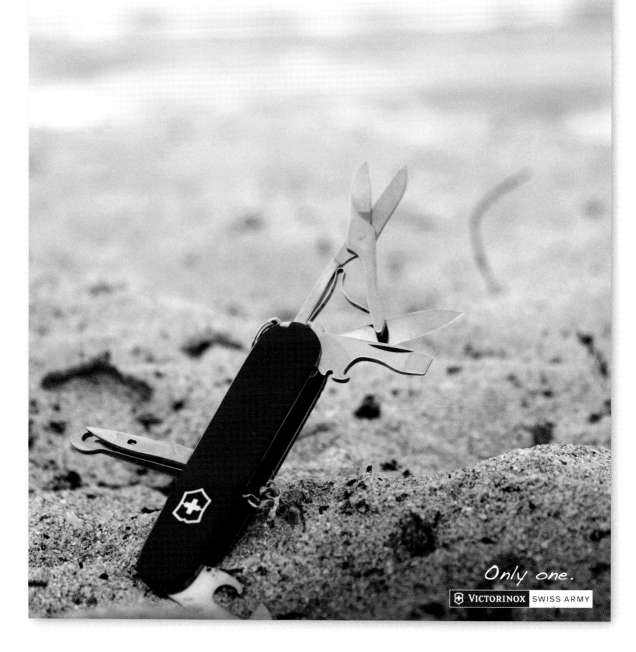

Only one.

VICTORINOX SWISS ARMY

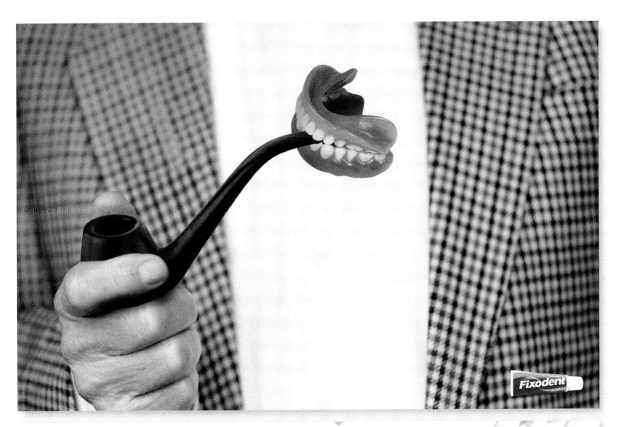

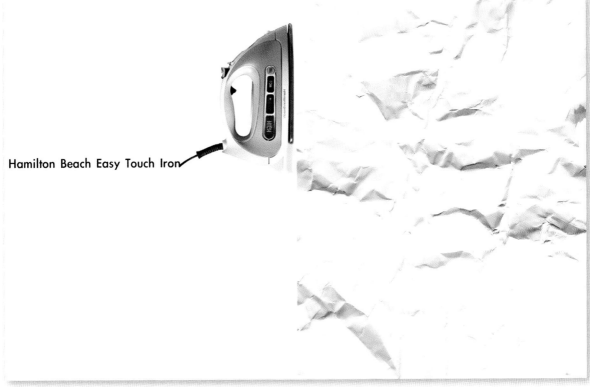

Hamilton Beach Easy Touch Iron

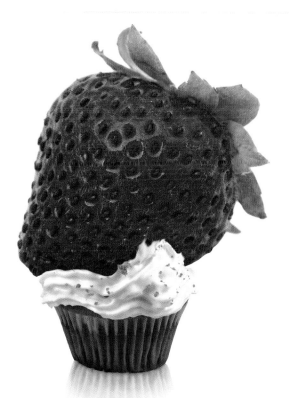

YOU'RE GONNA NEED MORE FROSTING  Miracle-Gro

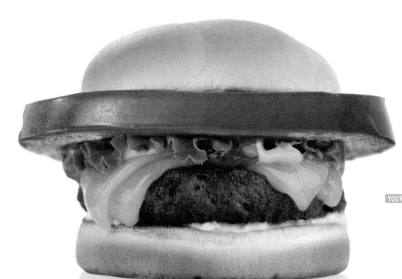

YOU'RE GONNA NEED LARGER BUNS Miracle-Gro

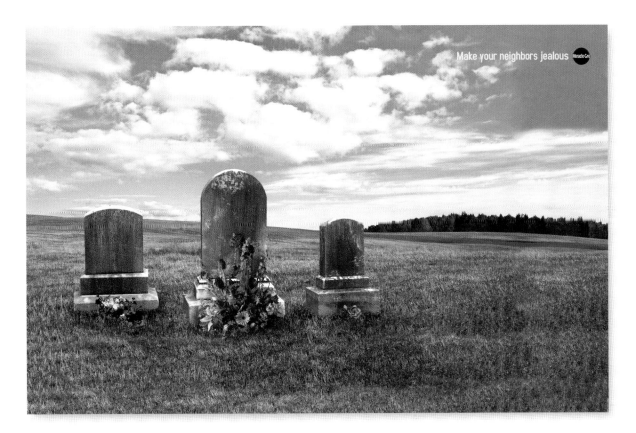

Make your neighbors jealous ●Miracle-Gro

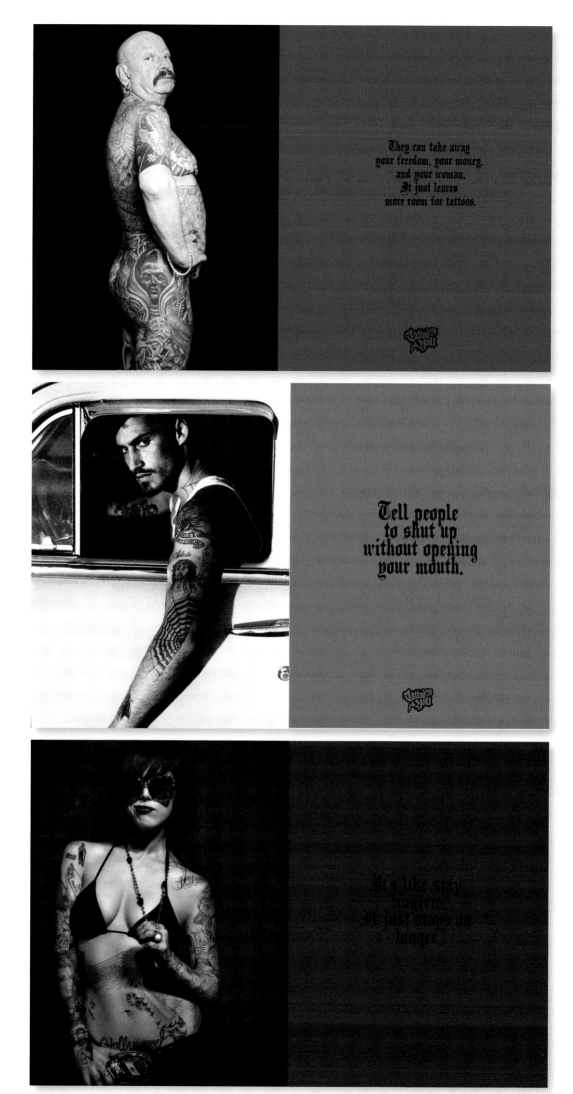

They can take away
your freedom, your money,
and your woman.
It just leaves
more room for tattoos.

Tell people
to shut up
without opening
your mouth.

It's like sexy
lingerie.
It just stays on
longer.

**Jack Mariucci** School of Visual Arts **Sara Roderick**

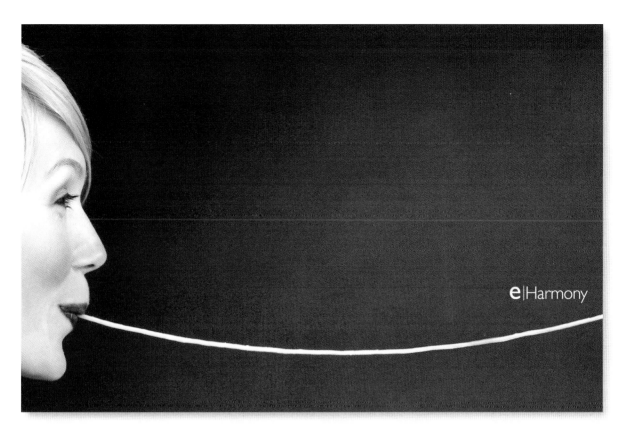

e|Harmony

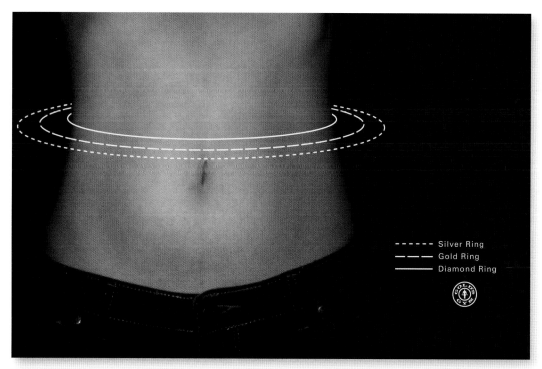

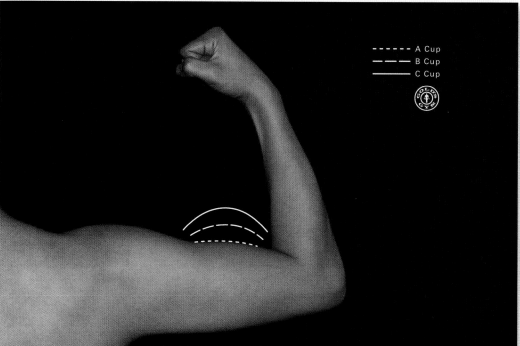

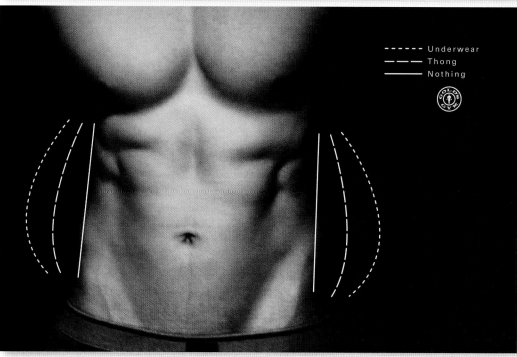

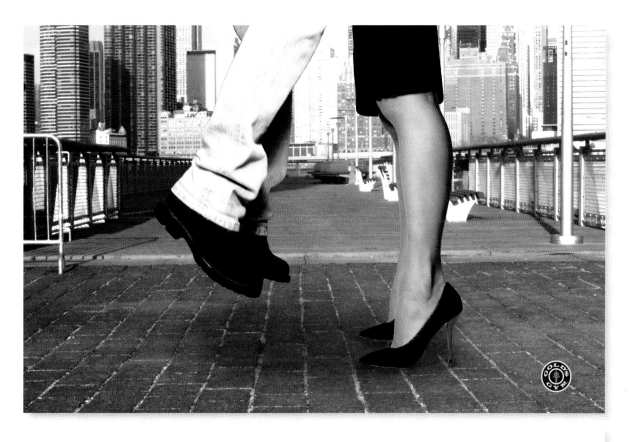

I joined Weight Watchers, and am no longer famous.

-*Rebecca Ure (former side show performer)*

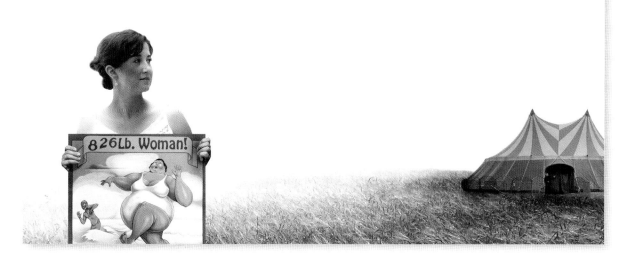

826 Lb. Woman!

**Jack Mariucci** School of Visual Arts **Kenji Akiyama**
**Jack Mariucci** School of Visual Arts **Lisa Gilardi, Itai Inselberg**      ProfessionalService|Advertising **67**

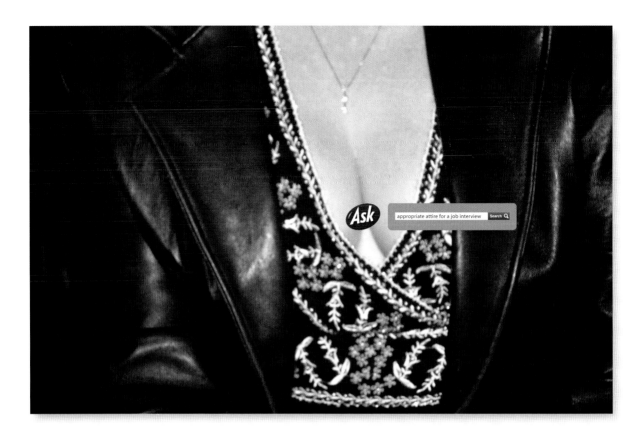

Ask

appropriate attire for a job interview    Search

"WHY IS BRA SINGULAR AND PANTIES PLURAL?"

Ask.com

**Jack Mariucci** School of Visual Arts **Catherine Eccardt, Giovanni Muniz, Hee Kyung Helen Shin**

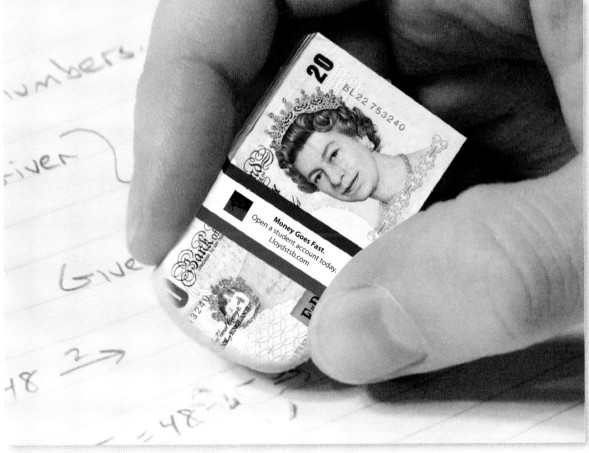

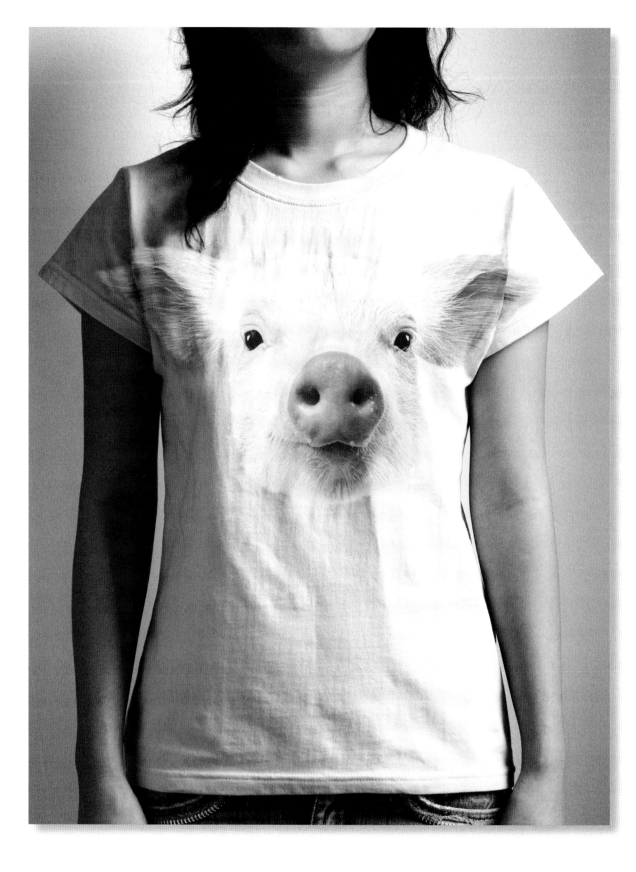

(this spread)

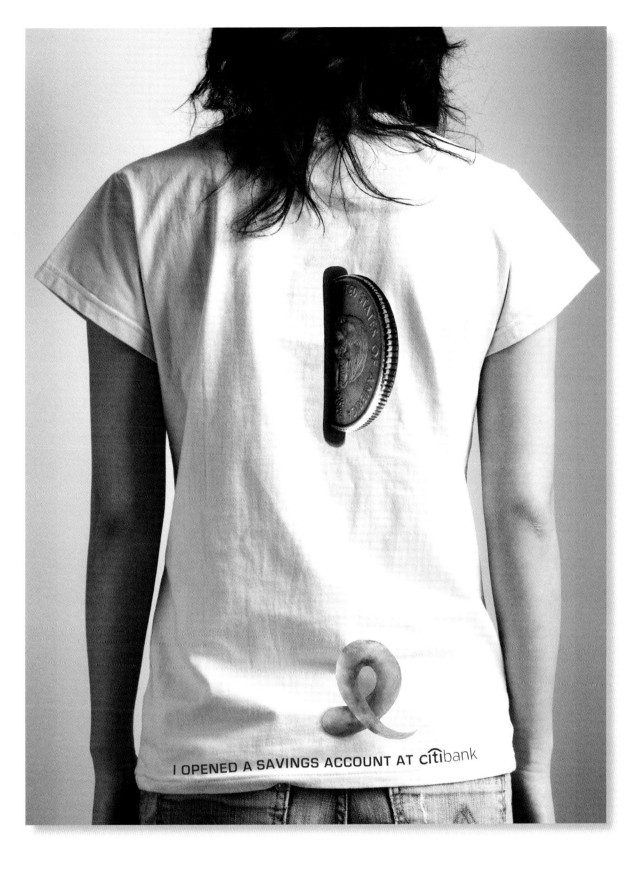

I OPENED A SAVINGS ACCOUNT AT citibank

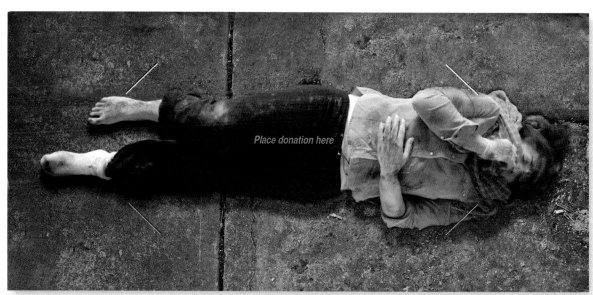

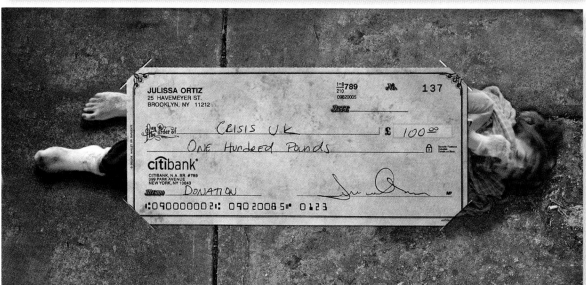

**Frank Anselmo** School of Visual Arts **Alex Sunyoung Koo, Julissa Ortiz**

Mr. John Sandler
116 Piccadilly
London W1J 7BJ
United Kingdom

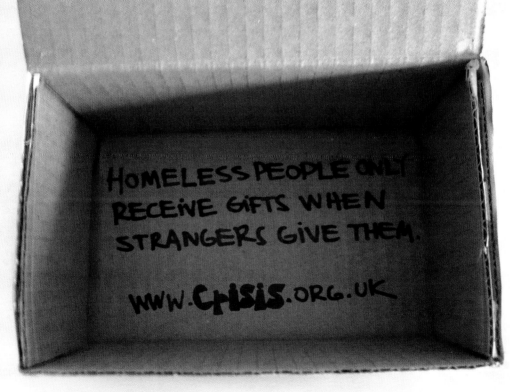

HOMELESS PEOPLE ONLY RECEIVE GIFTS WHEN STRANGERS GIVE THEM.

www.CRISIS.ORG.UK

Advertising|PublicService     **Frank Anselmo** School of Visual Arts **Hyungrak Choi**

You are not the only one at risk. Mothers Against Drunk Driving

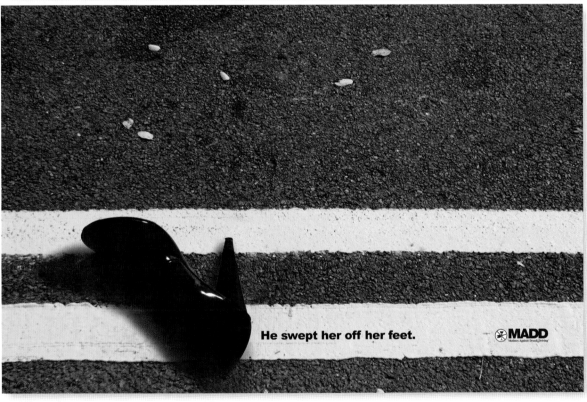

He swept her off her feet.

MADD Mothers Against Drunk Driving

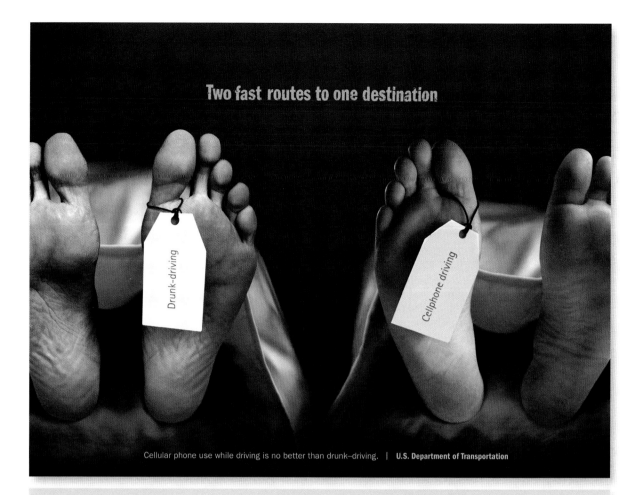

Two fast routes to one destination

Cellular phone use while driving is no better than drunk–driving. | U.S. Department of Transportation

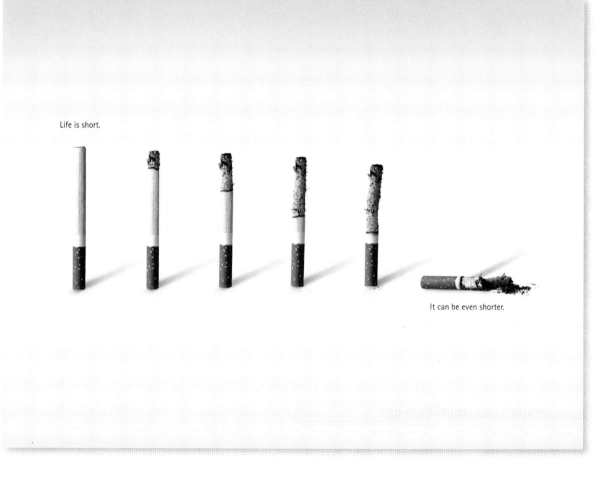

Life is short.

It can be even shorter.

Eric O'Toole, Bob Gill Pratt Institute Suhee Eom

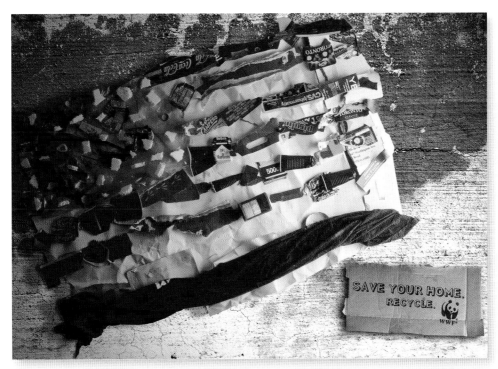

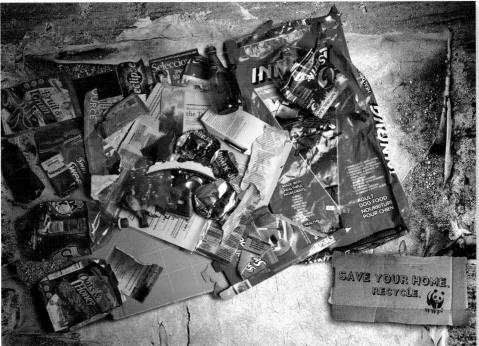

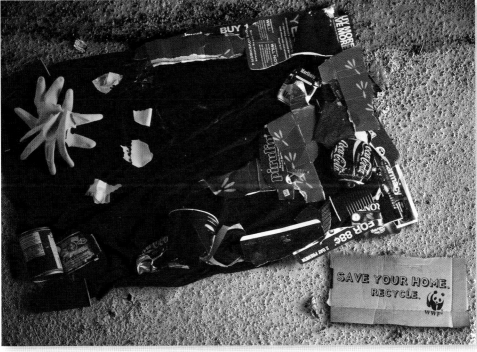

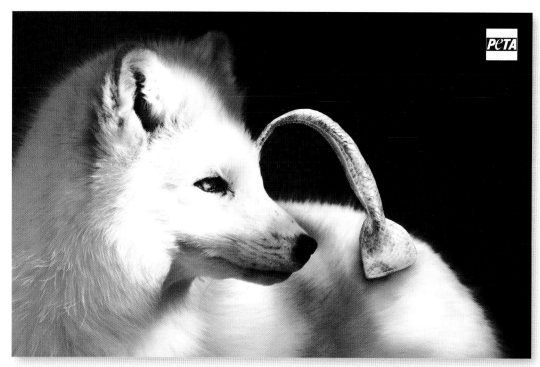

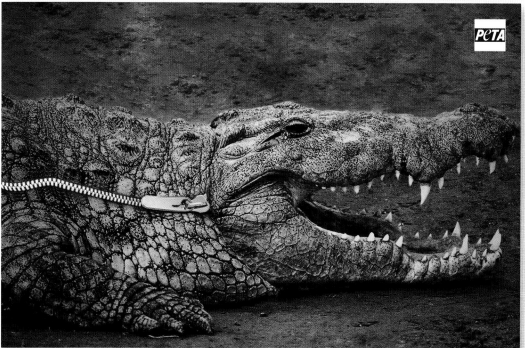

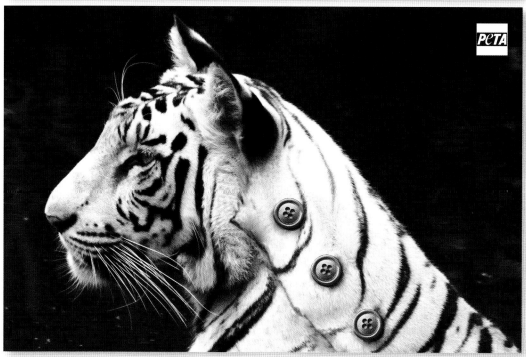

**Jack Mariucci** School of Visual Arts **Kenji Akiyama**

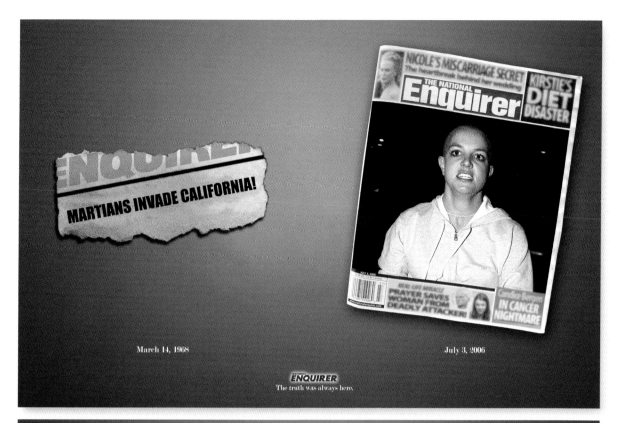

MARTIANS INVADE CALIFORNIA!

March 14, 1968

July 3, 2006

ENQUIRER
The truth was always here.

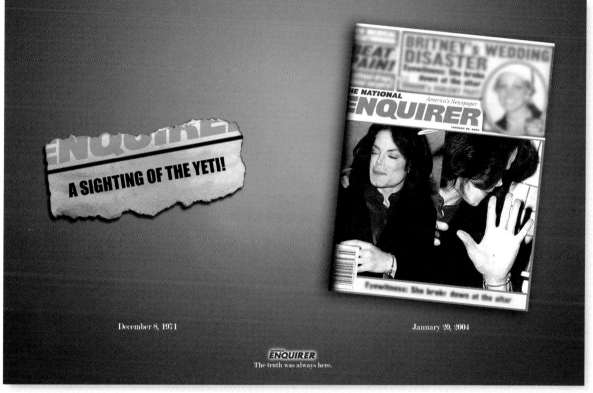

A SIGHTING OF THE YETI!

December 8, 1971

January 20, 2004

ENQUIRER
The truth was always here.

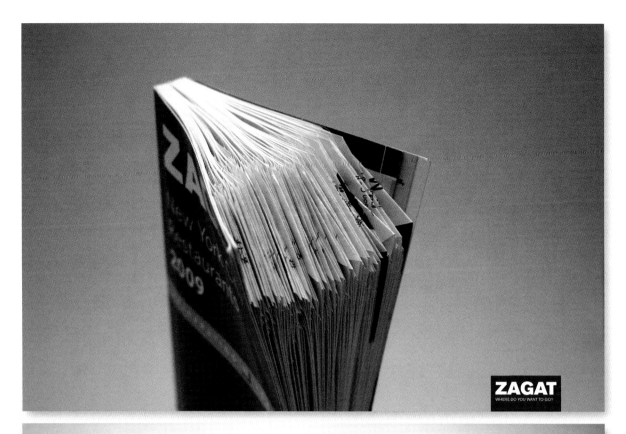

**Jack Mariucci** School of Visual Arts **Giovanni Muniz, Hee Kyung Helen Shin**

It all begins with nature. NATIONAL GEOGRAPHIC Explore.

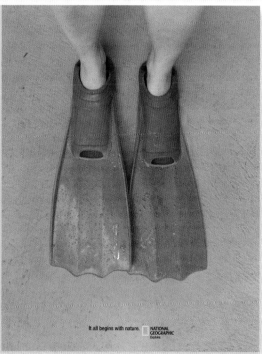

It all begins with nature. NATIONAL GEOGRAPHIC Explore.

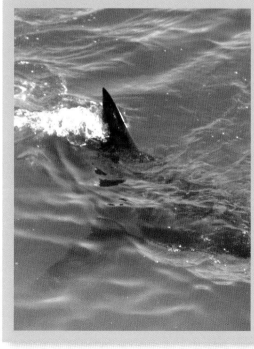
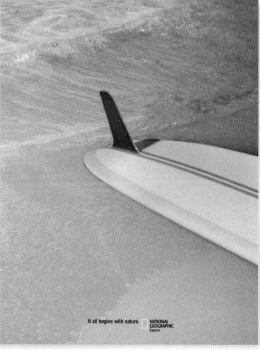

It all begins with nature. NATIONAL GEOGRAPHIC Explore.

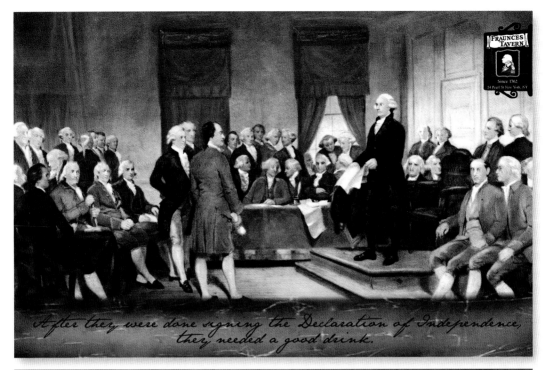

*After they were done signing the Declaration of Independence, they needed a good drink.*

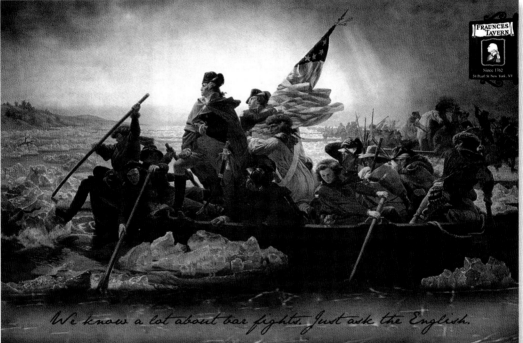

*We know a lot about bar fights. Just ask the English.*

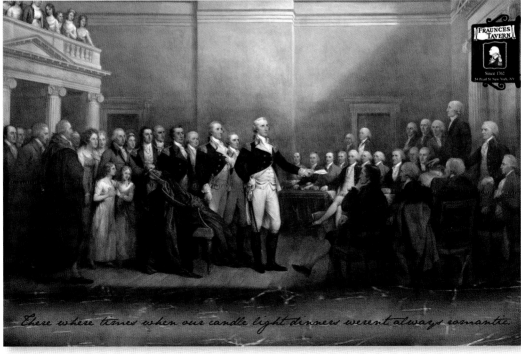

*There where times when our candle light dinners weren't always romantic.*

**Sal DeVito** School of Visual Arts **Sara Roderick**

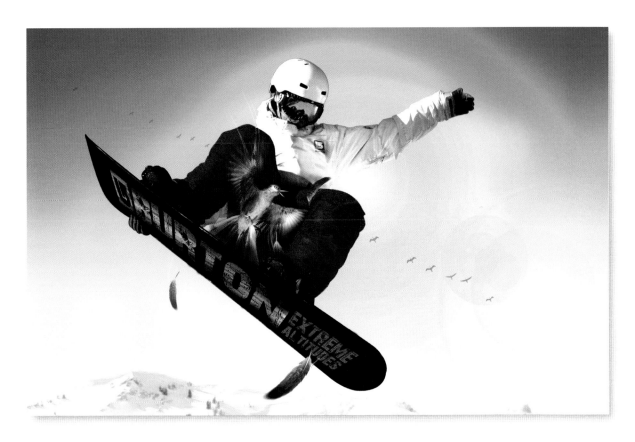

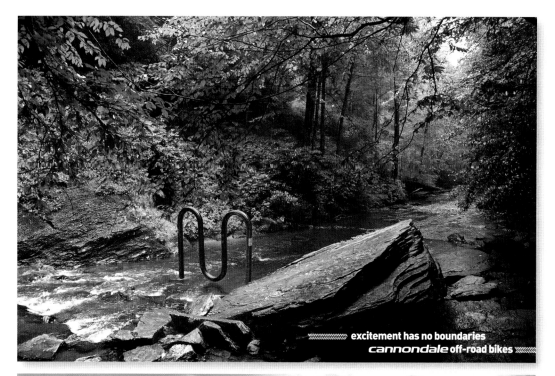

excitement has no boundaries
*cannondale* off-road bikes

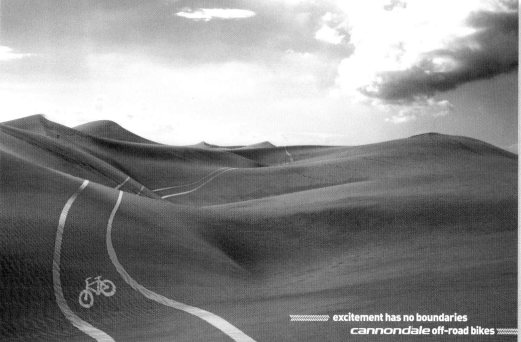

excitement has no boundaries
*cannondale* off-road bikes

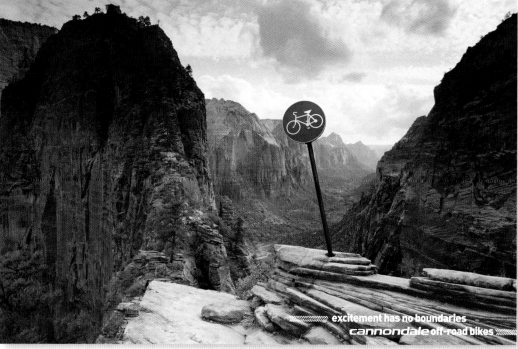

excitement has no boundaries
*cannondale* off-road bikes

**Jack Mariucci** School of Visual Arts **Lisa Gilardi, Itai Inselberg**

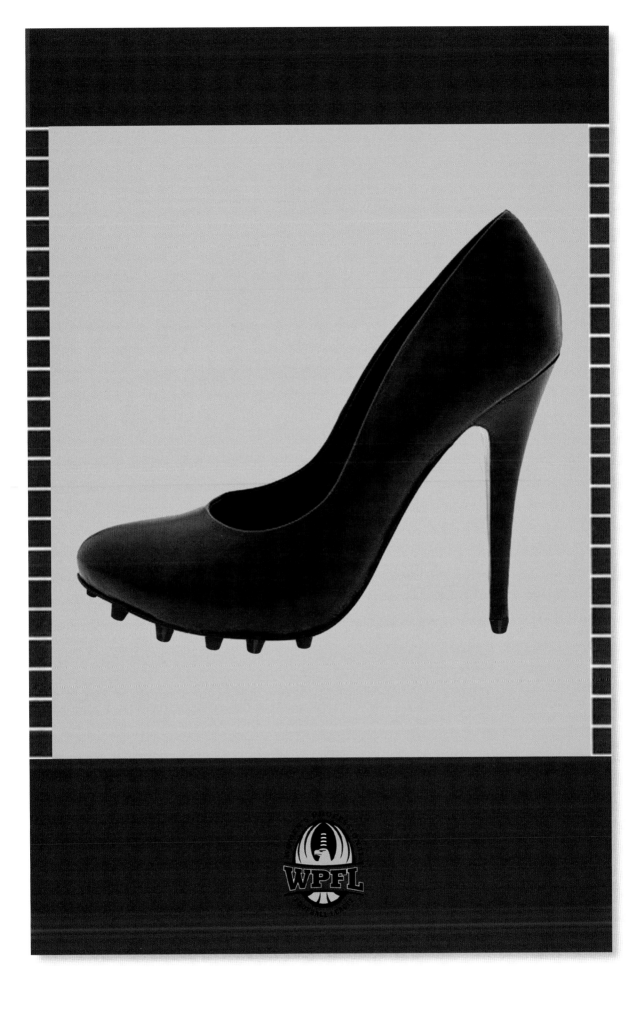

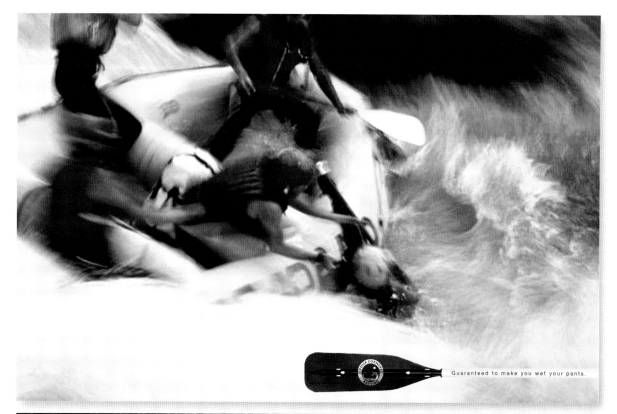

Guaranteed to make you wet your pants.

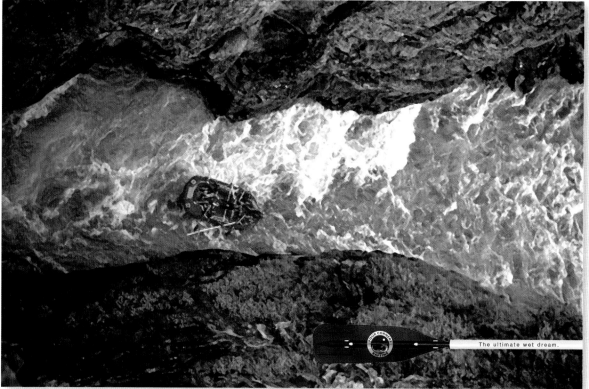

The ultimate wet dream.

**Jack Mariucci** School of Visual Arts **Sara Roderick**

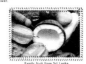

Sri Lanka
Flower.

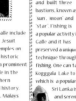

Exotic fruit from Sri Lanka.

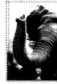

Wet elephants, sacred animals.

The Dutch built the present Fort in the year 1663. They built a fortified wall, using solid granite, and built three bastions, known as sun, moon and star. Fishing is a popular activity in Galle and it has preserved a unique technique throughout the years called Stilt fishing. One can take a boat trip in the lagoon and Kogggala Lake to see many of its small islands, which is a popular destination for bird watching. Sri Lanka is the embodiment of beauty and serendipity in a small island off the south coast of India. It's wildlife and rich heritage will take you on a cultural adventure that you'll never forget.

## The City of Galle is thought to be the legendary city of Tarshish mentioned in the Bible. We would like to thank God for the free publicity.

Other prominent landmarks in Galle include St. Mary's Cathedral founded by Jesuit priests, one of the main Shiva temples on the island, and The Amangalla, a historic luxury hotel. But Galle had been a prominent seaport long before western rule in the country. The capital of the southern province is a city with a colorful history. Persians, Arabs, Greeks, Romans, Malays and Indians were doing business through Galle port. The 'modern' history of Galle starts in 1505, when the first Portuguese ship, under Loureno de Almeida was driven there by a storm.

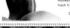

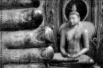

Monkey Eating
fresh fruit

What better place to visit than the legendary port city first mentioned in the Bible in the time of Solomon? Tarshish means literally the sea coast. Jonah's famous voyage began when he boarded a ship to the famous port from Joppa. This route was used usually for trades, but it is thought that king Solomon had his fleet of ships at Tarshish and drew ivory, peacocks, and other valuables.

View of Pool
in Sri Lanka.

Religious or not, Galle is an enchanting city to visit; it is a perfect example of a city fortified by the Europeans, many years later the Biblical days. Cruising the city one can see the interaction between European architectural styles and Asian traditions. Galle fort is a world heritage site and the largest remaining fortress in Asia built by European occupiers.

Buddha Head.

Detail of
Buddha statue.

Sri Lanka
A Land Like No Other.

---

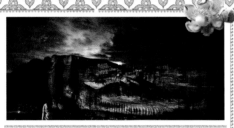

Sri Lanka
Flower.

Special fruit
from Sri Lanka.

Small Turtle
in Batticaloa
Lagoon.

The beach is in perfect harmony with its stunning natural setting on the island's eastern tip. With its atmosphere of rarefied tranquility, it is a place for relaxation and renewal. During the day there are many other activities like boating, fishing, and bird watching. For relaxation and renewal Sri Lanka is the embodiment of beauty and serendipity in a small island off the south coast of India. It's wildlife and rich heritage will take you on a cultural adventure that you'll never forget.

## If you hear strange noises at night, don't worry. It's just the fish singing.

The singing fish are known to perform their musical act in this very location and the singing can be heard even from a distance. A night the bridge is lit by the full moon's light and one can hear the musical charm in the middle of the night. A priest by the name of Father Lang recorded the sounds they made and broadcast in the 1960's over the Sri Lanka's Broadcasting Cooperation. The famous Batticaloa beaches run along 4 km of Sri Lanka's shoreline. People gather for the popular serene beach front near Kallady. Psikudah is a bay nearby that is protected from the ocean, its bed is flat and sandy and it's known for the pleasant effect it has on the feet.

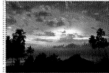

Fisherman with
big catch.

The first people who migrated to these lands were the Mutkuhar. They constructed villages in various areas that make today's town of Batticaloa. The name given to this area is Kallpu-Mattam which literally means: boundary of lagoon. In fact, the quiet place on the east coast of Sri Lanka is surrounded on three sides by a large lagoon, the rest of the area consist of a blend of magnificent views of land, oceans and beach.

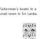 

Fisherman's boats in a
small town in Sri Lanka.

There are many bridges that connect the landmasses scattered throughout the lagoons that makes this region feel like an island. The largest of these bridges is Lady Manning; it is located at Kallady. the main access path to the city from the southern places. One of the many attractions of Batticola is singing fish. The musical sounds can be heard across the lagoon, near this very bridge.

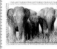

Sri Lankan
elephants.

Beautiful sunset
over Batticloa.

Sri Lanka
A Land Like No Other.

---

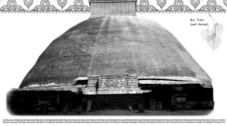

Bo Tree
leaf detail.

Among what remains today, one can find different classes of buildings: dagobas, a type of monastic building, and pokunas.

Goddess carved
in stone Temple.

Colorful details inside Temple with large Buddha.

## Climbing 2000 steps to a historic temple is something that you'll remember forever. Or at least until your legs stop hurting.

The dagobas are bell shaped masses of masonry that can reach up to 1100 ft in circumference. Some of these buildings contain enough raw materials and masonry to build a town for 25 thousand inhabitants. One can find remains like these in every direction, some in shape of raised platforms. The foundation for these buildings are stone pillars. In 164 BC King Dutugamunu erected the most famous of the dagobas style building. The pokunas on the other hand, are bathing tanks that were used for supplying drinking water to the inhabitants, these can be found scattered everywhere

throughout the jungle. Among the many other things to see are the Samadhi Buddha, the Brazen Place and temples. There are eight major places of veneration in Anuradhapura: Abhayagiri Dagaba, Ruvanvelisaya, Thuparamaya, Lovamahapaya, Abhayagiri Dagaba, Jetavanarama, Mirisaveti Stupa, Lankarama. Scattered in the vicinity of the city there is a large number of other ruins that cannot be identified properly and many where destroyed by the Tamil invaders or vandals. Sri Lanka is the embodiment of beauty and serendipity in a small island of the south coast of India. It's wildlife and rich heritage will take you on a cultural adventure that you'll never forget.

Anuradhapura was made the ancient royal capital of Sri Lanka back in 380 BC. It remained the residence for 119 successive Singhalese kings till the year 1000 AD when it was abandoned. The city has remained the same ever since, degraded only by time. It is like a time portal into the ancient world of the Sri Lanka's history. Here you can climb a 2000 step stairway that will take you to where the Buddha found enlightenment under the shade of a Bo tree. It is a good place to meditate and catch your breath. The tree dates back to the year 245 BC.

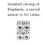 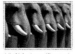

Detailed carving of
Elephants, a sacred
animal in Sri Lanka.

The great city was at its highest magnificence at the beginning of the Christian era. The city of Anuradhapura, being founded in one the driest zones of the country, could only survive by building one of the most complex and innovative irrigation systems of the ancient world to irrigate its lands. You can still find these structures today among the ruins.

Detail of carving Temple.

Detail of animals
carved into Temple.

Goddess carved in stone Temple.

Sri Lanka
A Land Like No Other.

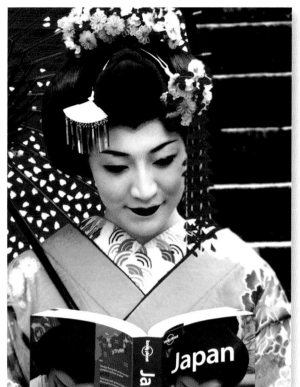

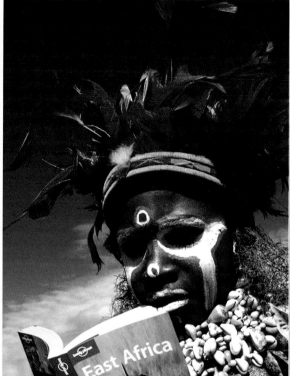

**Michael Schachtner** Miami Ad School **James Kiersted, Bipasha Mookherjee**

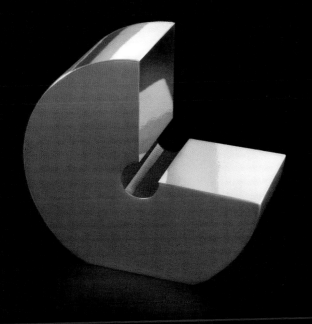

**22,000** employees are dedicated to operating its system, which support

**280,000** shipments in transit at any time.

An operation research and engineering team works for the movement routing, sequencing and timing of nearly **64** million miles per month.

At December 31, 2006, Yellow Transportation had **7,967** owned tractors, **648** leased tractors,

**32,982** owned trailers, **769** leased trailers,

Yellow Transportation accounted for **35%** of our total operating revenue in 2006.

YRC Worldwide, Inc.

# 2006 Annual Report

In today's competitive environment, standing still is not an option. The story of our company in 2006 is a story of progress, development and growth.

**ROADWAY**

provide freight service among all **50** states, **100** additional countries

**300,000** manufacturing, wholesale, retail and government customers

**336** service center **13,480** doors.

At December 31, 2006, Roadway had **6,807** owned tractors, **2,064** leased tractors,

**27,268** owned trailers, **3,183** leased trailers,

Roadway accounted for **34%** of our total operating revenue in 2006.

**YRC Annual Report**

**Dear Shareholder,**

Over the last several years, we have built our capabilities to become a global leader in transportation and supply-chain solutions. The progress made in 2006 is key to achieving that goal.

We delivered another year of record revenue and operating profit. For the fourth straight year, our return on committed capital exceeded our weighted average cost of capital. We also improved the speed and efficiency of our asset-based networks and we continued to enhance our presence around the world, especially in China. Our joint ventures there provide the platform for significant expansion in 2007 and beyond. We have a unique and powerful opportunity to follow our 800,000-plus customers around the world and create value for them, as well as for our employees and our shareholders.

At the end of 2006, we announced three structural changes that will accelerate our performance. We established the YRC National Transportation organization—which puts the strategic direction of Yellow and Roadway under one management team—to create better efficiency, resource utilization, and capital management. We will also have the opportunity for further differentiation and faster growth from these two great brands.

The Enterprise Solutions Group was formed to make it more convenient for our larger, more complex customers to do business with us and give them an easier way to access all of our brands and capabilities. Again, we see great opportunity for faster, more profitable growth as an outcome of this new approach.

Finally, we consolidated USF Bestway into USF Reddaway, creating an even stronger regional portfolio of companies. USF Reddaway, USF Holland, USF Glen Moore, and New Penn are all recognized as leaders in their respective markets with strong brands and a history of providing great service.

So the journey continues along the same strategic path we set for ourselves several years ago. In many ways, the year ahead is one where we will "connect the dots" by leveraging and integrating the capabilities we have assembled while focusing on faster growth and greater efficiency.

As has been the case in the past—and will be in the future—our people make it happen. And I want to thank each of them for their efforts in driving our continued success. Whether they work in a business unit, Enterprise Services, technology, or the corporate staff, their contributions are highly valued and greatly appreciated.

2006 was an exciting and productive year in many ways, but 2007 will be a year where we bring it all together for our employees, customers, and shareholders.

WILLIAM D. ZOLLARS
CHAIRMAN OF THE BOARD
PRESIDENT AND CEO
YRC WORLDWIDE, INC.

**MERIDIAN IQ**

delivers a wide range of global logistics management company that plans the movement of goods worldwide to provide customers solutions for logics management solution.

Meridian IQ has approximately **18,000** transactional

**350** contractual customers.

Meridian IQ has more than **2,700** employees, including

**2,300** located in North America,

**200** located in Asia, **130** located in Europe

Meridian IQ accounted for **6%** of our total operating revenue in 2006.

**Putting Information Technology to Work**

"In 2006, we deployed tools across multiple operating companies that enabled them to be more responsive to customer needs. We developed technology that allows shipments to seamlessly and securely move across borders. And we're making significant progress in developing next-generation systems for mobile technology and asset tracking. In short, we are enabling our operating companies to advance global supply-chain solutions."

LUEVINA HUSKEY, TECHNOLOGY SUPERVISOR
OVERLAND PARK, KANSAS

**Growing Global Reach**

"We continued to expand our global logistics capabilities to facilitate international trade, with China as a focal point for investment and growth. We intensified our focus on customer satisfaction, and introduced a turnkey transportation management solution designed for small and mid-sized companies. We also launched a new initiative to deepen our relationships with clients. These added capabilities are crucial to our long-term growth and have been extremely beneficial to our ability to serve our global logistics clients more efficiently each day."

WINNIE MA, GLOBAL DEVELOPMENT MANAGER
SAN FRANCISCO, CALIFORNIA

YRC Worldwide, Inc.

**Financial Pages**
2006 Annual Report

# content

**1** museum

**2** office building

**3** apartment

**4** retail

publication colophon

Publisher © 2007 by Collins Design, New York. No part of the contents of this book may be reproduced without the prior permission of the publisher.

Printed and Bound in Japan

Library of Congress Catalog Card Number No 18233
ISBN 0-06XX-XXXX-X
Copyright © 2007 Jeff Herbers. All rights reserved.

# SHAPE OF THE FUTURE

*Jill Herbers*

*Collins Design, Publishers*

---

Site Dimensions
Width: 25 feet
Depth: 81 feet, 4 inches

Building:
Height: 278 feet, 6 inches
Floor Area:
Gross: 33,000 square feet
Net: 24,850 square feet

Construction start: 1998
Completion: 2002

Client:
Republic of Austria,
Federal Ministry for Foreign Affairs.

Architect
Atelier Raimund Abraham,
New York, United States

11

## Whitney Museum of American Art

*Located in New York City, USA, the Whitney's permanent collection contains more than 12,000 works in a wide variety of media. The Whitney places a particular emphasis on exhibiting the work of living artists to its collection as well as maintaining an extensive permanent collection containing many important pieces from the ral rall of the century. The museum's Annual and Biennial exhibitions have long been a venue for younger and less well-known artists whose work the museum showcases.*

**Gertrude Vanderbilt Whitney**, the museum's namesake and founder, was herself a well-regarded sculptor as well as a serious art collector. As a patron of the arts, she had already achieved some success as the creator of the "Whitney Studio Club," a New York-based exhibition space which she created in 1918 to promote the works of avant-garde and unrecognized artists. By 1929, she had amassed nearly 700 works of contemporary American art which she offered to the Metropolitan Museum of Art. The Met turned down her gift, and Mrs. Whitney instead used her collection to found the "Whitney Museum of American Art" in 1931.

Gertrude Whitney's daughter, Flora Payne Whitney, served as a museum trustee, then as vice president. From 1942 to 1974 she was the museum's president

and chairman after which she functioned as honorary chairman until her death in 1986. Her daughter, Flora Miller Biddle, served as its president until 1985. In 1999, her book The Whitney Women and the Museum They Made was published by Arcade Publishing.

After two changes of venue, the Whitney settled in 1966 at Madison Avenue at 75th Street in Manhattan's Upper East Side. The present building, planned and built 1963-1966 by Marcel Breuer and Hamilton P. Smith in a distinctively modern style, is easily distinguished from the neighboring townhouses by its staircase facade made from granite stones and its external upside-down windows.

**Christopher Austopchuk** School of Visual Arts **Rachel Mui**

THE
AGE
OF

WIRE
AND
STRING

BEN
MARCUS

**Paul Sahre** School of Visual Arts **Lauren Jantz**

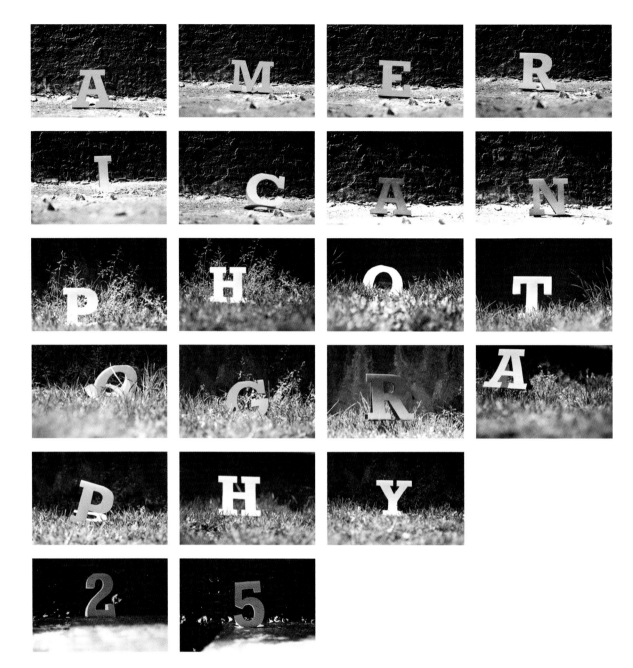

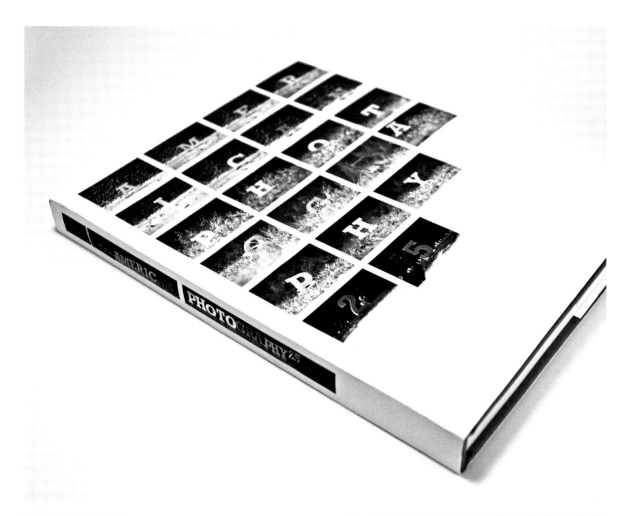

The

Return

*of*

Depression

Economics

*and*

The

Crisis

*of*

2008

Paul

Krugman

Winner of the Nobel Prize in Economics

**Michael Ian Kaye** School of Visual Arts **Takako Saegusa**

While the City Sleeps...
Crime Scene Photography

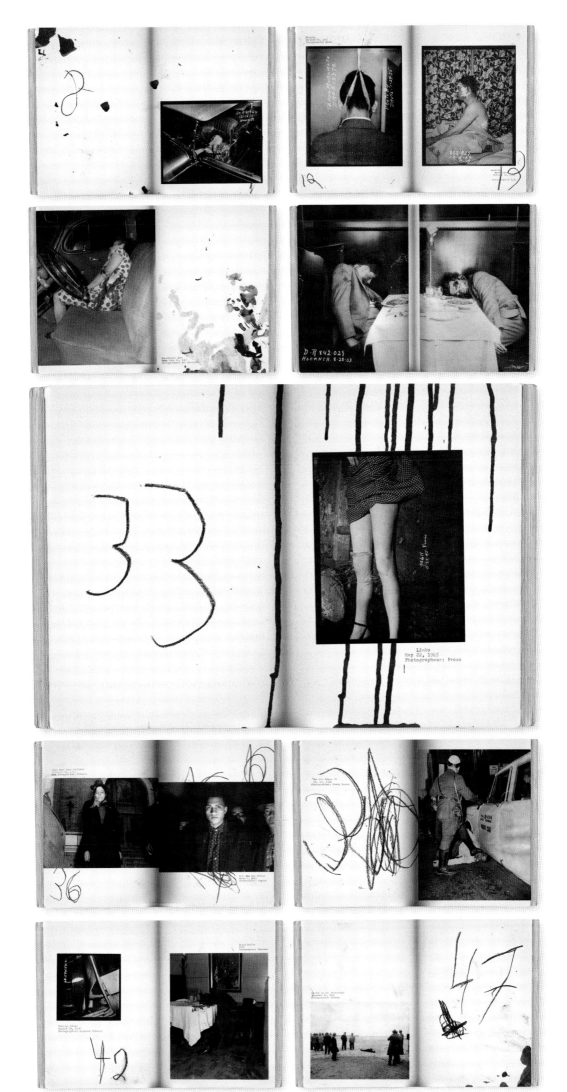

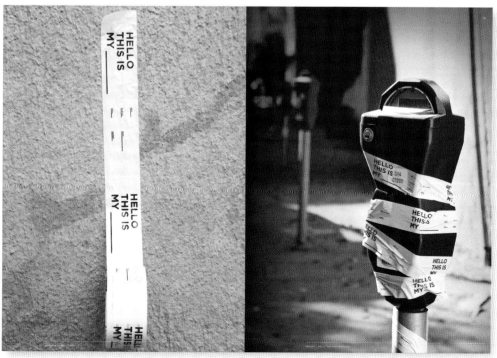

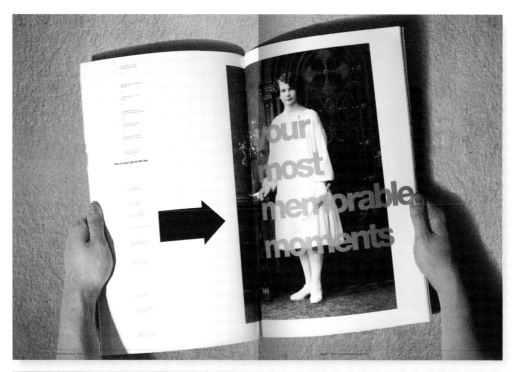

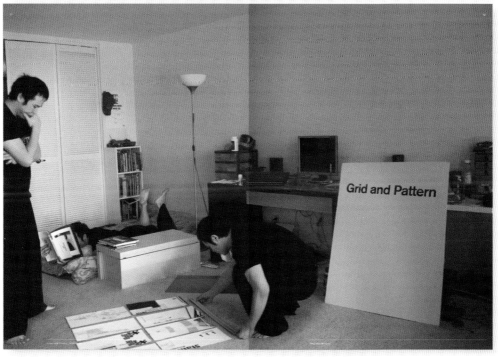

**David Asari** California College of the Arts **Daniel Amara**
**John Fulbrook** School of Visual Arts **Takako Saegusa**
**Adrienne Leban** School of Visual Arts **Nick Ruggiero**

THE TOMBS OF ATUAN

URSULA K. LE GUIN

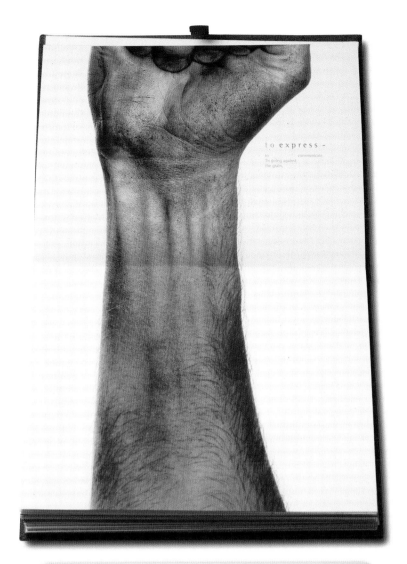

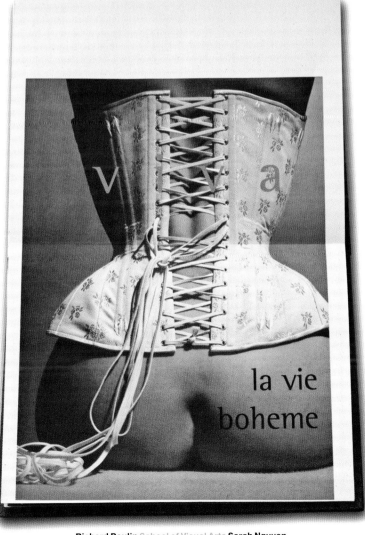

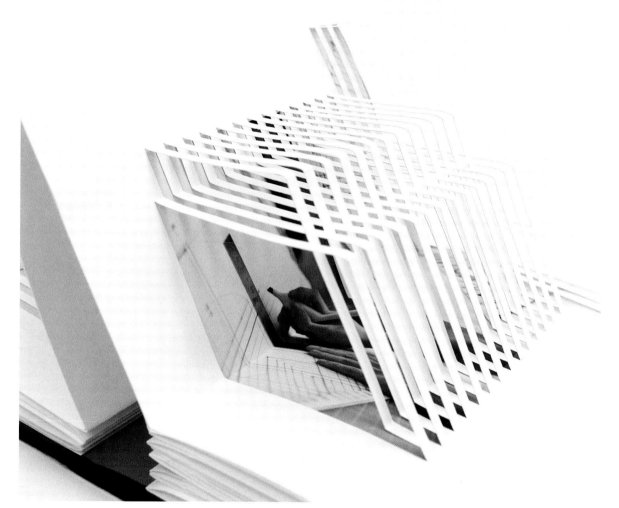
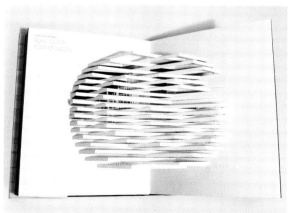
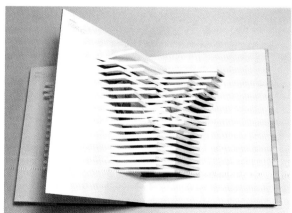

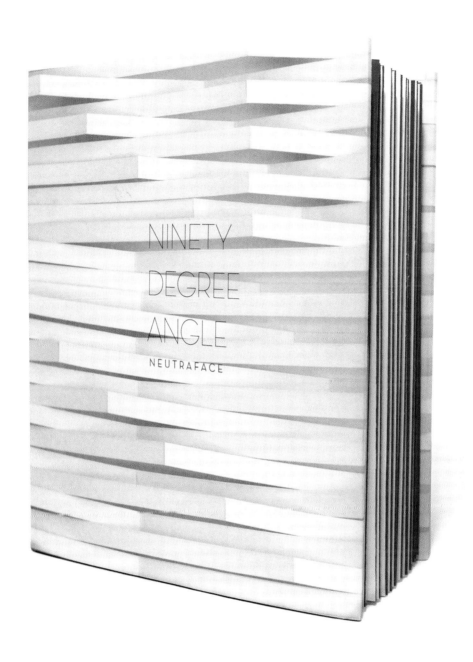

NINETY

DEGREE

ANGLE

NEUTRAFACE

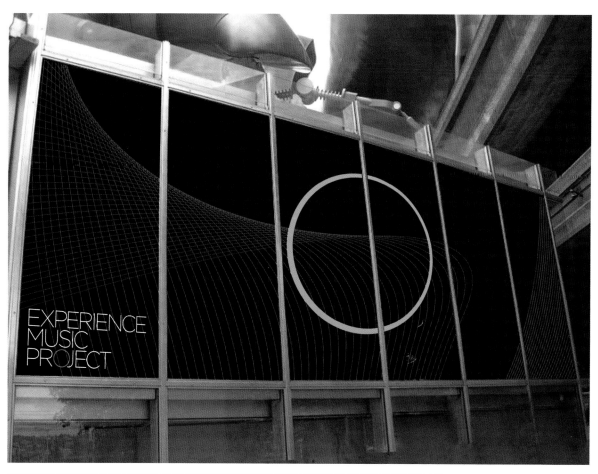

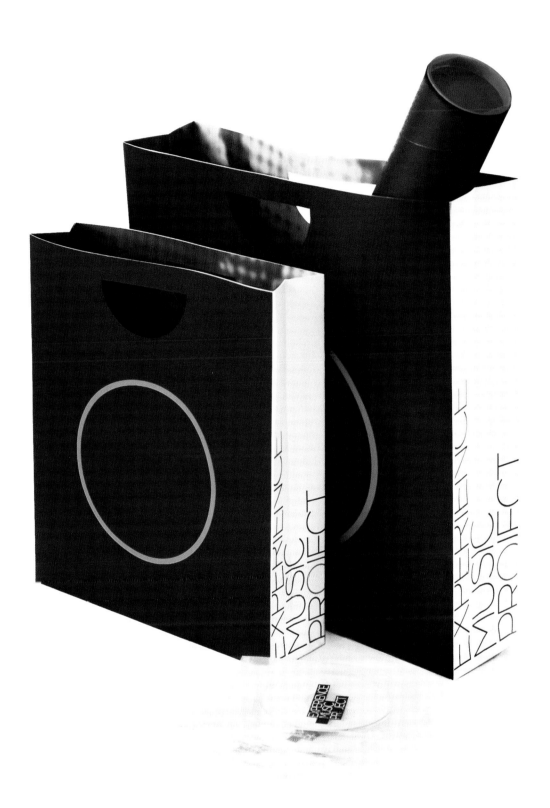

# BILD SCHÖ NE BÜ CHER

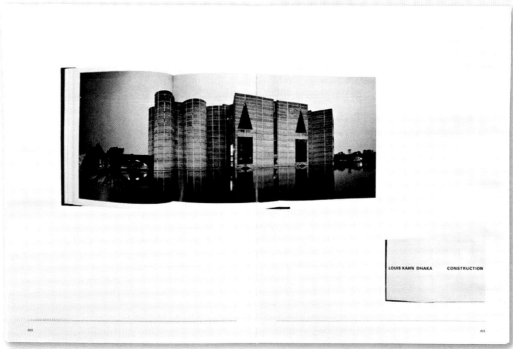

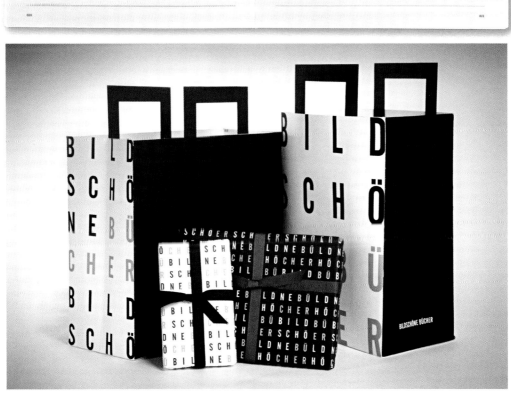

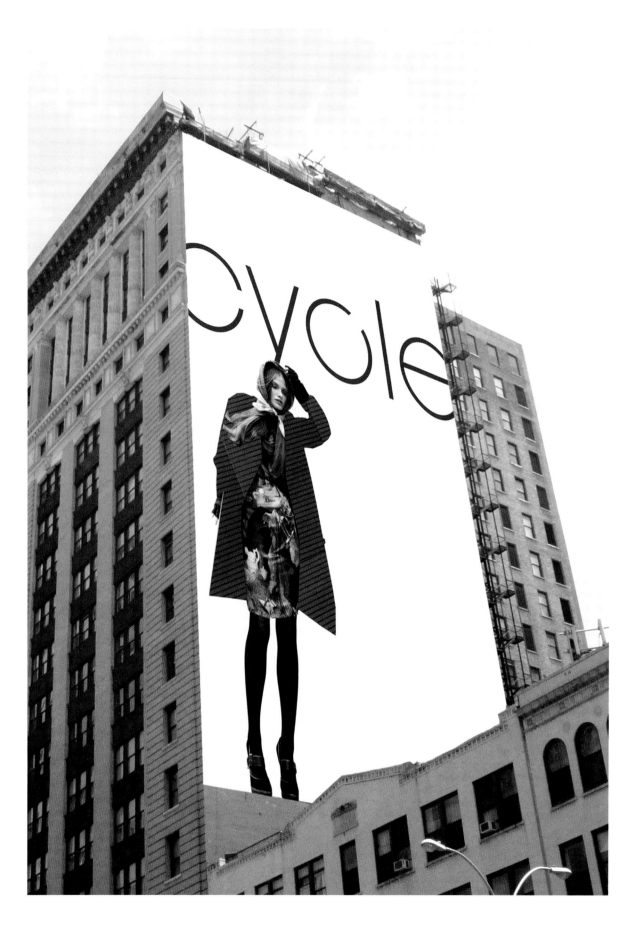

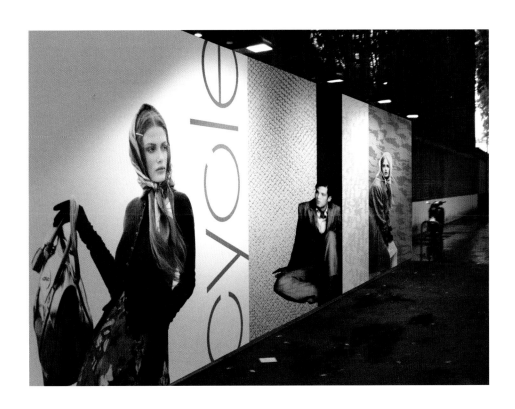

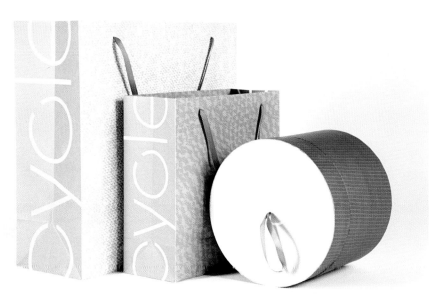

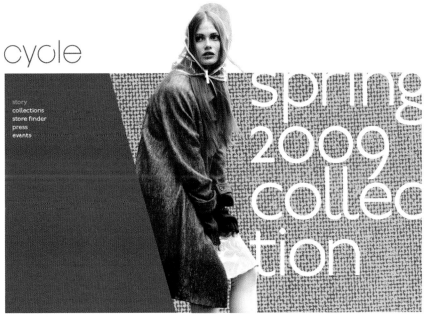

cycle

story
collections
store finder
press
events

spring
2009
collec
tion

**The Japanese Military** *[text illegible]*

*[paragraph of illegible body text]*

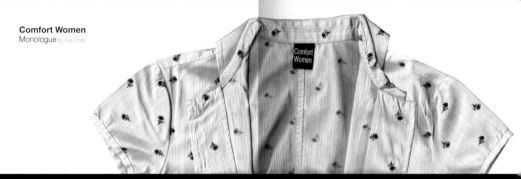

## Comfort Women
### Monologue by Eve Ensler

**What we were promised:**
*[body text illegible]*

**What we found:**
*[body text illegible]*
**No time to wear panties**

**What we were forced to do:**
*[body text illegible]*
**50 Japanese soldiers a day**
*[body text illegible]*
**So many men I couldn't walk**
*[body text illegible]*

**What they did to us over and over:**
*[body text illegible]*
**Tore bloody inside out**
*[body text illegible]*
**Raped.**

**What we became:**
*[body text illegible]*
**Meat**
*[body text illegible]*

**What we were left with:**
*[body text illegible]*
**A space where a uterus once was**
*[body text illegible]*

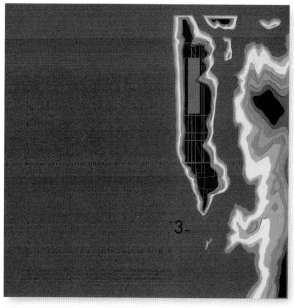

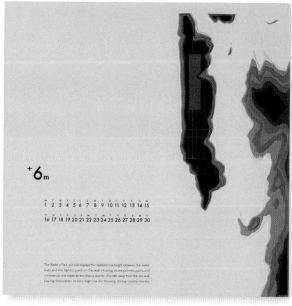

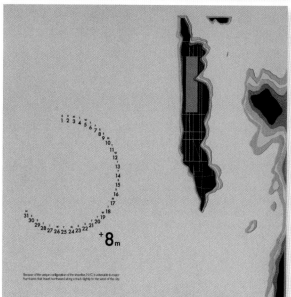

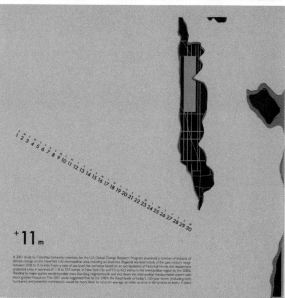

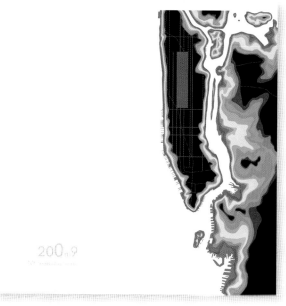

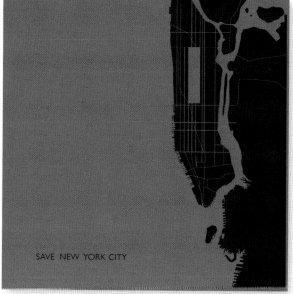

**Alex Liebergesell** Pratt Institute **Joungwon Cha**

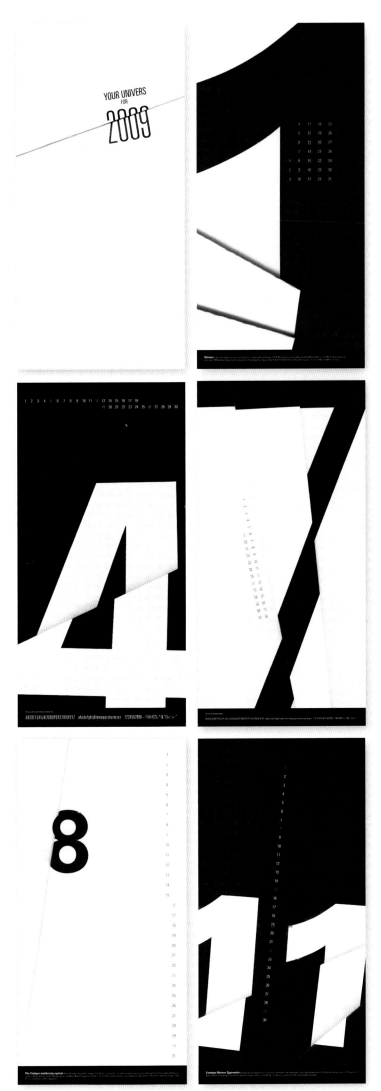

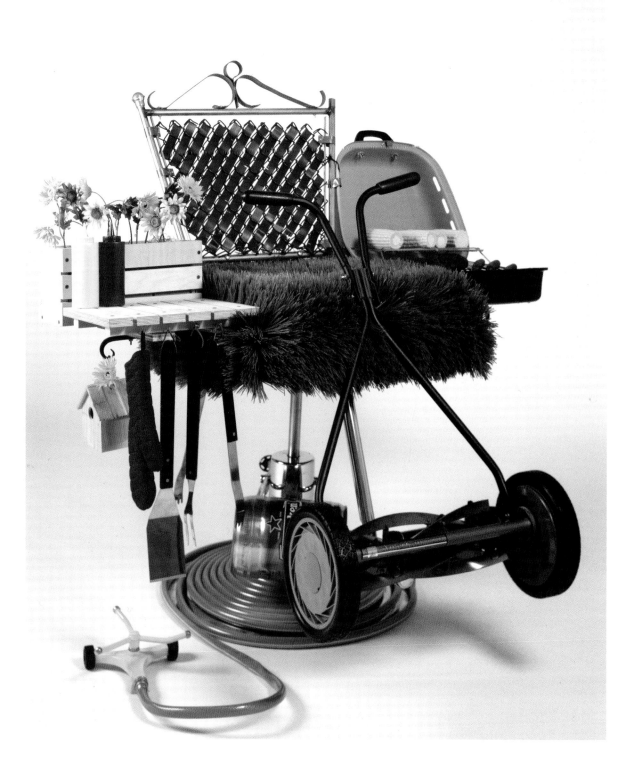

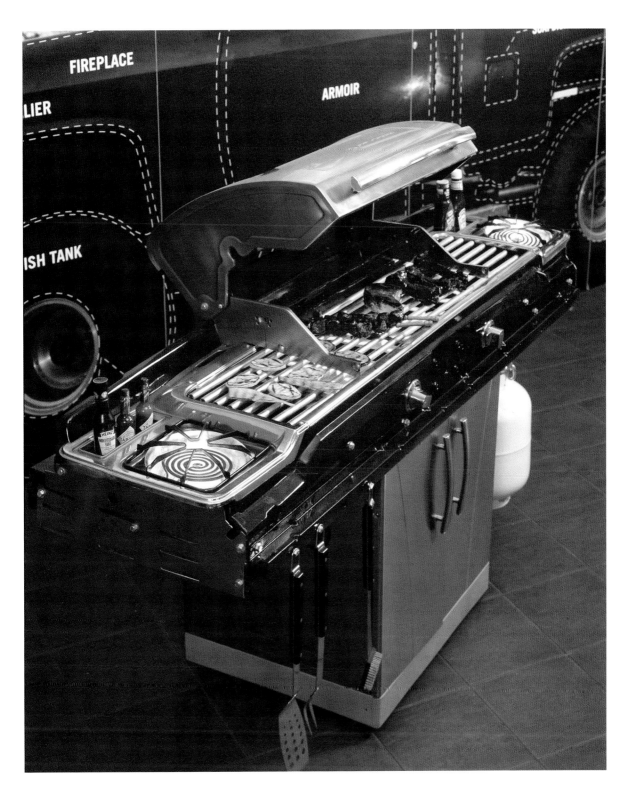

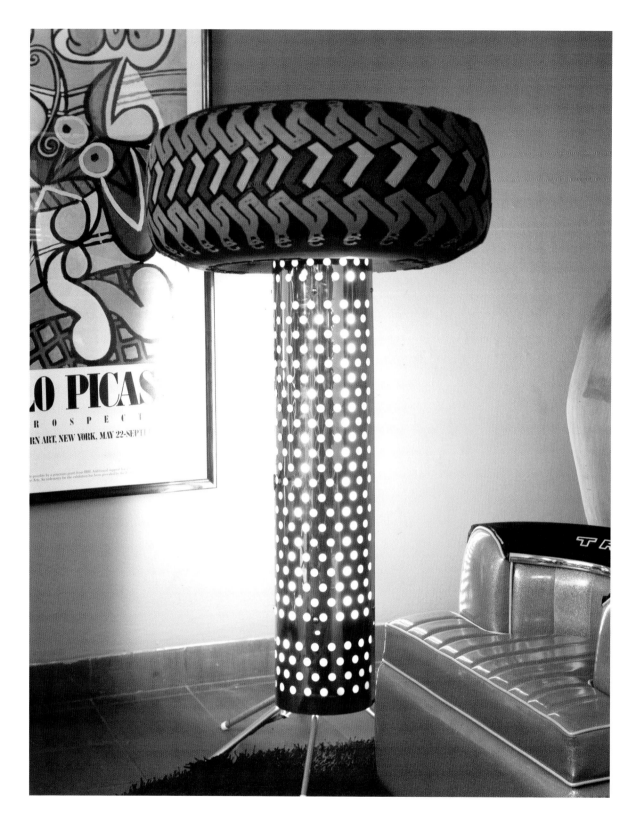

CONTENTS/

XVI

SUBLIME: THE FIRST
INTERNATIONAL
LIFESTYLE MAGAZINE

sub/ime

Cover for August 2008
Model: Beth Robertson
Makeup Artist: Amani Rodome

# architectural record

Vol.46 OCTOBER 2008
LANDSCAPE ARCHITECTURE

AARON BETSKY
VLADIMIR DJUROVIC
RICHARD MEIER
GIOVANNI D'AMBROSIO

The town of Yusuhara in Kochi Prefecture, known for its urban development using "Japanese Cedar", has a new starting point for its community with the "Kino-machi Hall" (Town Hall), the largest scaled "Wooden" town hall in Japan. Considering the snowing weather conditions, a large atraino functions as a space for traditional performances and festivals. Local Japanese cedar has been used fully to the regulations, which made possible to create a double lattice girder structure with an 18 meter long span. While making possible to visualize how cedar structural parts sustain the structure, the building aims to build an architecture capable of making people reconfirm the excellence of Japanese wooden structures. The indoor plaza and exterior plaza, separated by a large sliding door used for hangars, becomes one only space which is used during spring festivals. The appearance, smell, texture

The building is structured to combine a unit-based volume (the black box of the theatre) and a series of movement-based volumes (foyer and public circulation). Because this organizing principle is made constructive, a fluent internal spatial arrangement is actualised, efficiently connecting spaces to each other. The multipurpose auditorium can seat up to 450, and that is adaptable to a great variety of performances. The free-flowing space of the foyer is made possible by a spiraling constructive element that connects the entrance to the auditorium and to the music rooms above, thus welding together 'with a twist' the three levels of this side of the building. This twist forms a 3D interpretation of the repetitive pattern, executed in the muted tones of stage make up, which is applied to the facades and then enveloped by a glittering mesh.

This project aims to understand the building as a tool in re-establishing a balanced ecology between culture and commerce. It is a type of 'playground'; a safe haven where participants can congregate without fear of reprisal and a setting that people transiently share. In this design, the ancient ziggurat motif is transformed into a design model that combines various public and private programs in a stepped series of radically different environments: sun-seeking versus shadow-rich, open versus enclosed, serrated profile versus smooth elevation. The mediatheque, which stores and preserves information of all types, forms part of a network of new community centers dedicated to learning and culture. The mediatheque is also a hub, a place for meeting and ex-

The town of Yusuhara in Kochi Prefecture, known for its urban development using "Japanese Cedar", has a new starting point for its community with the "Kino-machi Hall" (Town Hall), the largest scaled "Wooden" town hall in Japan. Considering the snowing weather conditions, a large atraino functions as a space for traditional performances and festivals. Local Japanese cedar has been used fully to the regulations, which made possible to create a double lattice girder structure with an 18 meter long span. While making possible to visualize how cedar structural parts sustain the structure, this building aims to build an architecture capable of making people reconfirm the excellence of Japanese wooden structures. The indoor plaza and exterior plaza, separated by a large sliding door used for hangars, becomes one only space which is used during spring festivals. The appearance, smell, texture

The building is structured to combine a unit-based volume (the black box of the theatre) and a series of movement-based volumes (foyer and public circulation). Because this organizing principle is made constructive, a fluent internal spatial arrangement is actualised, efficiently connecting spaces to each other. The multipurpose auditorium can seat up to 450, and that is adaptable to a great variety of performances. The free-flowing space of the foyer is made possible by a spiraling constructive element that connects the entrance to the auditorium and to the music rooms above, thus welding together 'with a twist' the three levels of this side of the building. This twist forms a 3D interpretation of the repetitive pattern, executed in the muted tones of stage make up, which is applied to the facades and then enveloped by a glittering mesh.

This project aims to understand the building as a tool in re-establishing a balanced ecology between culture and commerce. It is a type of 'playground'; a safe haven where participants can congregate without fear of reprisal and a setting that people transiently share. In this design, the ancient ziggurat motif is transformed into a design model that combines various public and private programs in a stepped series of radically different environments: sun-seeking versus shadow-rich, open versus enclosed, serrated profile versus smooth elevation. The mediatheque, which stores and preserves information of all types, forms part of a network of new community centers dedicated to learning and culture. The mediatheque is also a place for meeting and exchange, with differently themed landscaped plateaus that garland the building. The development momentum propitiated by the event of the Olympic Games

UN STUDIO/////BEN VAN BERKEL AND CAROLINE BOS////AGORA THEATRE LELYSTADT, NETHERLANDS

056

COLOR PERHAPS WAS THE MOST NEGLECTED ASPECT IN THE MODERNIST APPROACH TO ARCHITECTURAL DESIGN DURING THE 20TH CENTURY. ESPECIALLY THE DOGMATIC INCLINATION TOWARD THE USE OF NATURAL MATERIALS IN ARCHITECTURAL THEORY CAUSED AN IGNORANCE OF THE JOY OF THE ARTISTIC USE OF COLOR IN ARCHITECTURE. BY WHO CONSIDERED COLOR AS AN ESSENTIAL DIMENSION IN THE DESIGN OF ARCHITECTURAL FORMS AND SPACES.

TRUE COLORS – DESIGN & PROJECT FOR SHOPS BY WENDY MOONAN

052

INSIGHT BEAUTIFUL STORIES AND INGREDIENTS ARE FORGOTTEN AND HIDDEN IN HISTORY. IT'S A MATTER REVEALING THESE ELEMENTS AND RELEASING THEM FROM A THICK LAYER OF DUST.

053

The town of Yusuhara in Kochi Prefecture, known for its urban development using "Japanese Cedar", has a new starting point for its community with the "Kino-machi Hall" (Town Hall), the largest scaled "Wooden" town hall in Japan. Considering the snowing weather conditions, a large atrium is inserted, and an indoor plaza was created to connote facilities necessary by town members in everyday life such as bank, the Agricultural Cooperative Society,

and the Chamber of Commerce. The atrium also functions as a space for traditional performances and festivals. Local Japanese cedar has been used fully to the regulations, which made possible to create a double lattice girder structure with an 18 meter long span. While making possible to visualize how cedar structural parts sustain the structure, this building aims to build an architecture capable of making people reconfirm the excellence of Japanese

wooden structures. The indoor plaza and exterior plaza, separated by a large sliding door used for hangars, becomes one only space which is used during spring festivals. The appearance, smell, texture The town of Yusuhara in Kochi Prefecture, known for its urban development using "Japanese Cedar", has a new starting point for its community with the "Kino-machi Hall" (Town Hall), the largest scaled "Wooden" town hall in Japan. Considering the snowing

059

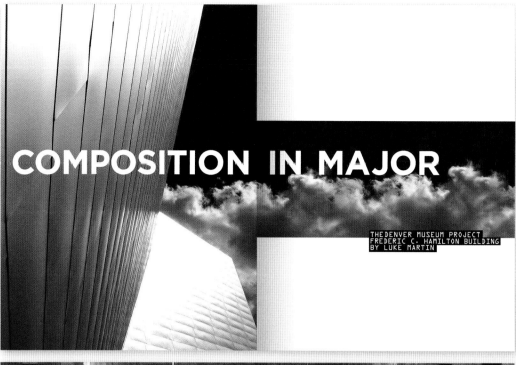

# COMPOSITION IN MAJOR

THE DENVER MUSEUM PROJECT
FREDERIC C. HAMILTON BUILDING
BY LUKE MARTIN

# J A P A N E S E
# A T T I T U D E

PAST AND PRESENT VISIONS
MERGE IN THE ARCHITECTURE
OF TADAO ANDO
BY JEFFREY SIMPSON

The Extension to the Denver Art Museum, The Frederic C. Hamilton Building, is an expansion and addition to the existing museum, designed by the Italian Architect Gio Ponti. Inspired by the vitality and growth of Denver, the addition currently houses the Modern and Contemporary art collections as well as the collection of Oceanic and African Art. The extension, which opened in October 2006, was a joint venture with Davis Partnership Architects, the Architect of Record, working with M.A. Mortensen Co.

To complete the vision for the extension Studio Daniel Libeskind worked closely with the director, curators, core exhibition team, the contract architect and the Board of Trustees. Since its opening, the new building has become an for Denver, attracting thousands of visitors to the museum complex. "Nexus is conceived in close connection with the function and aesthetic of the existing Ponti museum, as well as the entire Civic Center and public library. The new building is a kind of city hub, tying together downtown, the Civic Center, and forming a strong connection to the golden triangle neighborhood. The project is not designed as a stand alone building, but as part of a composition of

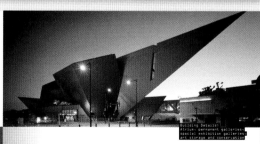

Building Details:
Atrium, permanent galleries,
special exhibition galleries,
art storage and conservation

Extension to the Denver
Art Museum: Frederic
C. Hamilton Building
Daniel Libeskind
Denver, Colorado

public spaces, monuments and gateways in the developing part of the city, contributing to the synergy amongst neighbors, large and intimate. "The materials of the building closely relate to the existing context (local stone) as well as innovative new materials (titanium) which together will form spaces that connect local Denver tradition to the 21st Century.

"The amazing vitality and growth of Denver – from its foundation to the present – inspires the form of the new museum. Coupled with the magnificent topography with its breathtaking views of the sky and the Rocky Mountains, the dialogue between the boldness of construction and the romanticism of the landscape creates a unique place in the world. The bold and forward looking engagement of the public in forging its own cultural, urban and spirited destiny is something that would strike anyone upon touching the soil of Colorado. "One of the challenges of building the Denver Art Museum was to work closely and respond to the extraordinary range of transformations in light, coloration, atmospheric

The Extension to the Denver Art Museum, The Frederic C. Hamilton Building, is an expansion and addition to the existing museum, designed by the Italian Architect Gio Ponti. Inspired by the vitality and growth of Denver, the addition currently houses the Modern and Contemporary art collections as well as the collection of Oceanic and African Art. The extension, which opened in October 2006, was a joint venture with Davis Partnership Architects, the Architect of Record, working with M.A. Mortensen Co. To complete the vision for the extension Studio Daniel Libeskind worked closely with the director, curators, core exhibition team, the contract architect and the Board of Trustees. Since its opening, the new building has become an for Denver attraction thousands of visitors to the museum complex. "Nexus is concerned in close connection with the function and aesthetic of the existing Ponti museum, as well as the entire Civic Center and public library. The new building is a kind of city hub, tying together downtown, the Civic Center, and forming a strong connection to the golden triangle neighborhood. The project is not designed as a stand alone building, but as part of a composition of public spaces, monuments and gateways in the developing part of the city, contributing to the synergy amongst neighbors, large and intimate.

"The materials of the building closely relate to the existing context (local stone) as well as innovative new materials (titanium) which together will form spaces that connect local Denver tradition to the 21st Century.

"The amazing vitality and growth of Denver – from its foundation to the present – inspires the form of the new museum. Coupled with the magnificent topography with its breathtaking views of the sky and the Rocky Mountains, the dialogue between the boldness of construction and the romanticism of the landscape creates a unique place in the world. The bold and forward looking engagement of the public in forging its own cultural, urban and spirited destiny is something that would strike anyone upon touching the soil of Colorado. "One of the challenges of building the Denver Art Museum was to work closely and respond to the extraordinary range of transformations in light, coloration, atmospheric effects, temperature and weather conditions unique to the City. I wanted these be integrated not only functionally and physically, but culturally and experientially for the benefit of the visitors' experience.

Inspired by the vitality and growth of Denver, the addition currently houses the Modern and Contemporary art collections as well as the collection of Oceanic and African Art. The extension was a joint venture with Davis Partnership Architects, the Architect of Record, working with M.A. Mortensen Co.

# WALLPAPER 01

- (1.1) WHY WE LOVE FASHION? IT'S THE CLICK, CLICK, CLICK.
- (1.2) TO BE ENLIGHTENED, YOU PULL THE SWITCH.
- (1.3) A VISION IN THE DESERT.

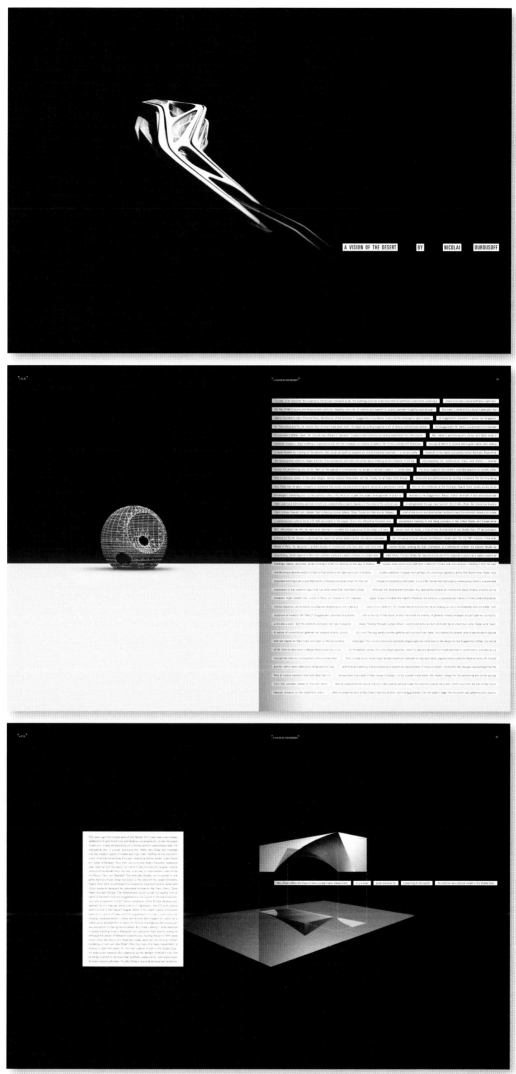

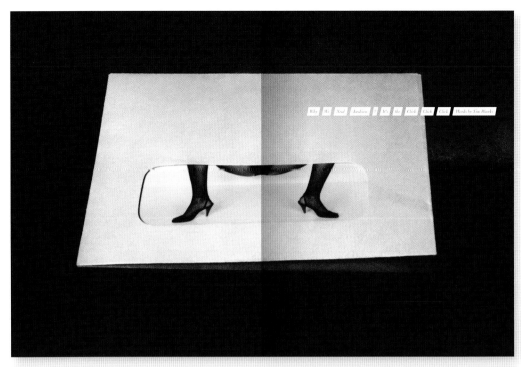

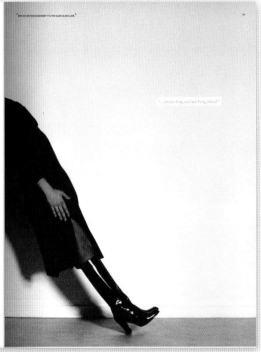

*"... on my long soul and being ahead"*

*The death of his reputation was just one more insult.*

# WALLPAPER 01

- [1.1] WHY WE LOVE FASHION? IT'S THE CLICK, CLICK, CLICK.
- [1.2] TO BE ENLIGHTENED, YOU PULL THE SWITCH.
- [1.3] A VISION IN THE DESERT.

*

# WALLPAPER 01

+ [1.1]  WHY WE LOVE FASHION? IT'S THE CLICK, CLICK, CLICK.
+ [1.2]  TO BE ENLIGHTENED, YOU PULL THE SWITCH.
+ [1.3]  A VISION IN THE DESERT.

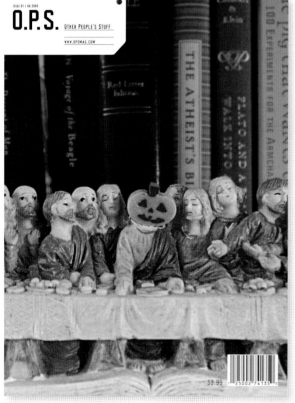

**Adrian Pulfer** Brigham Young University **John Jensen**
**Christopher Austopchuck** School of Visual Arts **Jeanette Kaczorowski**

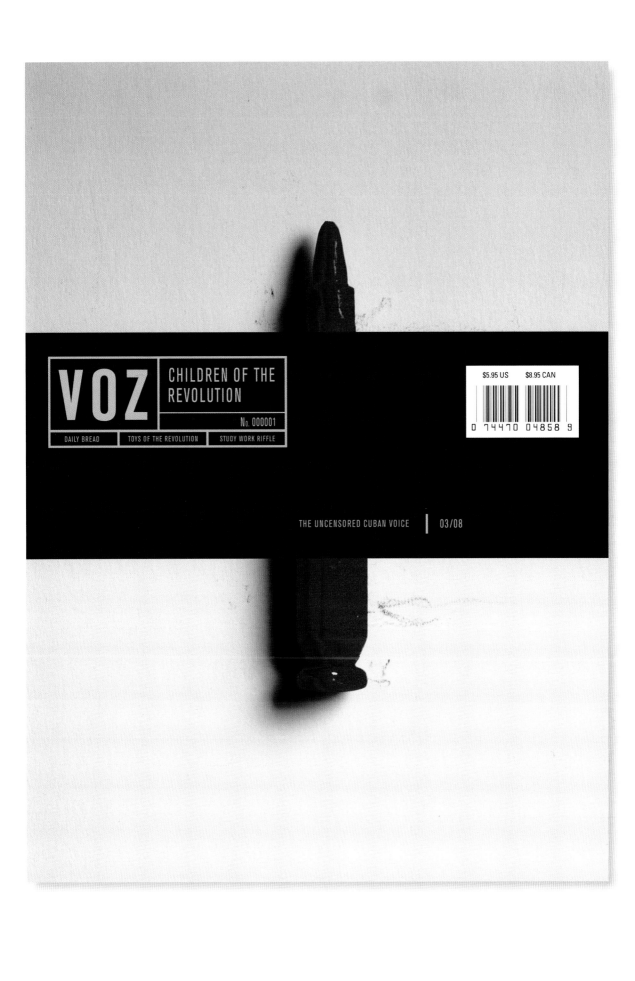

VOZ
CHILDREN OF THE REVOLUTION
No. 000001
DAILY BREAD | TOYS OF THE REVOLUTION | STUDY WORK RIFFLE

$5.95 US    $8.95 CAN

0 74470 04858 9

THE UNCENSORED CUBAN VOICE | 03/08

# VOZ

## UTENSILS OF THE REVOLUTION

No. 000002

| DAILY BREAD | TOYS OF THE REVOLUTION | STUDY WORK RIFFLE |

$5.95 US    $8.95 CAN

0 74470 04858 9

THE UNCENSORED CUBAN VOICE | 05/08

**Jeff Glendenning, Luise Stauss** School of Visual Arts **Ron Aguilla**

the drawings of his early period so many times, that all pages turned black," says Tadao Ando. "In my mind I quite often wonder how Le Corbusier would have thought about this project or that." First Tadao Ando's realisation was Row House in Sumiyoshi, Osaka in 1975.

Tadao Ando was born in 1941 in Osaka, Japan. Growing up in that city in Japan recovered from the war, Tadao Ando spent the most of time out of doors, and was raised by his grandmother, whose name was Ando. From the age of 10 to 17 Tadao Ando worked at local carpenter, where Tadao Ando learned how to work with wood and built a number of models of airplanes and ships. His studying was very unusual. "I was never a good student. I always preferred learning things on my own outside of class. When I was about 18, I traveled to visit temples, shrines and tea houses in Kyoto and nara. There is a lot of great traditional architecture in the area. I was studying architecture by going to see actual buildings, and reading books about them. His first interest in architecture was nourished in Tadao's 15 by buying a book of Le Corbusier sketches. "I traced

This mentioned building was a simple block building, inserted into a narrow street of row houses. This residence is immediately noticeable because of its blank concrete fasade punctuated only by doorway. The whole object space is divided into a three equal rectangular spaces, while the central part is atrium. The space nearest the doorway contains the living room at ground level, and the bedroom above. The last final space contains the kitchen and bathroom below, and the master bedroom above. Build in the wooden residential area above the port city of Kobe.

The Church of the Light is a place for all to come and hence it is open all year round; there will be no grand and no locks.

# CHURCH OF THE LIGHT

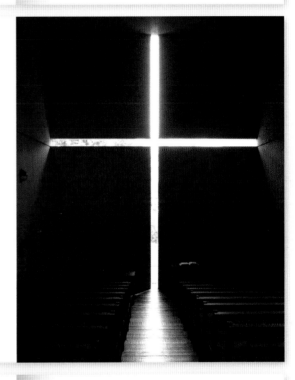

in Osaka, Japan. Growing up in that city in Japan recovered from the war, Tadao Ando spent the most of time out of doors, and was raised by his grandmother, whose name was Ando. From the age of 10 to 17 Tadao Ando worked at local carpenter, where Tadao Ando learned how to work with wood and built a number of models of airplanes and ships. His studying was very unusual. "I was never a good student. I always preferred learning things on my own outside of class. When I was about 18, I traveled to visit temples, shrines and tea houses in Kyoto and nara. There is a lot of great traditional architecture in the area. I was studying architecture by going to see actual building, and reading books about them. His first interest in architecture was nourished in Tadao's 15 by buying a book of Le Corbusier sketches. "I traced the

drawings of his early period so many times, that all pages turned black," says Tadao Ando. "in my mind I quite often wonder how Le Corbusier would have thought about this project or that." First Tadao Ando's realisation was Row House in Sumiyoshi, Osaka in 1975. This mentioned building was a simple block building, inserted into a narrow street of row houses. This residence is immediately noticeable because of its blank concrete fasade punctuated only by doorway. The whole object space is divided into a three equal rectangular spaces, while the central part is atrium. The space nearest the doorway contains the living room at ground level, and the bedroom above. The last final space contains the kitchen and bathroom below, and the master bedroom above. Build in the wooden residential area above the port city of Kobe.

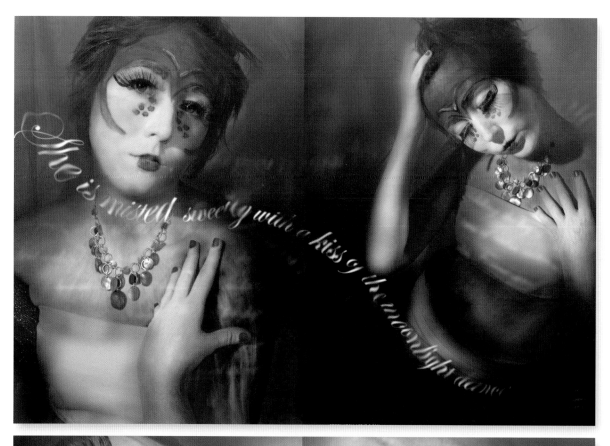

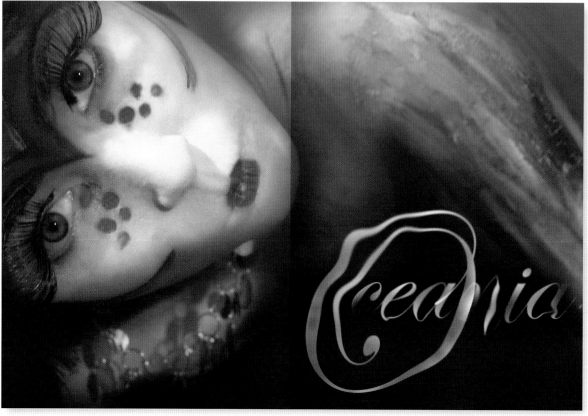

**Kristin Sommese** Pennsylvania State University **Amy Blumenthal**

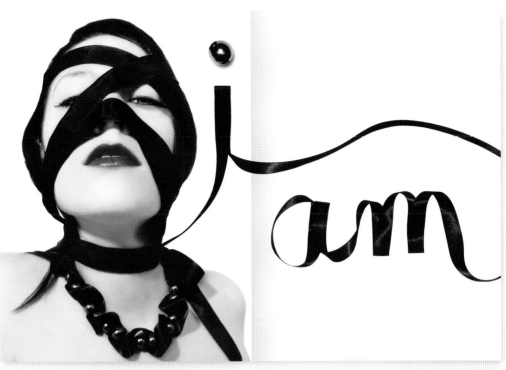

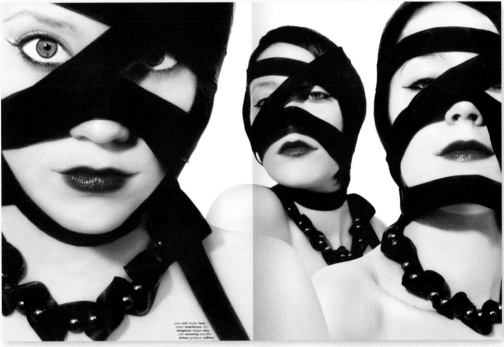

pure evil lovely toxic
sweet treacherous shy
dangerous elegant sexy
cute menacing beautiful
vicious gorgeous ruthless

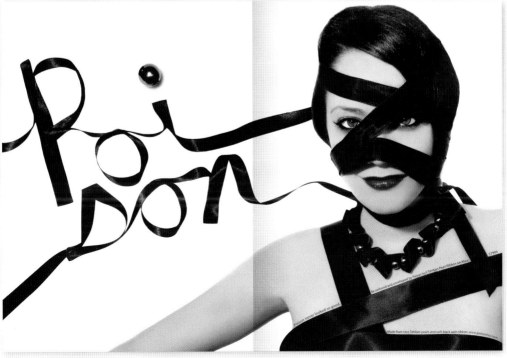

DENNIS BROWN WAS A SCOUTMASTER NOT A

# KILLER

DENNIS LOVED HIS NEIGHBOURS. HE COULD NOT BELIEVE IT WHEN AN ACCLAIMED WITNESS SAID SHE SAW DENNIS MURDER AND ROB HIS FRIEND NEXT DOOR. THE COURT DID NOT BELIEVE HIS TESTIMONY, HE PLEADED INNOCENT. NOW AFTER 12 YEARS BEHIND BARS DNA FINGER PRINTING HAS TOLD THE TRUTH, DENNIS IS NOT GUILTY.

## THE INNOCENCE PROJECT

DNA EVIDENCE HAS FREED 235 INNOCENT INMATES, HOW MANY MORE SIT IN PRISON WAITING FOR HELP?

183/235    WWW.INNOCENCEPROJECT.ORG    YOU CAN ALSO DONATE BY CALLING 1-800-INNOCENCE

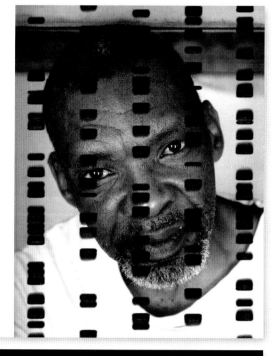

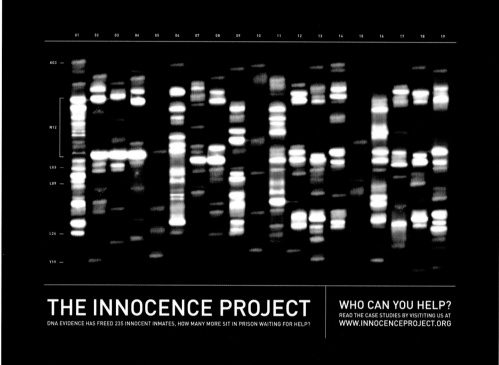

## THE INNOCENCE PROJECT
DNA EVIDENCE HAS FREED 235 INNOCENT INMATES, HOW MANY MORE SIT IN PRISON WAITING FOR HELP?

### WHO CAN YOU HELP?
READ THE CASE STUDIES BY VISITITING US AT
WWW.INNOCENCEPROJECT.ORG

KATHY GONZALES HAS NEVER STOLEN AND THEREFORE IS NOT A

# THIEF

KATHY LOVED HER JOB AS A NURSE FOR AN OLDER LADY. ON SUNDAY, JUNE, 8TH THE OLD LADY WAS FOUND DEAD IN HER APPARTMENT WITH HER BELONGINGS MISSING. KATHY FIT THE CRITERA DESPITE HER TEARS, JURORS AGREED. EIGHT YEARS BEHIND BARS IS A LONG TIME WHEN YOU ARE INNOCENT. DNA EVIDENCE SET HER FREE.

## THE INNOCENCE PROJECT
DNA EVIDENCE HAS FREED 235 INNOCENT INMATES, HOW MANY MORE SIT IN PRISON WAITING FOR HELP?

221/235    WWW.INNOCENCEPROJECT.ORG    YOU CAN ALSO DONATE BY CALLING 1-800-INNOCENCE

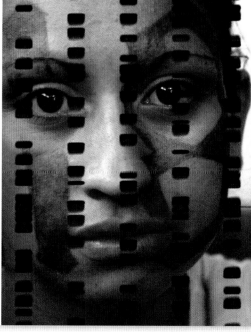

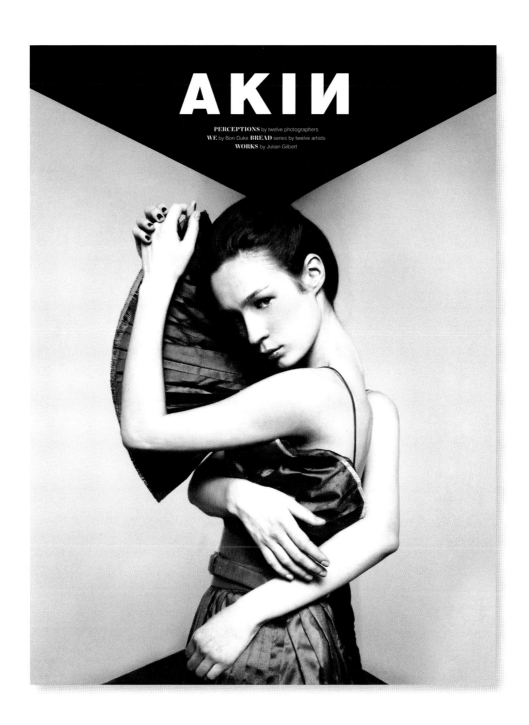

# AKIN

PERCEPTIONS by twelve photographers
WE by Bon Duke BREAD series by twelve artists
WORKS by Julian Gilbert

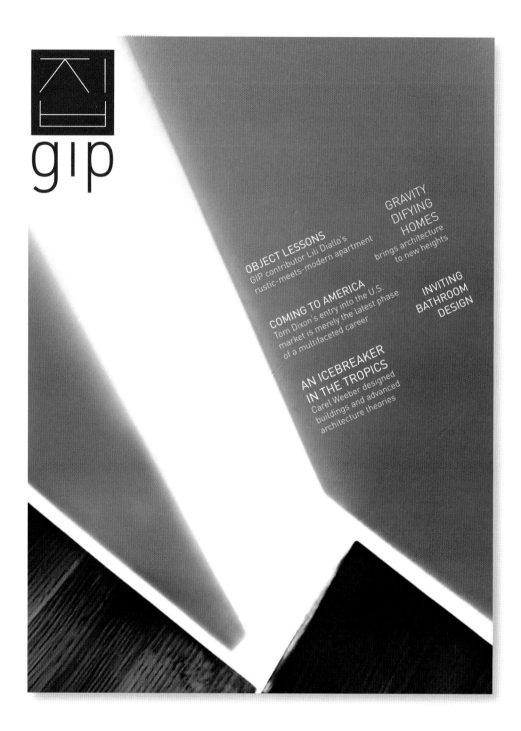

gIp

OBJECT LESSONS
GIP contributor Lili Diallo's
rustic-meets-modern apartment

GRAVITY
DIFYING
HOMES
brings architecture
to new heights

COMING TO AMERICA
Tom Dixon's entry into the U.S.
market is merely the latest phase
of a multifaceted career

INVITING
BATHROOM
DESIGN

AN ICEBREAKER
IN THE TROPICS
Carel Weeber designed
buildings and advanced
architecture theories

     **Christopher Austopchuk** School of Visual Arts **Eun Young Kim**

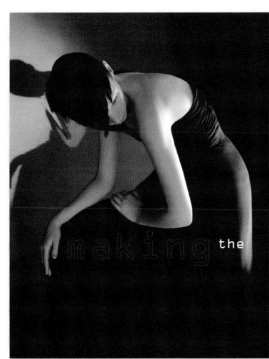

THE SHAPES
THE SEASON
SHIFT INTO HAUTE GEAR

PHOTOGRAPHY
Javier
vallhonrat

making the KUT

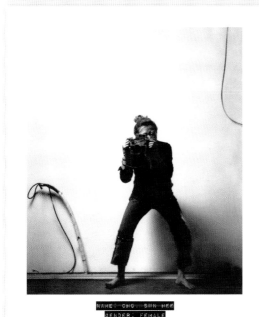

NAME: CHO SUN HEE
GENDER: FEMALE
OCCUPATION: PHOTOGRAPHER

286

CAPTURE
CHO's PASSION

Her love of photography drives her life, her career, and her
passion as the best woman photographer in Korea.

photography by Sun Hee Cho

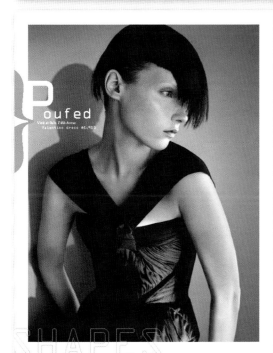

Poufed
Worn at Saks Fifth Avenue
Valentino dress $5,900

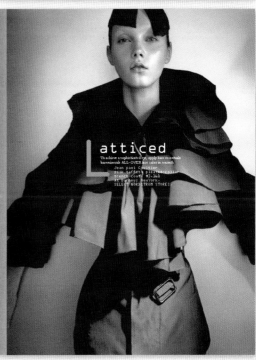

Latticed
To achieve a sophisticated eye, apply base essentials
bareminerals ALL-OVER face color in warmth
Jean paul Gaultier
silk taffeta pleated occasion
trench Coat $3,160
at Barneys NewYork,
SELECT NORDSTROM STORES.

SHAPES

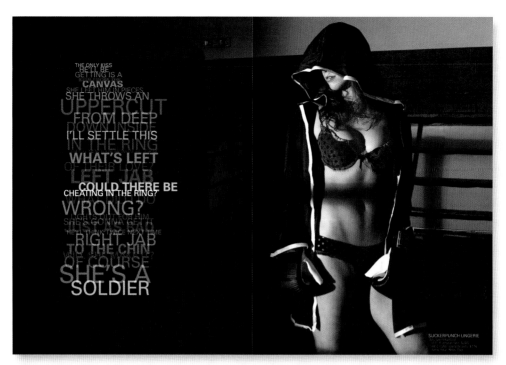

THE ONLY KISS
HE'LL BE
GETTING IS A
**CANVAS**
SHE LEFT HIM IN PIECES
SHE THROWS AN
UPPERCUT
FROM DEEP
DOWN INSIDE
I'LL SETTLE THIS
IN THE RING
**WHAT'S LEFT**
LEFT JAB
OF THEIR LOVE?
**COULD THERE BE**
CHEATING IN THE RING?
WRONG?
SHE'S GOING FOR HIM
HE'LL THINK TWICE NEXT TIME
RIGHT JAB
TO THE CHIN
OF COURSE
SHE'S A
SOLDIER

SUCKERPUNCH LINGERIE

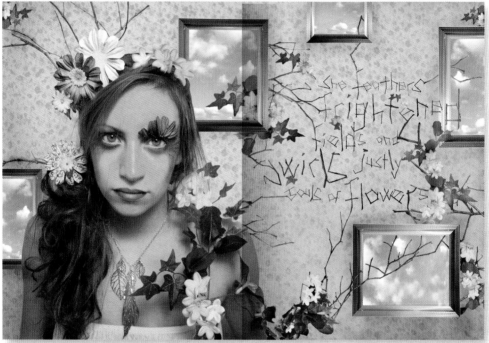

she feathers
frightened
fields and
swirls justly
souls of flowers

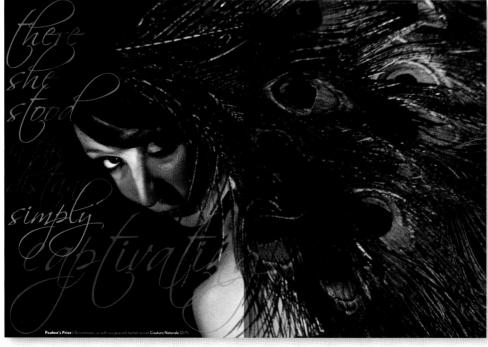

there
she
stood
simply
captivated

Peahen's Prize Old fashioned cut with real peacock feather accent Couture Naturale $375

**Kristin Sommese** Pennsylvania State University **Chris Rizzo**
**Kristin Sommese** Pennsylvania State University **Megan Yanchitis**
**Kristin Sommese** Pennsylvania State University **Jenny Lubkin**

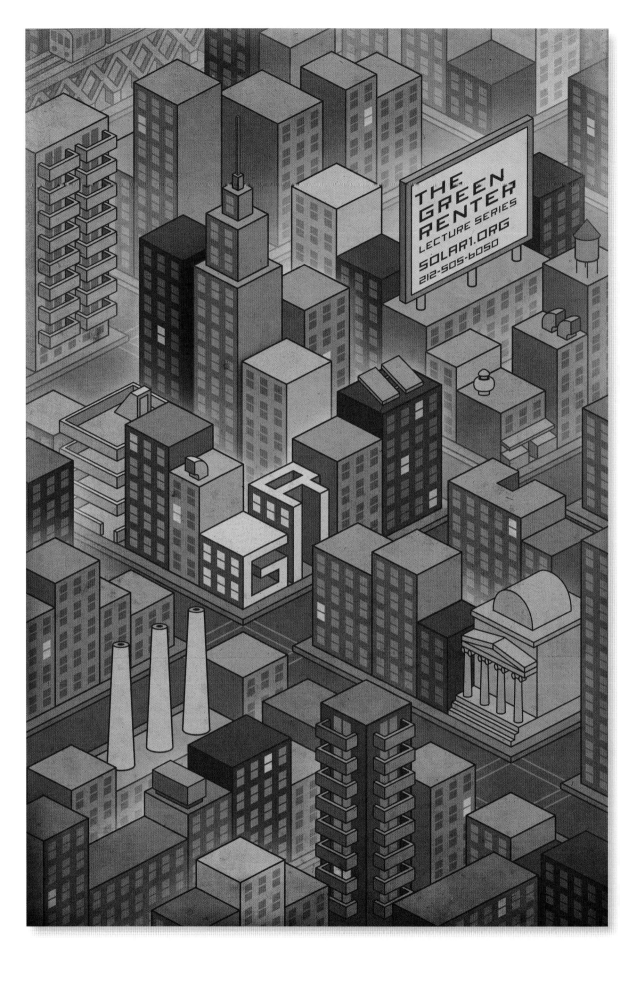

The Green Center
Lecture Series
SOLAR1.ORG
212-505-6050

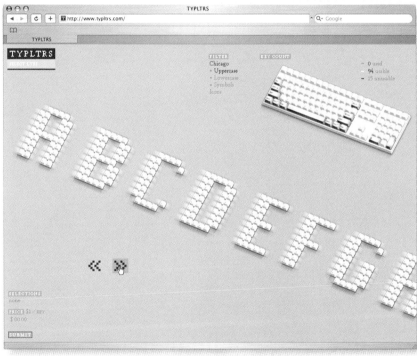

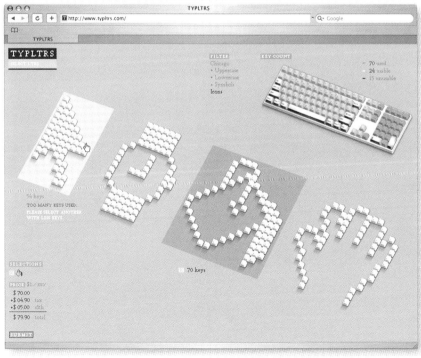

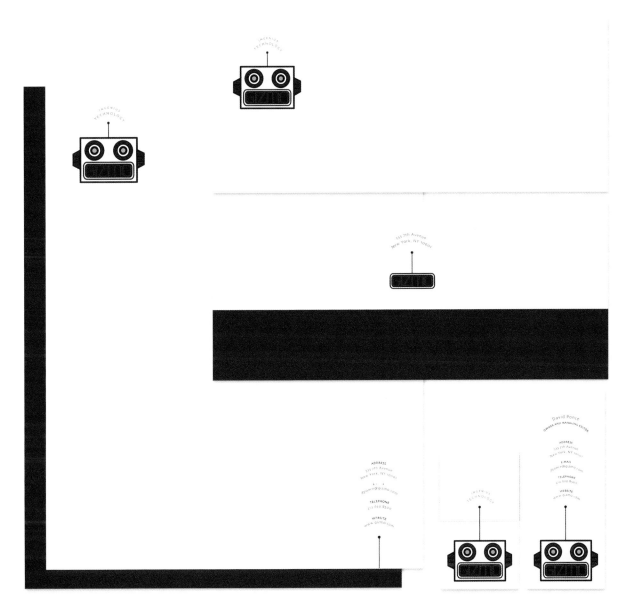

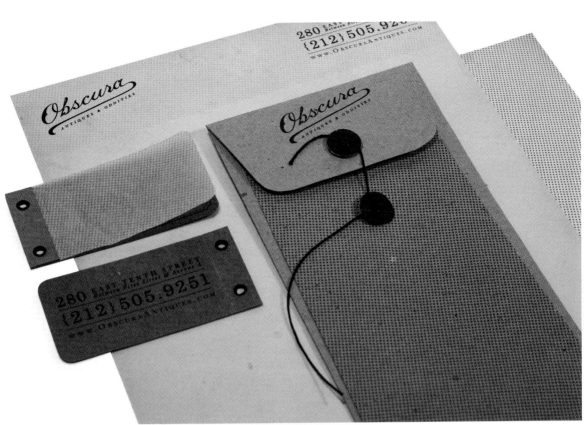

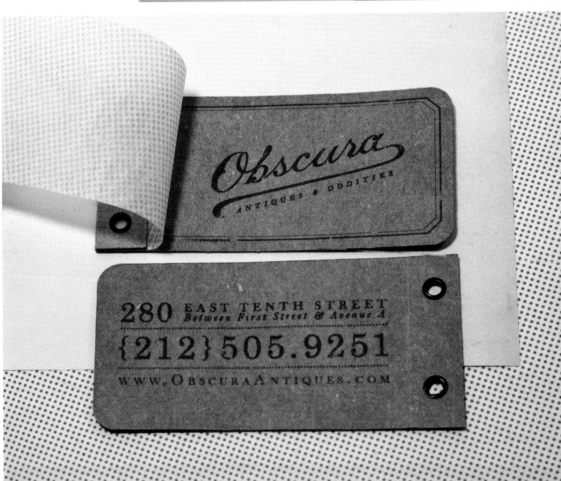

THE **MERMAID** INN

212-674-9870
96 2nd Ave. NYC 10003

2<sup>B</sup>

**Dan Brawner** Watkins College of Art, Design & Film **Daniel Meney**

JOHN FLUEVOG

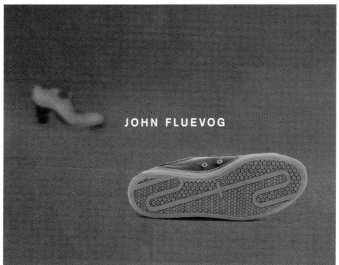

JOHN FLUEVOG

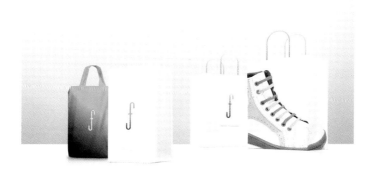

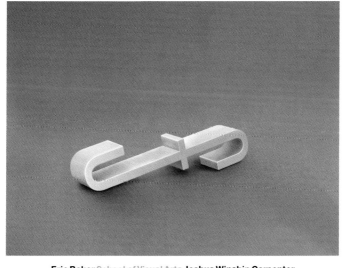

# UNTITLED

# Veloce

**Alice Drueding** Tyler School of Arts, Temple University **Bo Rum Hur**
**Adrian Pulfer** Brigham Young University **Natalie Davis**
**Rachel Donovan** School of Visual Arts **Eric Perez**
**Christopher Austopchuk** School of Visual Arts **Eun Sook Choi**
**Alice Drueding** Tyler School of Arts, Temple University **Brian Brotman**

GOTTINO

 **Christopher Austopchuk** School of Visual Arts **Eun Joung Park**

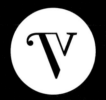

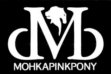

MOHKAPINKPONY

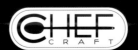

**Mark Fox** California College of the Arts **Kenichi Tanaka**
**Kelly Holohan** Tyler School of Arts, Temple University **Wade Keller**
**Adrian Pulfer** Brigham Young University **Beth Robertson**
**Alli Truch** School of Visual Arts **Jin Hee Park**
**Chad Roberts** School of Visual Arts **Jaewoo Park**

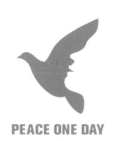

**PEACE ONE DAY**

PEACE ONE DAY

**Ji Lee** School of Visual Arts **Jeanelle Mak** (top, opposite page)
**Louise Fili** School of Visual Arts **Emily Kowzan**
**Dirk Kammerzel** School of Visual Arts **Stephen Rojack**
**Timothy Samara** School of Visual Arts **Michael Sutherland**
**Ji Lee** School of Visual Arts **Raul Aguilla**

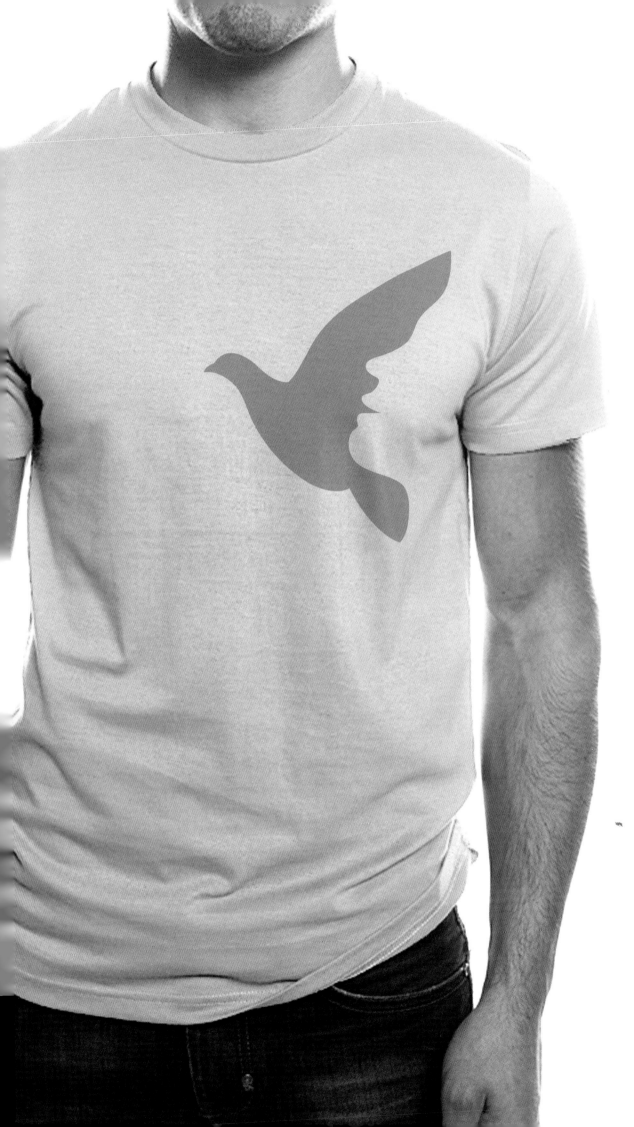

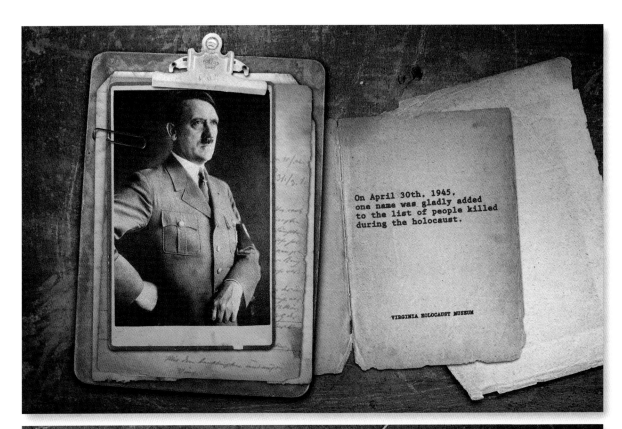

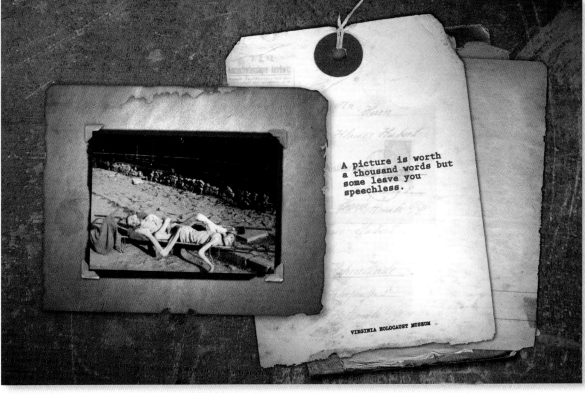

**Jack Mariucci** School of Visual Arts **Alex Sunyoung Koo**

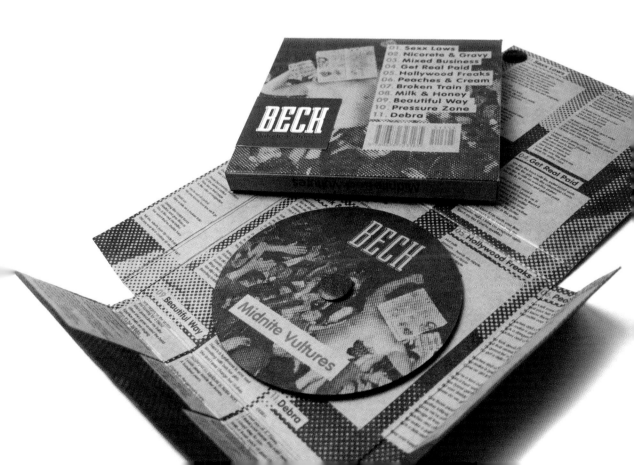

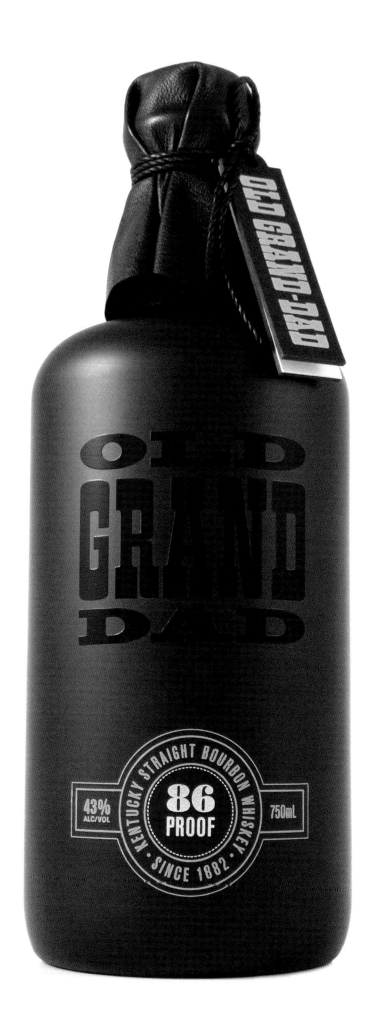

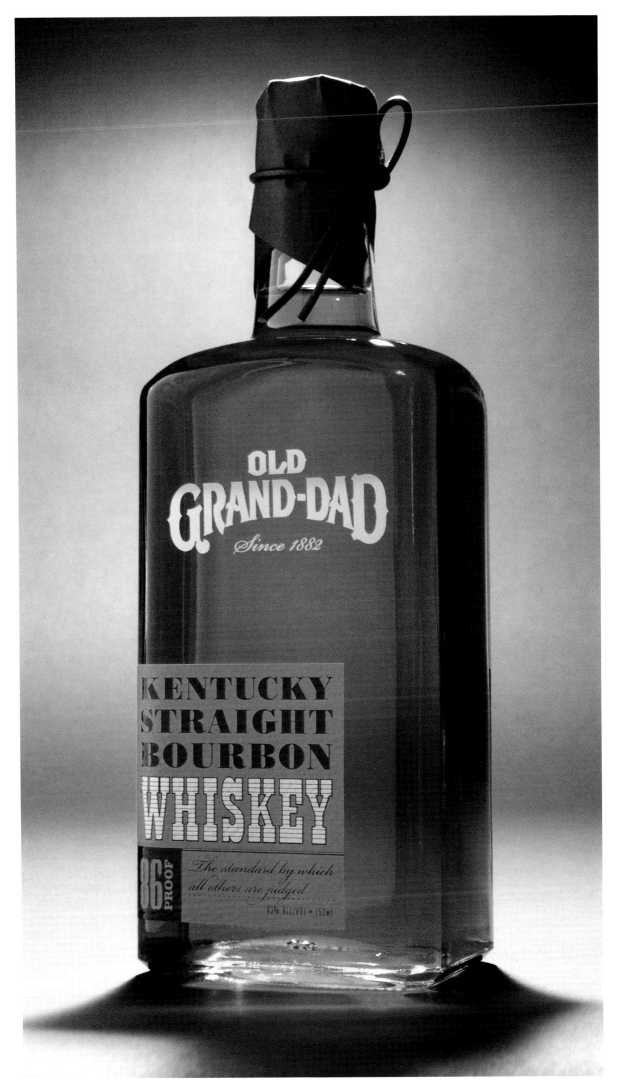

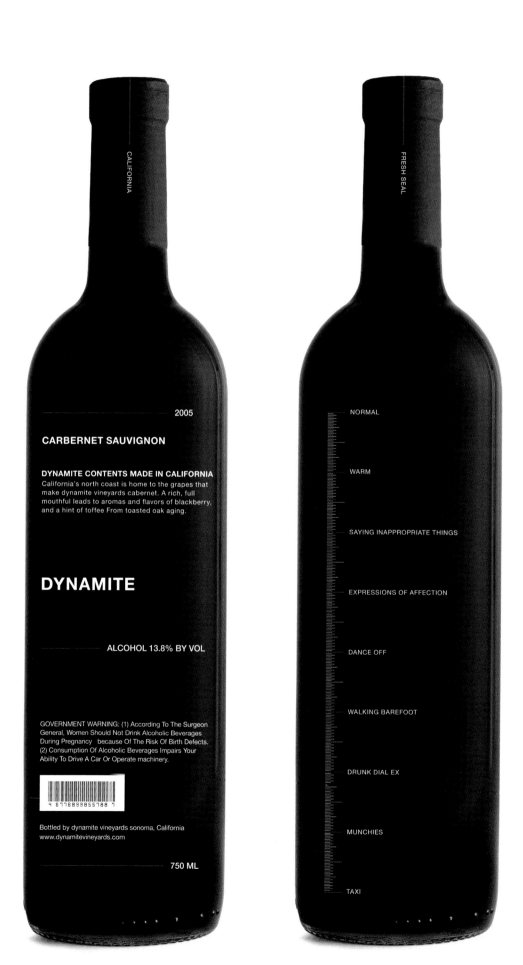

CALIFORNIA

FRESH SEAL

2005

**CARBERNET SAUVIGNON**

**DYNAMITE CONTENTS MADE IN CALIFORNIA**
California's north coast is home to the grapes that
make dynamite vineyards cabernet. A rich, full
mouthful leads to aromas and flavors of blackberry,
and a hint of toffee From toasted oak aging.

# DYNAMITE

ALCOHOL 13.8% BY VOL

GOVERNMENT WARNING: (1) According To The Surgeon
General, Women Should Not Drink Alcoholic Beverages
During Pregnancy   because Of The Risk Of Birth Defects.
(2) Consumption Of Alcoholic Beverages Impairs Your
Ability To Drive A Car Or Operate machinery.

Bottled by dynamite vineyards sonoma, California
www.dynamitevineyards.com

750 ML

NORMAL

WARM

SAYING INAPPROPRIATE THINGS

EXPRESSIONS OF AFFECTION

DANCE OFF

WALKING BAREFOOT

DRUNK DIAL EX

MUNCHIES

TAXI

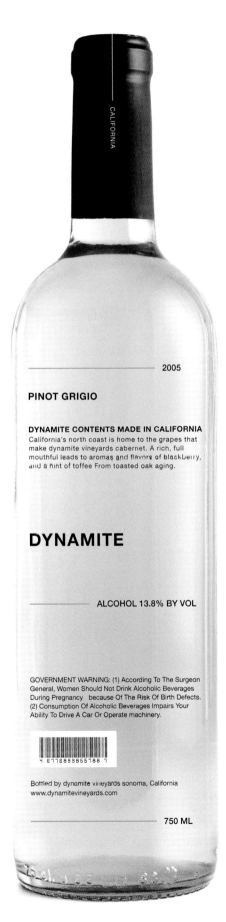

CALIFORNIA

2005

**PINOT GRIGIO**

**DYNAMITE CONTENTS MADE IN CALIFORNIA**
California's north coast is home to the grapes that
make dynamite vineyards cabernet. A rich, full
mouthful leads to aromas and flavors of blackberry,
and a hint of toffee From toasted oak aging.

**DYNAMITE**

——— ALCOHOL 13.8% BY VOL

GOVERNMENT WARNING: (1) According To The Surgeon
General, Women Should Not Drink Alcoholic Beverages
During Pregnancy   because Of The Risk Of Birth Defects.
(2) Consumption Of Alcoholic Beverages Impairs Your
Ability To Drive A Car Or Operate machinery.

Bottled by dynamite vineyards sonoma, California
www.dynamitevineyards.com

750 ML

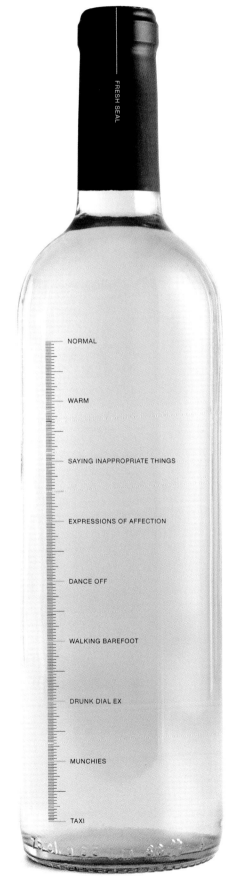

FRESH SEAL

NORMAL

WARM

SAYING INAPPROPRIATE THINGS

EXPRESSIONS OF AFFECTION

DANCE OFF

WALKING BAREFOOT

DRUNK DIAL EX

MUNCHIES

TAXI

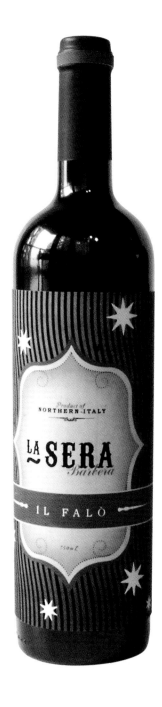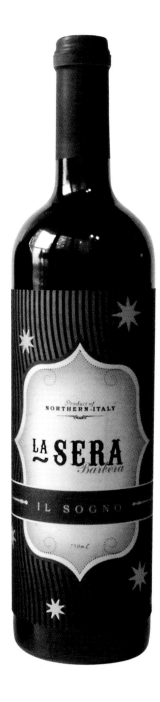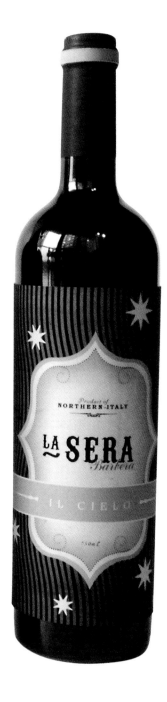

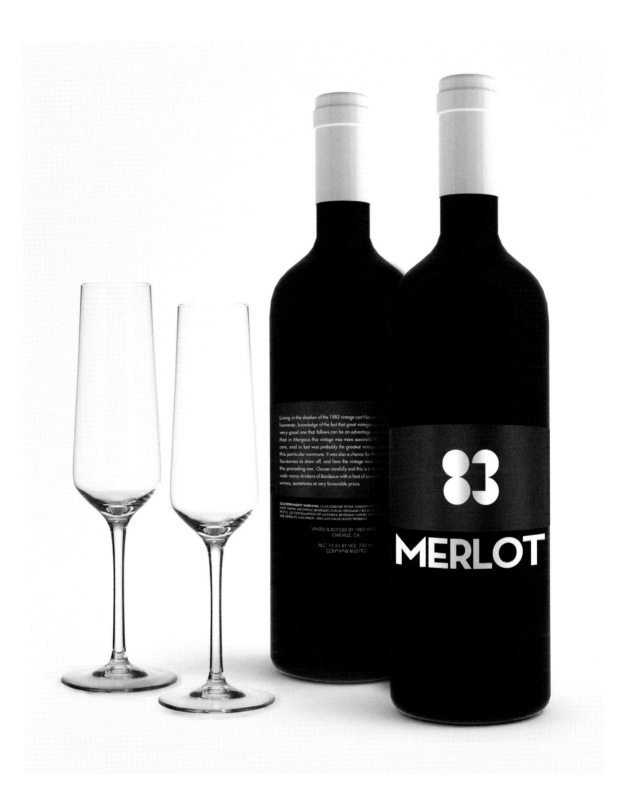

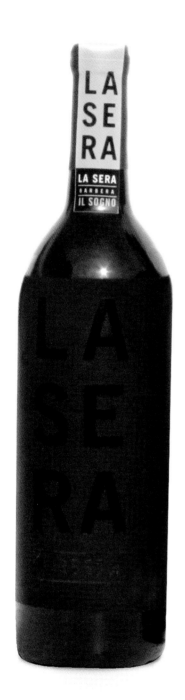
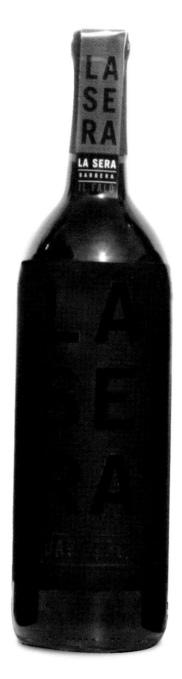
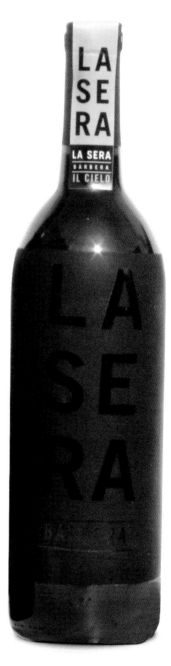

**Louise Fili** School of Visual Arts **Emily Kowzan**

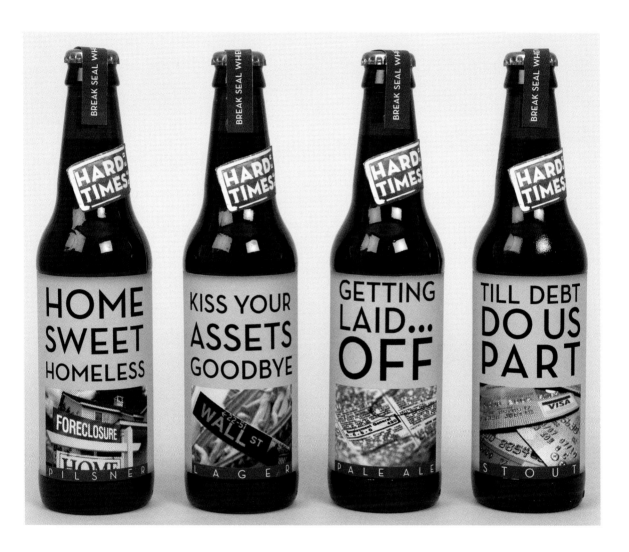

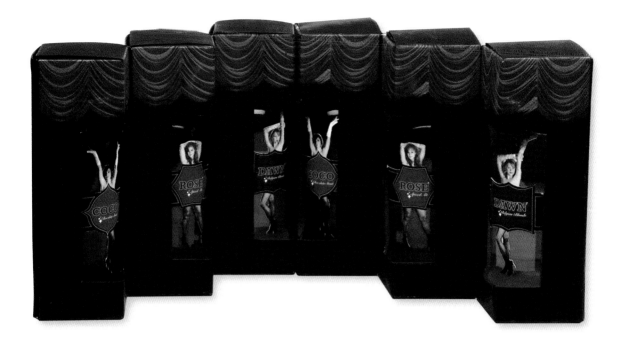

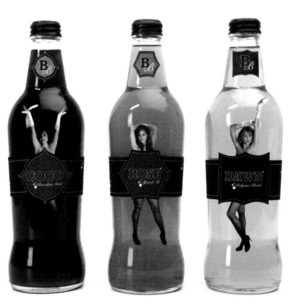

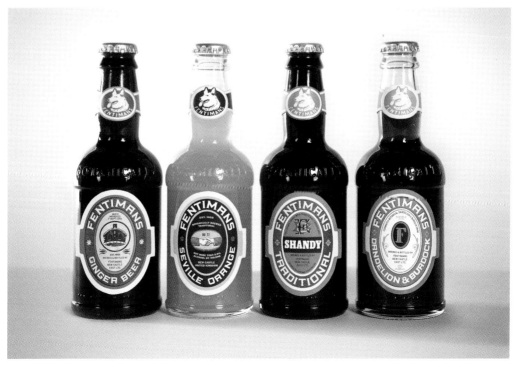

**Maribeth Kradel-Weitzel** Philadelphia University **Kristin Bigness** (top, middle)

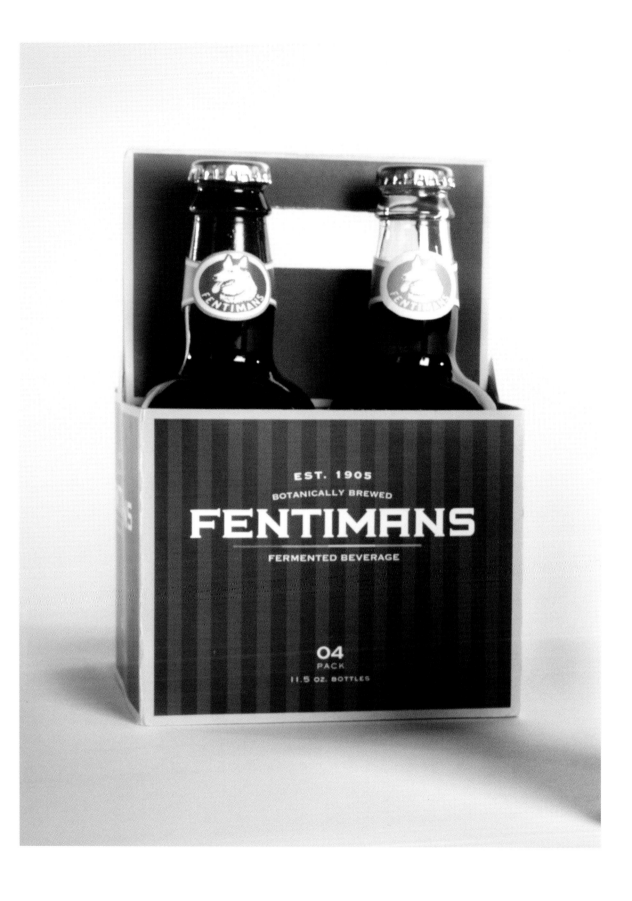

**Christopher Austopchuck** School of Visual Arts **Seungyon Chung**

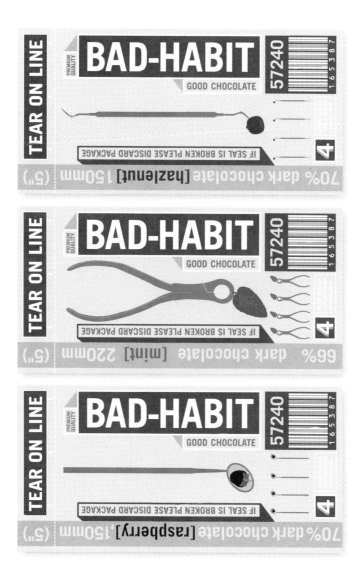

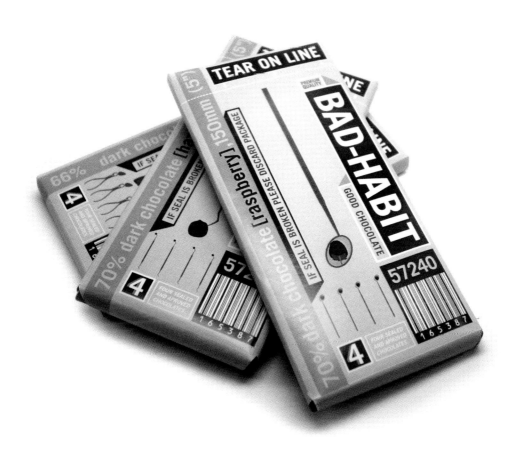

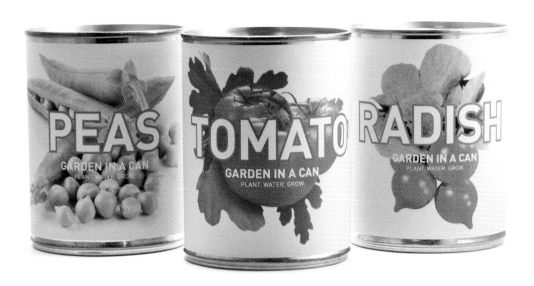

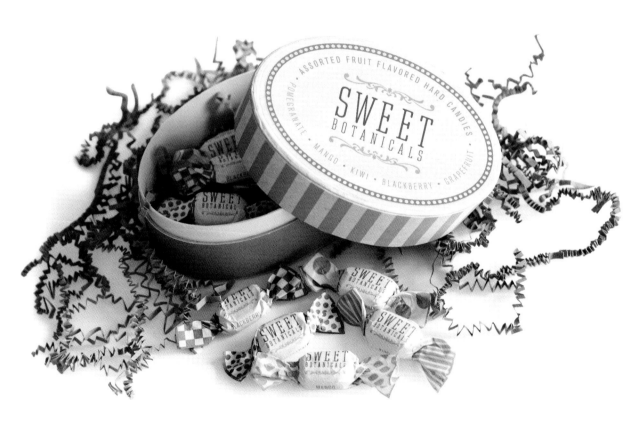

**Peter Buchanan-Smith** School of Visual Arts **Victoria Abrami**
**Louise Fili** School of Visual Arts **Jeanette Kaczorowski**

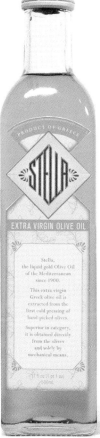
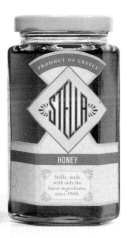

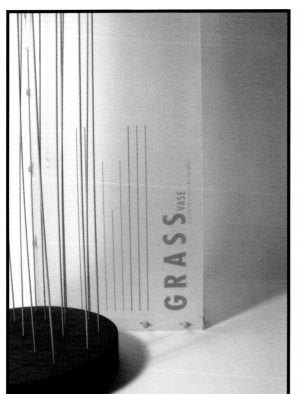

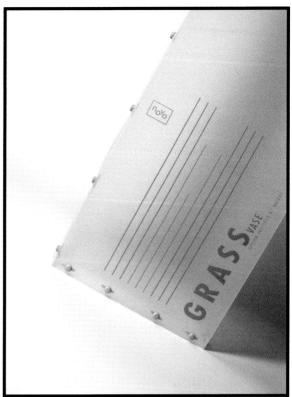

NOVO GRASS is a sculptural vase inspired by nature. Its varying height grass — like stems are configurable to your own style. At the top of each stem is a single bud vase to contain each flowers as a piece of art on its own.
NOVO vase is passion for nature.
The objects you see are result from nature shapes. Our vases are unique, frail but strong at the same time. Our vases are great thinking for a special present for your home or you work environment. Please visit us at www.novo.com

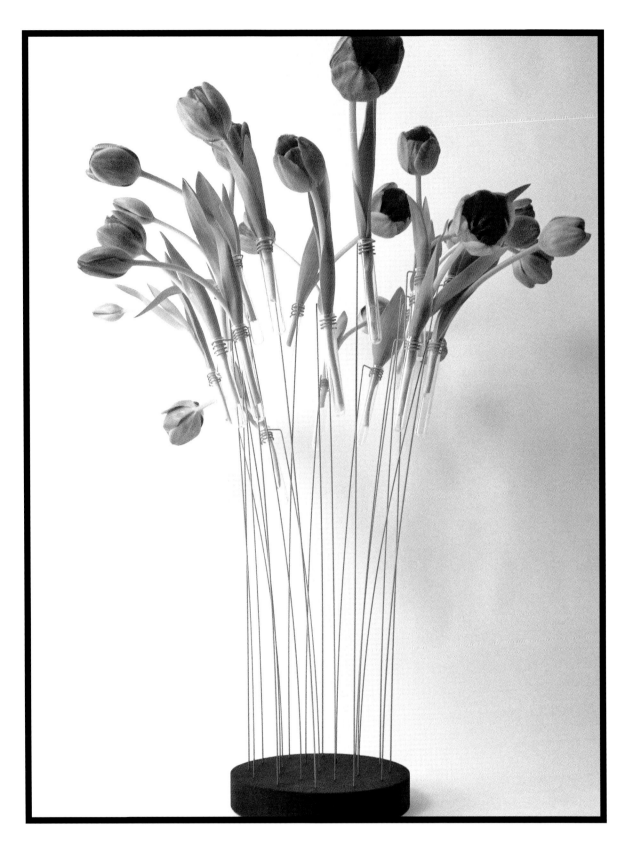

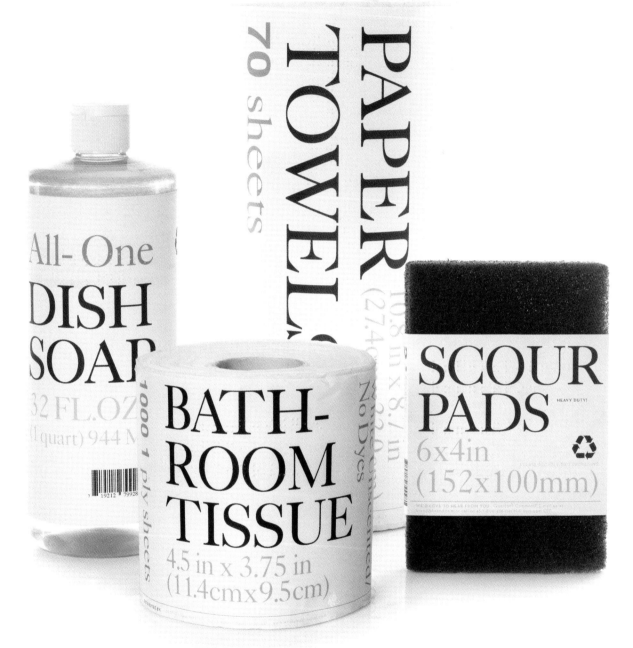

All-One
DISH
SOAP
32 FL.OZ
(1 quart) 944 M

7 19212 79928

70 sheets

PAPER
TOWELS

10.8 in x 8.7 in
(27.4cm x 22.0cm)
No Dyes

1000 1 ply sheets

BATH-
ROOM
TISSUE
4.5 in x 3.75 in
(11.4cm x 9.5cm)

SCOUR
PADS
HEAVY DUTY!
6x4in
(152x100mm)

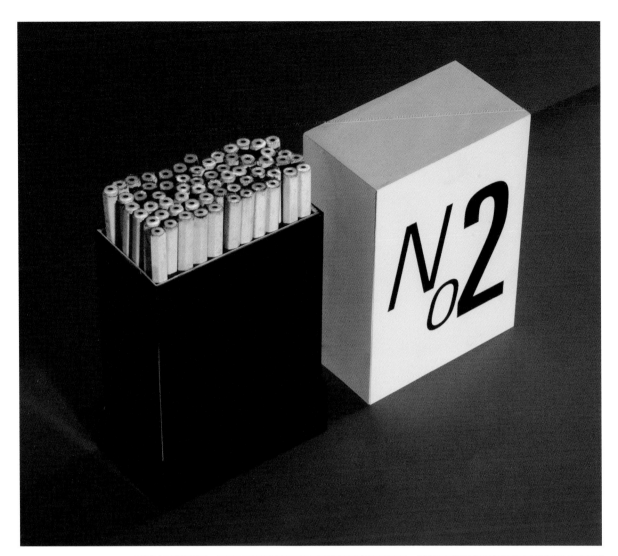

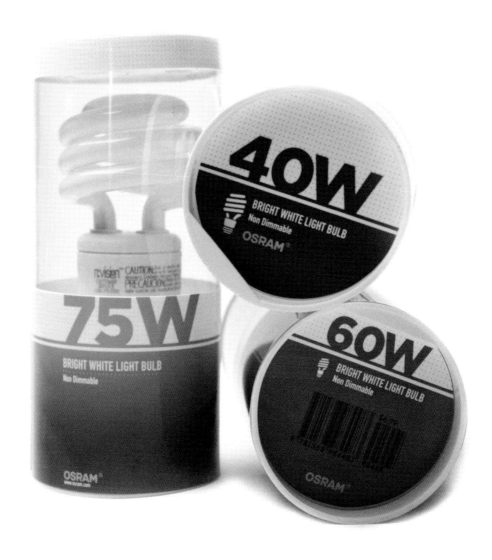

**Mitch Shostak** School of Visual Arts **Krzysztof Piatkowski**

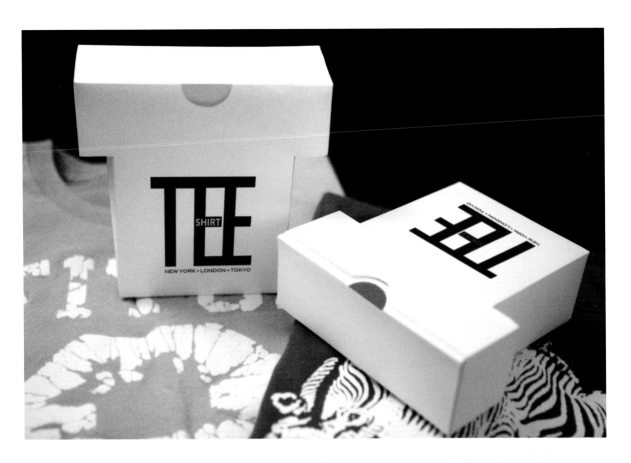

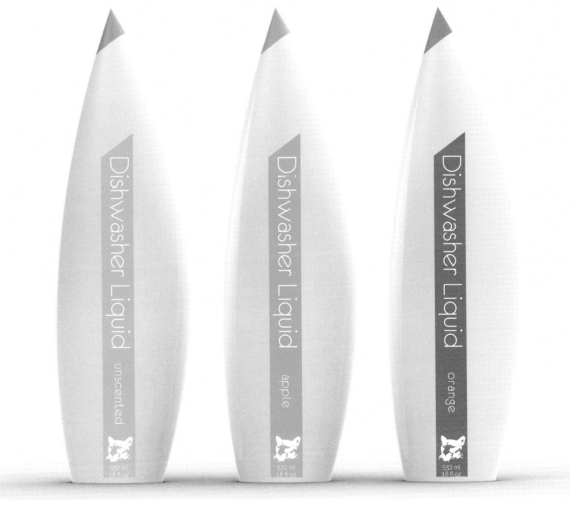

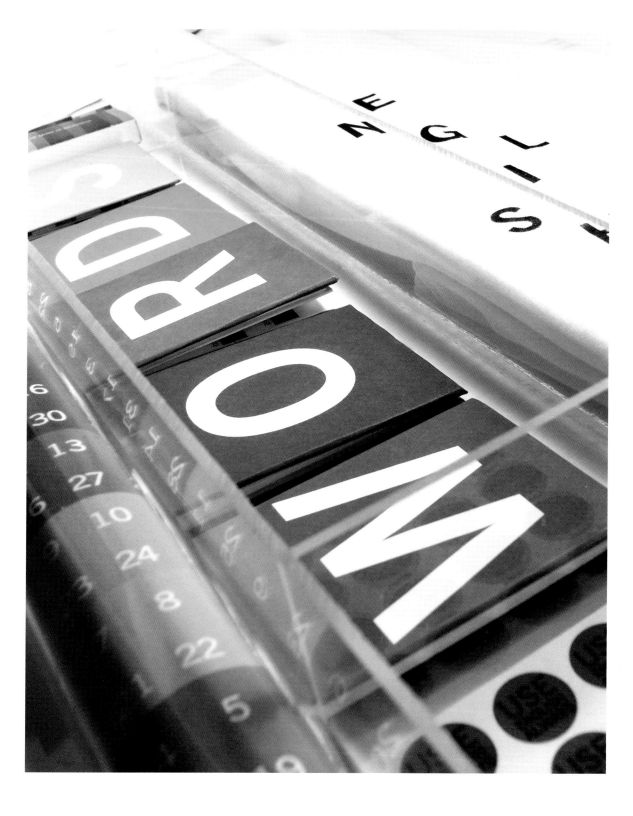

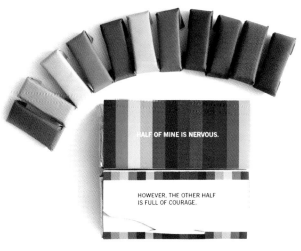

(this spread)

# PLANNER

월 화 수 목 금 토 일 M T W T F S S

| | | | | | | | | | | | | |
|---|---|---|---|---|---|---|---|---|---|---|---|---|
| 1 | 2 | 3 | 4 | 5 | 6 | 7 | 8 | 9 | 10 | 11 | 12 | 13 |
| 14 | 15 | 16 | 17 | 18 | 19 | 20 | 21 | 22 | *USE ENGLISH ALWAYS* | 24 | 25 | 26 | 27 |

**일월**

| 28 | 29 | 30 | *USE ENGLISH ALWAYS* | 1 | 2 | 3 | 4 | 5 | 6 | 7 | 8 | 9 | 10 |
|---|---|---|---|---|---|---|---|---|---|---|---|---|---|
| 11 | 12 | 13 | 14 | 15 | *USE ENGLISH ALWAYS* | 17 | 18 | 19 | 20 | 21 | 22 | 23 | 24 |

**이월**

| 25 | 26 | 27 | 28 | 29 | 1 | 2 | *USE ENGLISH ALWAYS* | 4 | 5 | 6 | 7 | 8 | 9 |
|---|---|---|---|---|---|---|---|---|---|---|---|---|---|
| 10 | 11 | 12 | 13 | *USE ENGLISH ALWAYS* | 15 | 16 | 17 | 18 | 19 | 20 | 21 | 22 | 23 |

**삼월**

| 24 | 25 | 26 | 27 | 28 | 29 | 30 | 31 | 1 | *USE ENGLISH ALWAYS* | 3 | 4 | 5 | 6 |
|---|---|---|---|---|---|---|---|---|---|---|---|---|---|
| 7 | 8 | 9 | 10 | 11 | 12 | 13 | 14 | 15 | 16 | 17 | 18 | 19 | 20 |

**사월**

| 21 | 22 | 23 | 24 | 25 | 26 | 27 | 28 | 29 | 30 | 1 | 2 | 3 | 4 |
|---|---|---|---|---|---|---|---|---|---|---|---|---|---|
| 5 | 6 | 7 | 8 | 9 | 10 | 11 | 12 | 13 | 14 | 15 | 16 | 17 | 18 |

**5**

| 19 | 20 | 21 | 22 | 23 | 24 | 25 | 26 | 27 | 28 | 29 | 30 | 31 | 1 |
|---|---|---|---|---|---|---|---|---|---|---|---|---|---|
| 2 | 3 | 4 | 5 | 6 | 7 | 8 | 9 | 10 | 11 | 12 | 13 | 14 | 15 |

**6**

| 16 | 17 | 18 | 19 | 20 | 21 | 22 | 23 | 24 | 25 | 26 | 27 | 28 | 29 |
|---|---|---|---|---|---|---|---|---|---|---|---|---|---|
| 30 | 1 | 2 | 3 | 4 | 5 | 6 | 7 | 8 | 9 | 10 | 11 | 12 | 13 |

**7**

| 14 | 15 | 16 | 17 | 18 | 19 | 20 | 21 | 22 | 23 | 24 | 25 | 26 | 27 |
|---|---|---|---|---|---|---|---|---|---|---|---|---|---|
| 28 | 29 | 30 | 31 | 1 | 2 | 3 | 4 | 5 | 6 | 7 | 8 | 9 | 10 |

**8**

| 11 | 12 | 13 | 14 | 15 | 16 | 17 | 18 | 19 | 20 | 21 | 22 | 23 | 24 |
|---|---|---|---|---|---|---|---|---|---|---|---|---|---|
| 25 | 26 | 27 | 28 | 29 | 30 | 31 | 1 | 2 | 3 | 4 | 5 | 6 | 7 |

**September**

| 8 | 9 | 10 | 11 | 12 | 13 | 14 | 15 | 16 | 17 | 18 | 19 | 20 | 21 |
|---|---|---|---|---|---|---|---|---|---|---|---|---|---|
| 22 | 23 | 24 | 25 | 26 | 27 | 28 | 29 | 30 | 1 | 2 | 3 | 4 | 5 |

**October**

| 6 | 7 | 8 | 9 | 10 | 11 | 12 | 13 | 14 | 15 | 16 | 17 | 18 | 19 |
|---|---|---|---|---|---|---|---|---|---|---|---|---|---|
| 20 | 21 | 22 | 23 | 24 | 25 | 26 | 27 | 28 | 29 | 30 | 31 | 1 | 2 |

**November**

| 3 | 4 | 5 | 6 | 7 | 8 | 9 | 10 | 11 | 12 | 13 | 14 | 15 | 16 |
|---|---|---|---|---|---|---|---|---|---|---|---|---|---|
| 17 | 18 | 19 | 20 | 21 | 22 | 23 | 24 | 25 | 26 | 27 | 28 | 29 | 30 |

**December**

| 1 | 2 | 3 | 4 | 5 | 6 | 7 | 8 | 9 | 10 | 11 | 12 | 13 | 14 |
|---|---|---|---|---|---|---|---|---|---|---|---|---|---|
| 15 | 16 | 17 | 18 | 19 | 20 | 21 | 22 | 23 | 24 | 25 | 26 | 27 | 28 |
| 29 | 30 | 31 | | | | | | | | | | | |

This is my English planner. It is for one year. Every day I will check myself and see if I spoke English a lot or not When I didn't speak it too much, I will attach a sticker that says "Use English Always." as a reminder.

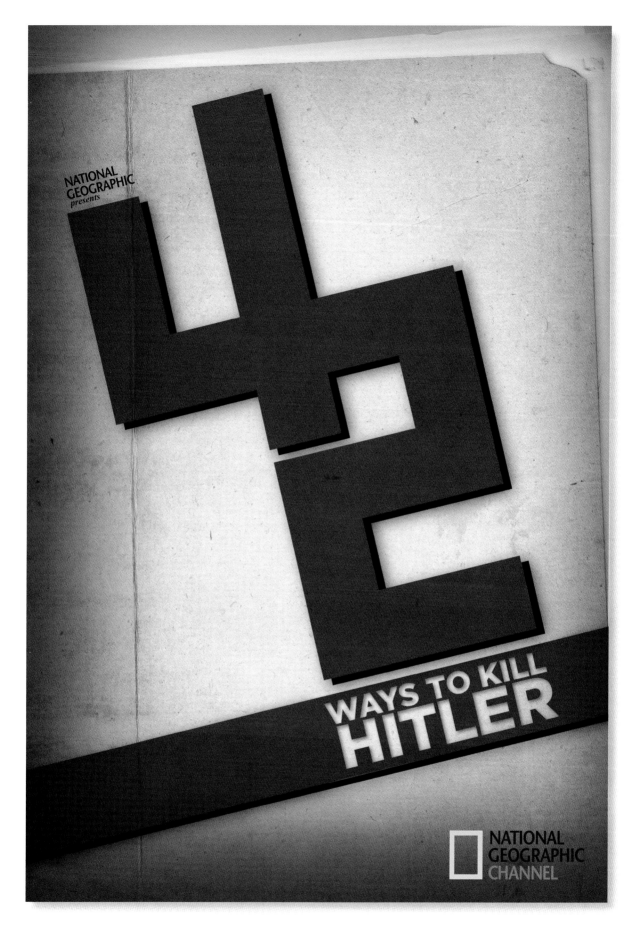

NATIONAL
GEOGRAPHIC
presents

WAYS TO KILL
HITLER

NATIONAL
GEOGRAPHIC
CHANNEL

**Richard Wilde** School of Visual Arts **Jeanette Kaczorowski**

January 6 - March 1

**2009 WINTER SEASON**

Our 2009 Winter Season features some of the Company's most spectacular works: the monumental scope of George Balanchine's Vienna Waltzes and his rousing Stars and Stripes, Jerome Robbins' immortal West Side Story Suite, and the charming full-length Coppélia, which tells the tale of a mad inventor and the life-like doll he creates.

Lincoln Center
**E:** www.nycballet.com
**T:** 212-508-8730

New York City
**Ballet**

# Art is a tool. Nail it with an idea.

(ACTUAL SIZE)

School of the VISUAL ARTS

**Tony Paladino** School of Visual Arts **Chih Ting Ko**

Begins 4.14
8 pm

Always Fun!
History.com

The School of Visual Arts

**Kim Maley** School of Visual Arts **Christopher Spinella**

WWW.GREENPEACE.ORG

N° 1 /    Space
N° 2 /    Time
N° 3 /    Touch
N° 4 /    Phantoms
N° 5 /    Color
N° 6 /    Everything

An exploration
of the emergence
of ghosts within
our senses. Error
within responses.

May 24–Sept 17
Opening Reception:
May 24th 7:30 pm
6109 Olmypic Blvd.
Los Angeles CA
RSVP 213.330.8004

**Carolina Trigo** Art Center College of Design **Eric Hu, Tsz Ho Ip, Ji Shin**

2005 BIENNIAL MARCH 6—JUNE 1

Matthew McGuiness School of Visual Arts Michelle Deluca

# SVA Motion Graphics
PORTFOLIO SCREENING
## 2009

Anthony Cafaro •
Alysson Castro •
Jungmi Cho •
Yuliya Dagayeva
Andrei Dan •
Jordana Ferraro •
James Gundersen •
Aleksander Ivanov •
Myungsun Jang •
Sang Un Jeon •
Helen Kim •
Mikihiro Kobayashi •
Adam Lee •
Lance Marxen
Ji Hyun Moon •
Hyesung Park •
Jaewoo Park •
Hyun Jung Ra •
Evan Silva •
Yung Jae Suh

Photography by
John and Chris Cafaro

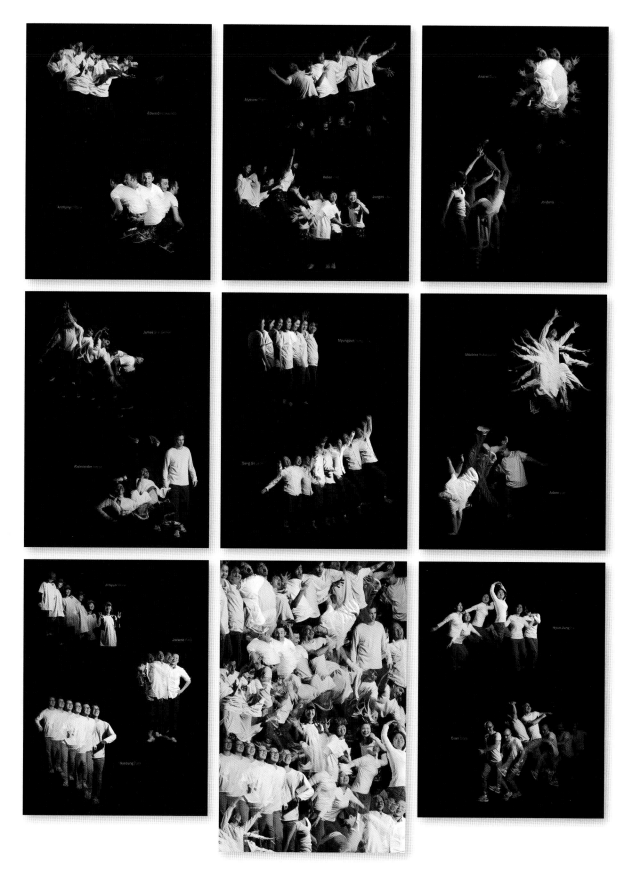

**Ori Kleiner** School of Visual Arts **Anthony Cafaro**

The Museum of Modern Art

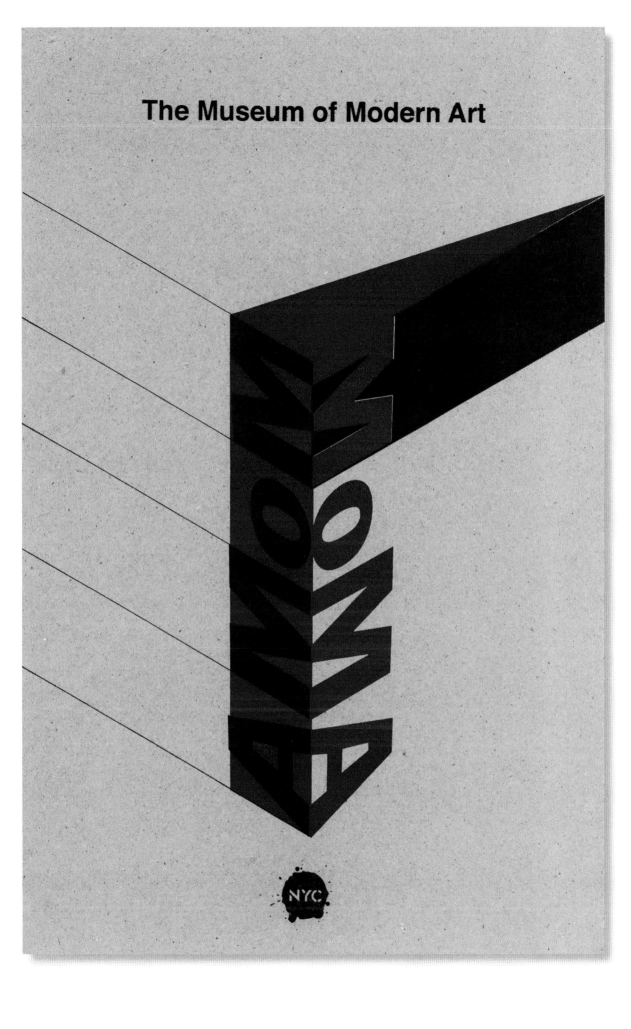

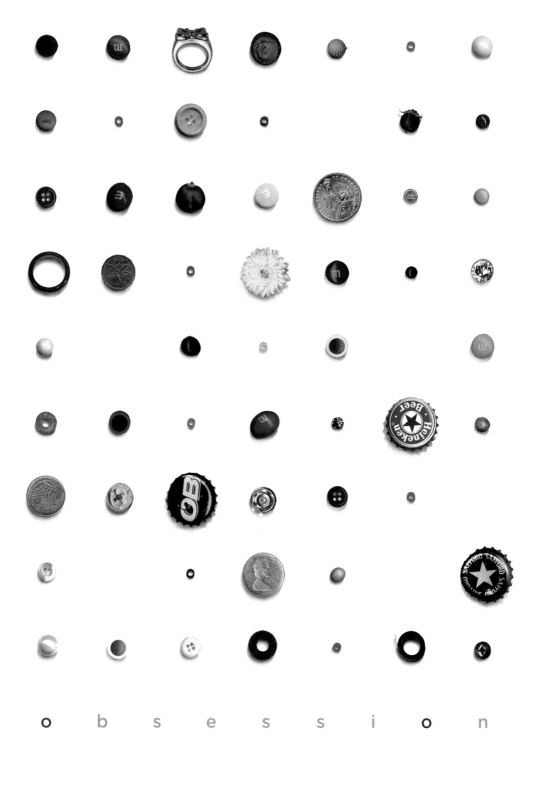

o  b  s  e  s  s  i  o  n

**MoMA**  C I R C L E   I S   B E A U T I F U L   August • September 2009

**Skip Sorvino** School of Visual Arts **Hana Yoo**

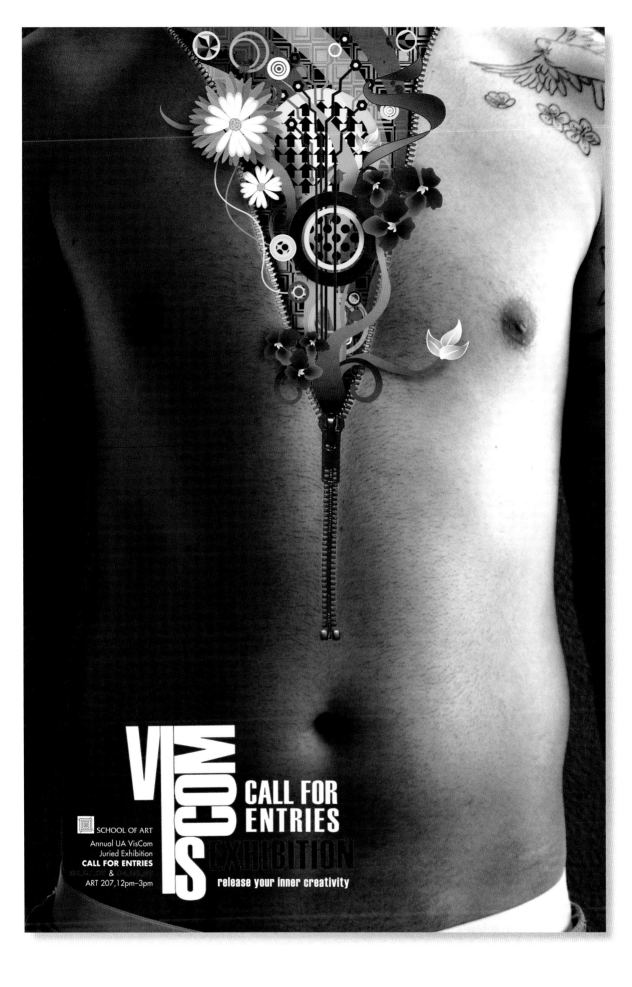

VISCOM

CALL FOR
ENTRIES

EXHIBITION

SCHOOL OF ART

Annual UA VisCom
Juried Exhibition
**CALL FOR ENTRIES**
&
ART 207,12pm–3pm

IS

release your inner creativity

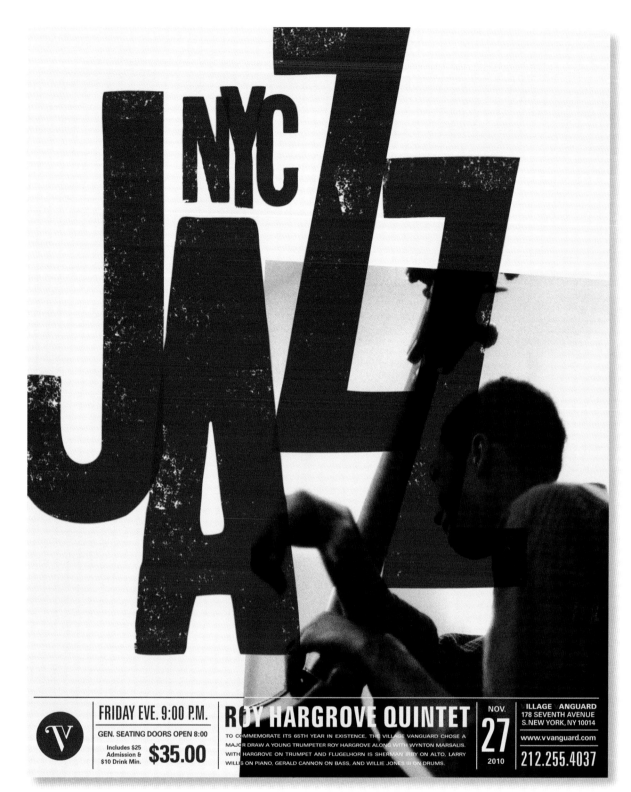

Adrian Pulfer Brigham Young University **Beth Robertson**

# 50 +

## in one day

The Japanese Army recruited women to work in
factories during World War II, the recruits became
known as the "comfort women". The women had to
serve sometimes as many as 50 men a day.

**Violence Against Women**
www.amnesty.org

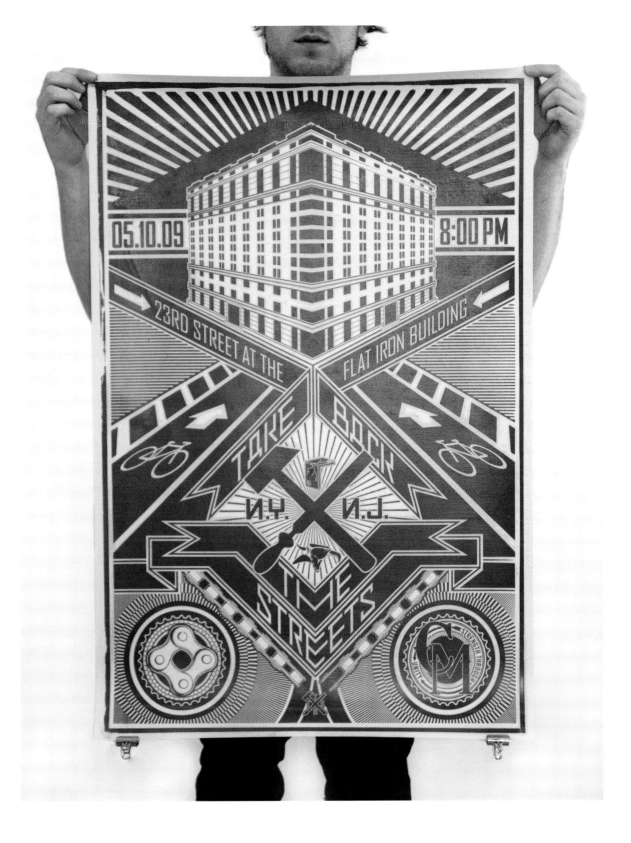

WHO'S YOUR DADDY?

#02475

#01453

#01675

#01286

#02065

#01865

#00789

#02059

#01507

Timothy Samara School of Visual Arts Ann Im Sunwoo

A Gay Fantasia on National Themes
Part One: Millennium Approaches

TONY KUSHNER

Center Theatre Group/Mark Taper Forum
213.628.2772
www.centertheatregroup.org

Angels In America

**Eric Baker, Ryan Gerber, Richard Poulin** School of Visual Arts **Joshua Winship Carpenter**

Mime Festival

Collectif Petit Travers I Patrick Sims I Tomas Kubinek

Tues at 7pm; Wed-Sat at 8pm; Wed and Sat at 2pm; Sun at 3pm, Call Ticketmaster: 212-307-4100/800-755-4000
Visit: Ticketmaster.com, Group: 212-398-8383, Premium Tickets: 212-220-0500/212-2200501, www.Mimefest.com
MAJESTIC THEATRE, 247 WEST 44TH STREET

www.mimefest.com

**Adrienne Leban, Michael Walsh** School of Visual Arts **Ryan Durinick**

1 bedroom
apartment
for rent.
1/2 mile
to purdle
airport.
441 690
6410

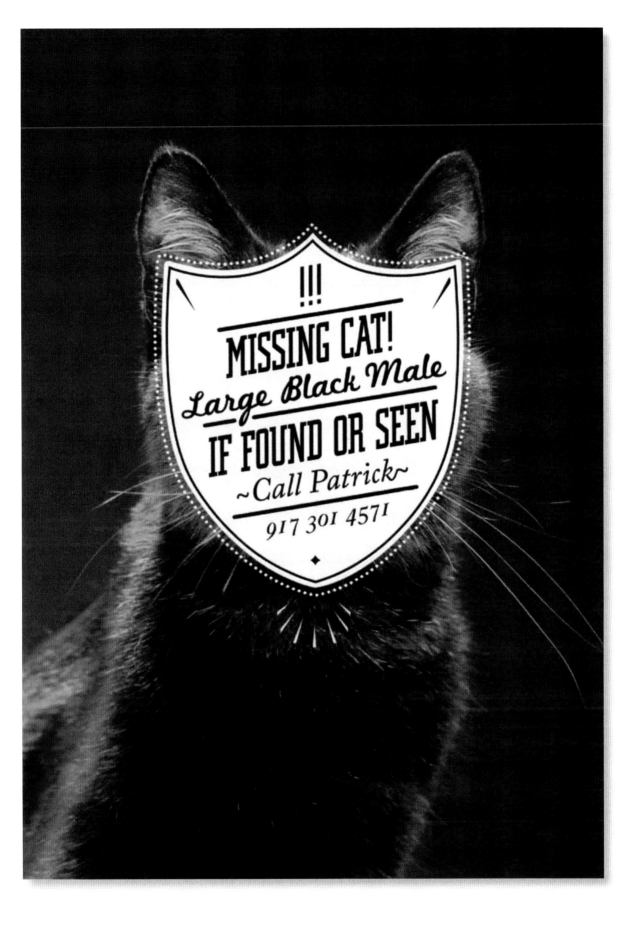

**Paul Sahre** School of Visual Arts **Eric Ku**

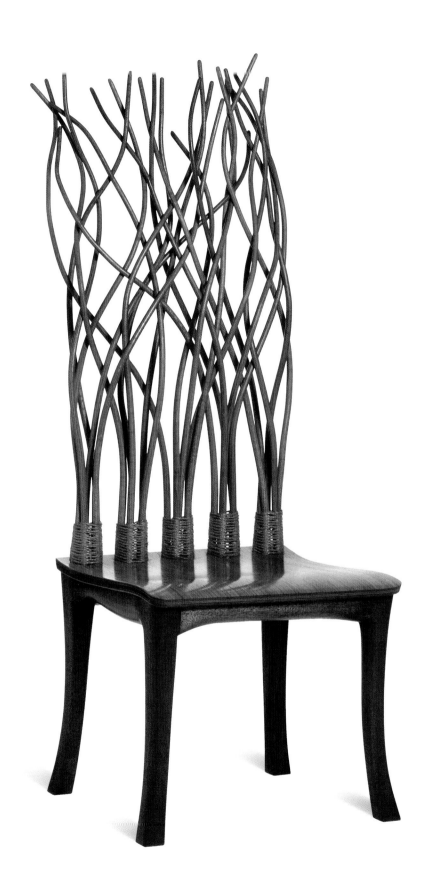

**Hank Richardson** Portfolio Center **Ali Dick**

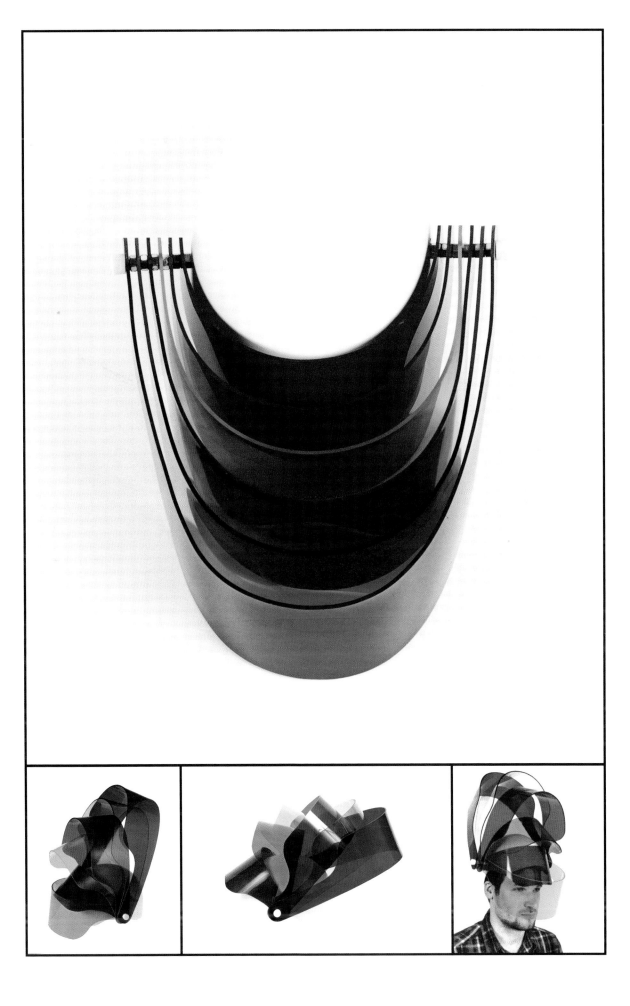

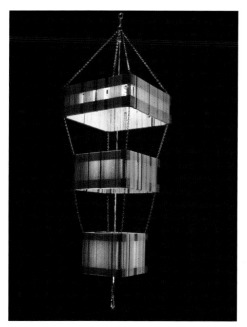
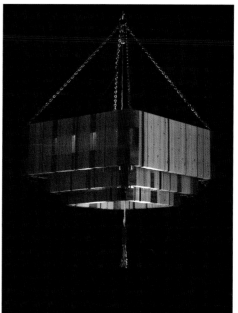
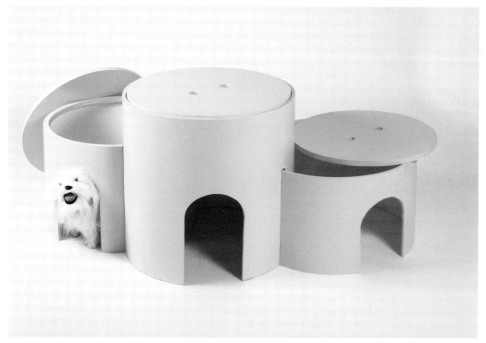

**Kevin O'Callighan** School of Visual Arts **Sarah Nguyen** (top, middle)
**Kevin O'Callighan** School of Visual Arts **Nicole Penna** (bottom)

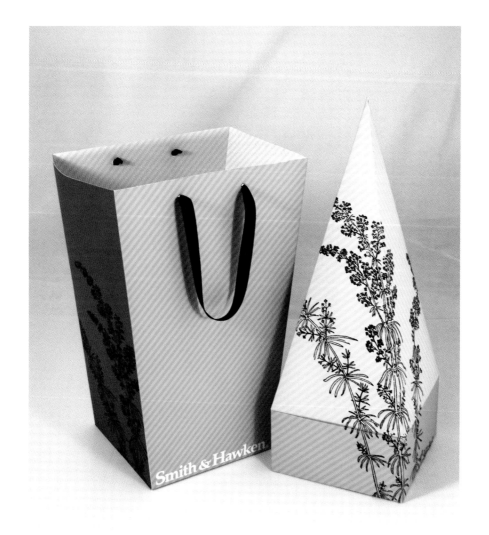

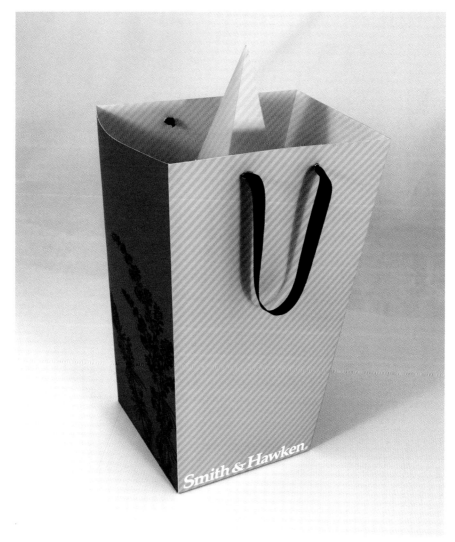

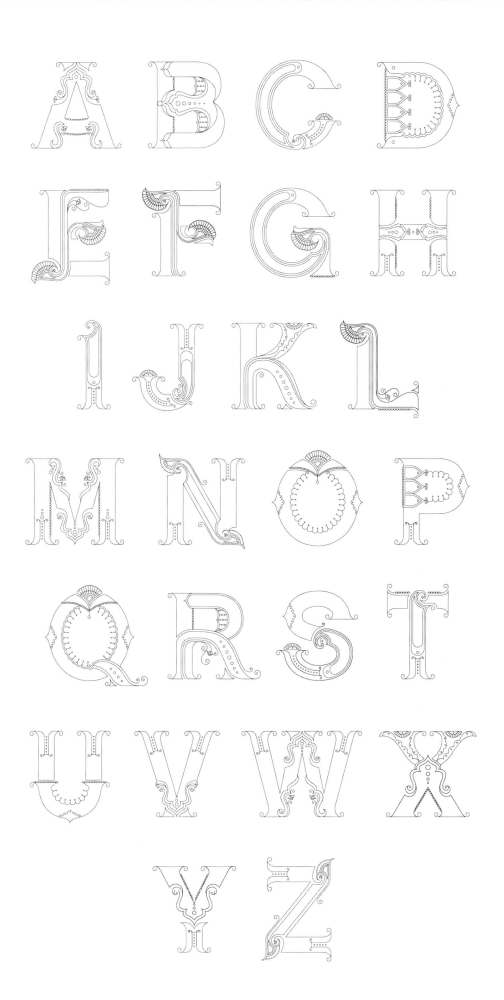

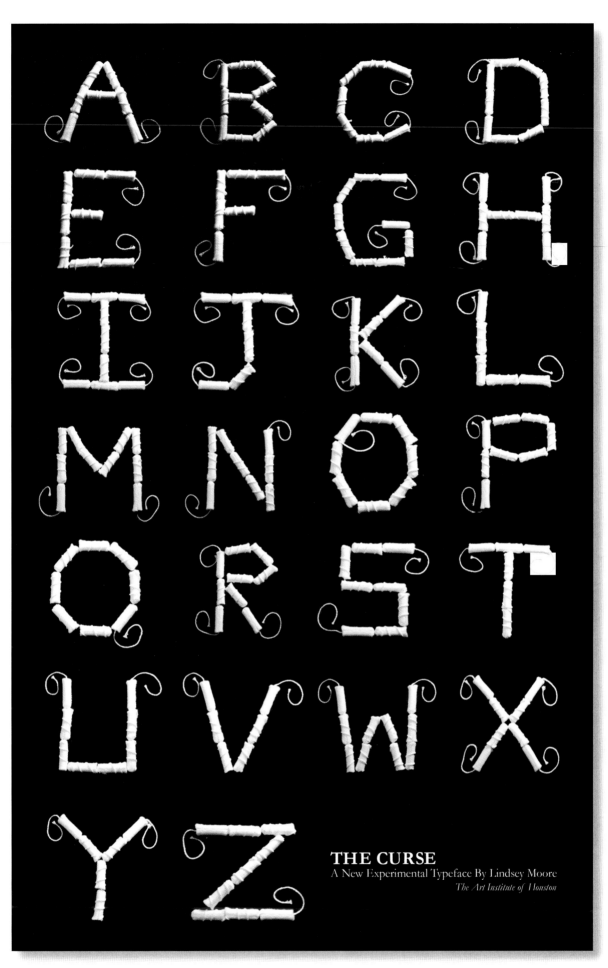

**THE CURSE**
A New Experimental Typeface By Lindsey Moore
*The Art Institute of Houston*

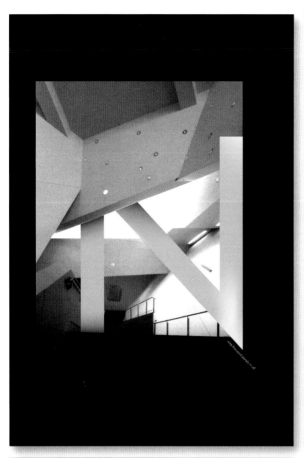

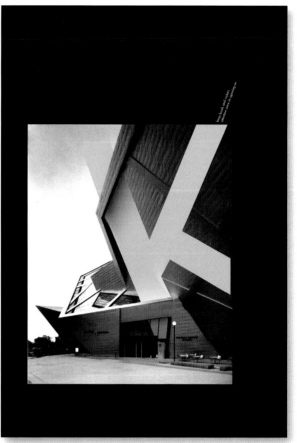

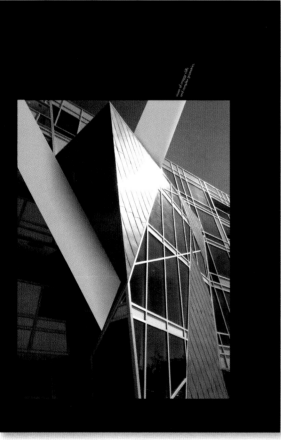

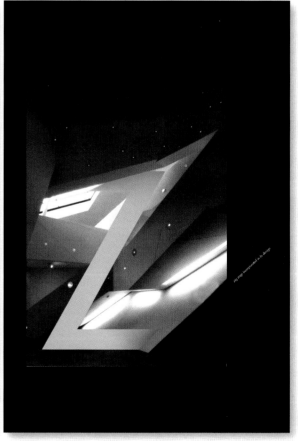

**Henrieta Condak** School of Visual Arts **Cassandra Barboe**

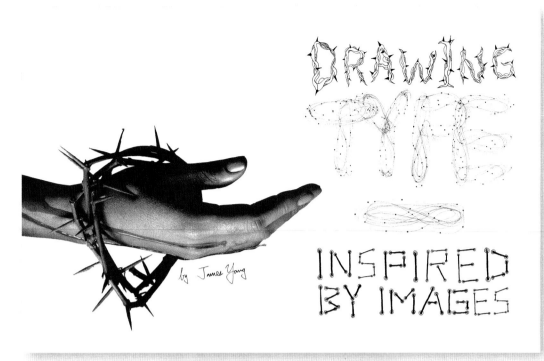

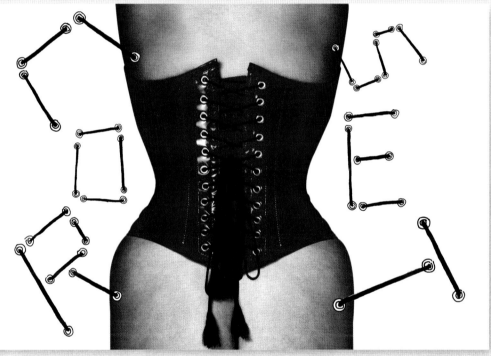

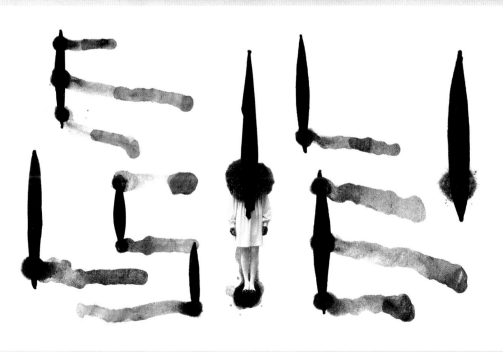

**Michele Damato** The Art Institute of Houston **Nathan Li**

**Phil Bekker** Art Institute of Atlanta **Deb Jansen**

The sign on the wall reads:

**AUTHORIZED PERSONNEL ONLY**

**Phil Bekker** Art Institute of Atlanta **Alex Benigno**

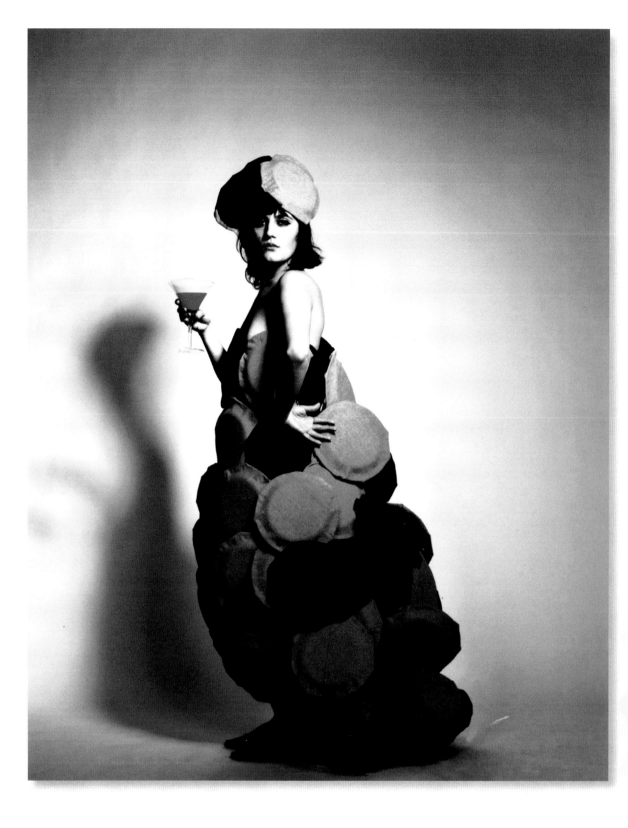

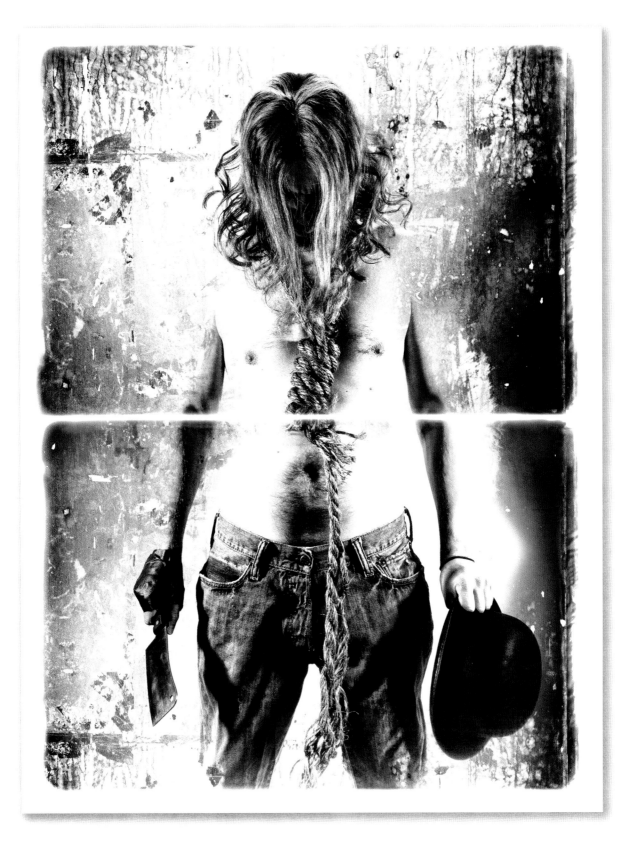

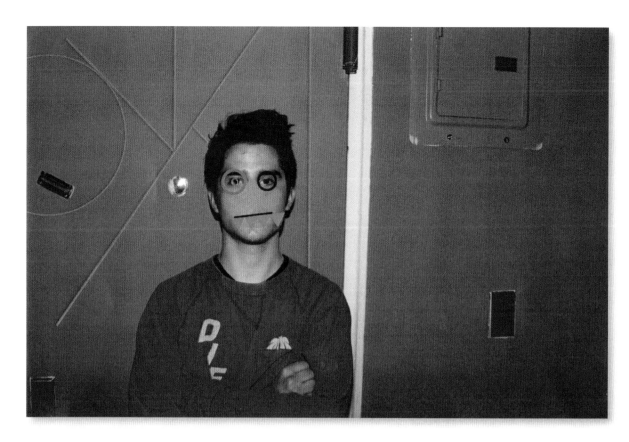

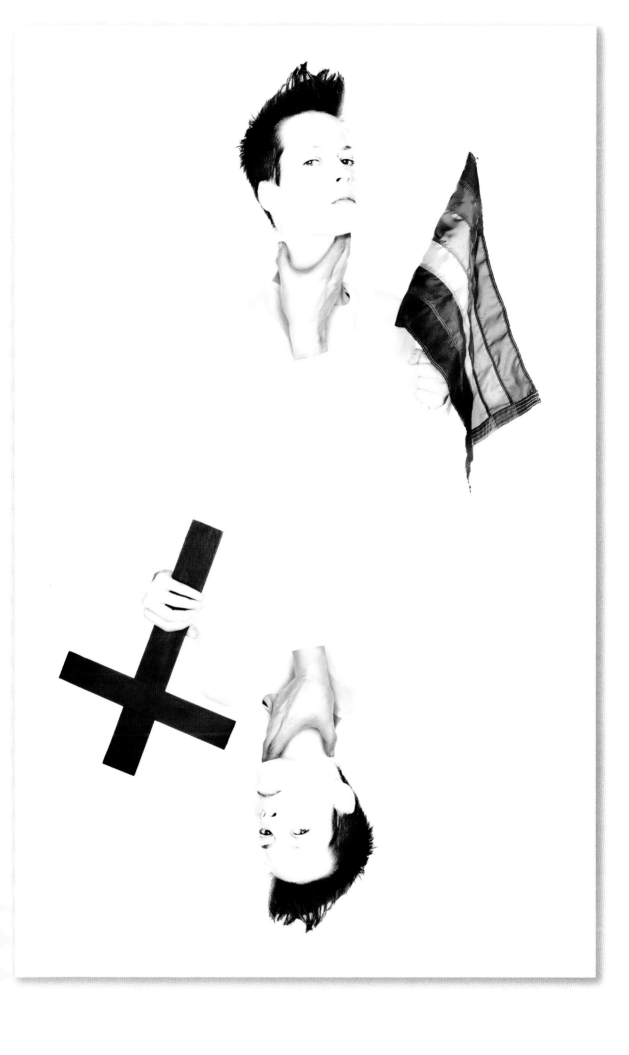

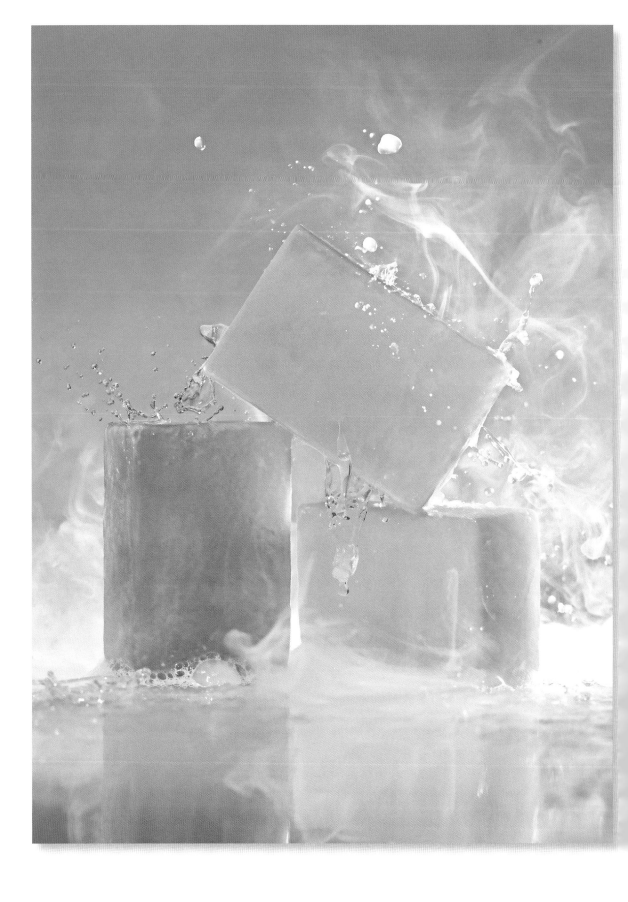

**Phil Bekker** Art Institute of Atlanta **Alex Benigno**

# Credits&Comments

**Advertising/Automotive**
**20** Radar Detectors (top) | Student: Julissa Ortiz | Instructor: Jack Mariucci | Department: Advertising & Graphic Design | Department Chair: Richard Wilde | School: School of Visual Arts

**20** Parking Spot (middle) | Student: Young Wook Kim | Instructor: Frank Anselmo | Department: Advertising | Department Chair: Richard Wilde | School: School of Visual Arts

**20** Carfax (bottom) | Student: Carolina Macias Vega | Instructor: Jack Mariucci | Department: Advertising & Graphic Design | Department Chair: Richard Wilde | School: School of Visual Arts

**21** Rolls Royce | Student: Ian Bae | Instructor: Jack Mariucci | Department: Advertising & Graphic Design | Department Chair: Richard Wilde | School: School of Visual Arts

**Advertising/Beauty&Cosmetics**
**22** Dove Soap | Student: Sara Roderick | Instructor: Jack Mariucci | Department: Advertising & Graphic Design | Department Chair: Richard Wilde | School: School of Visual Arts

**Advertising/Beverage**
**23** Powerful | Student: Guilherme Fregonesi | School: Miami Ad School

**24** Chest Hair | Student: Alain Baburam | Instructor: Frank Anselmo | Department: Advertising | Department Chair: Richard Wilde | School: School Of Visual Arts

**25 PLATINUM** On Every Corner | Student: Cindy Eunhaee Cho | Instructor: Jack Mariucci | Department: Advertising & Graphic Design | Department Chair: Richard Wilde | School: School of Visual Arts

**26** Print Campaign | Student: Czarine Yee | Instructor: Frank Anselmo | Department: Advertising | Department Chair: Richard Wilde | School: School of Visual Arts

**27** Label | Student: Jin H. Chang, Hyungrak Choi | Instructor: Frank Anselmo | Department: Advertising | Department Chair: Richard Wilde | School: School Of Visual Arts

**Advertising/Billboard**
**28** Oreo (top) | Student: Carolina Macias Vega | Instructor: Jack Mariucci | Department: Advertising & Graphic Design | Department Chair: Richard Wilde | School: School of Visual Arts

**28** Dyson (middle) | Student: Carolina Macias Vega | Instructor: Sal De Vito | Department: Advertising & Graphic Design | Department Chair: Richard Wilde | School: School of Visual Arts

**28** Clorox (bottom) | Student: Carolina Macias Vega | Instructor: Jack Mariucci | Department: Advertising & Graphic Design | Department Chair: Richard Wilde | School: School of Visual Arts

**29** Crane | Student: Jyn Yi, Sara Roderick | Instructor: Frank Anselmo | Department: Advertising | Department Chair: Richard Wilde | School: School Of Visual Arts

**30** Building Billboards (top) | Student: Cindy Eunhaee Cho, Hyojoo Kim | Instructor: Frank Anselmo | Department: Advertising | Department Chair: Richard Wilde | School: School Of Visual Arts

**30** Ziploc Nature (bottom) | Student: Pablo Jimenez, Colleen Layman | Instructor: Maggi Machado, Stephanie Price | School: Miami Ad School, Miami Beach
*Description:* Ziploc keeps it fresh.

**31** Glass Doors | Student: Kenji Akiyama | Instructor: Frank Anselmo | Department: Advertising | Department Chair: Richard Wilde | School: School Of Visual Arts

**32** Tools | Student: Marianna DiAnnunzio | Instructor: Frank Anselmo | Department: Advertising | Department Chair: Richard Wilde | School: School Of Visual Arts

**Advertising/Broadcast**
**33** Paparazzi | Student: Jin Young Choi | Instructor: Jung Seung-Hyoun | School: Hongik University, Bucheon-si
*Description:* The world always hides something. Discovery channel is the paparazzi who disclose secrets of the world.

**Advertising/Cameras**
**34 PLATINUM** Freeze the moment | Student: Cindy Eunhaee Cho | Instructor: Jack Mariucci | Department: Advertising & Graphic Design | Department Chair: Richard Wilde | School: School of Visual Arts

**Advertising/Computers&Software**
**35, 36** Controller | Student: Evert John Vonk | Instructor: Frank Anselmo | Department: Advertising | Department Chair: Richard Wilde | School: School of Visual Arts

**37** Cut | Student: Alex Sunyoung Koo | Instructor: Frank Anselmo | Department: Advertising | Department Chair: Richard Wilde | School: School Of Visual Arts

**Advertising/DeliveryService**
**38 PLATINUM** Clock | Student: Ian Bae, Brian McLaughlin | Instructor: Frank Anselmo | Department: Advertising | Department Chair: Richard Wilde | School: School of Visual Arts

**Advertising/Education**
**39** Easel | Student: Jyn Yi, Sara Roderick | Instructor: Frank Anselmo | Department: Advertising | Department Chair: Richard Wilde | School: School of Visual Arts

**Advertising/Fashion**
**40** Print Campaign | Student: Jyn Yi | Instructor: Jack Mariucci | Department: Advertising & Graphic Design | Department Chair: Richard Wilde | School: School of Visual Arts

**Advertising/Food**
**41** Insert Oreo here | Student: Cindy Eunhaee Cho | Instructor: Jack Mariucci | Department: Advertising & Graphic Design | Department Chair: Richard Wilde | School: School of Visual Arts

**42** The Savior (top) | Student: Michael Youssef | School: Miami Ad School

**42** Made Fresh Daily (bottom) | Student: Kenji Akiyama | Instructor: Frank Anselmo | Department: Advertising | Department Chair: Richard Wilde | School:

School of Visual Arts

**43** Barrel (top) | Student: Alain Baburam | Instructor: Frank Anselmo | Department: Advertising | Department Chair: Richard Wilde | School: School Of Visual Arts

**43** Long's Horseradish (bottom) | Student: Adam Hook, Travis Robertson, David Taylor | Instructor: Duncan Stone | Department: Advertising | Department Chair: Eddie Snyder | School: Portfolio Center, Atlanta

**44** From Farm To Home | Student: Jyn Yi, Sara Roderick | Instructor: Frank Anselmo | Department: Advertising | Department Chair: Richard Wilde | School: School Of Visual Arts

**45** The Condiment With The Kick | Student: Alex Sunyoung Koo, Julissa Ortiz | Instructor: Frank Anselmo | Department: Advertising | Department Chair: Richard Wilde | School: School Of Visual Arts

**Advertising/Museum**
**46** Intrepid | Student: Sara Roderick | Instructor: Sal Devito | Department: Advertising & Graphic Design | Department Chair: Richard Wilde | School: School of Visual Arts

**47 PLATINUM** Integrated Campaign | Student: Jyn Yi, Sara Roderick | Instructor: Jack Mariucci | Department Chair: Richard Wilde | School: School of Visual Arts

**48** Intrepid Museum | Student: Chelsea Cumings, Jane Cronk | Instructor: Sal De Vito | Department: Advertising & Graphic Design | Department Chair: Richard Wilde | School: School of Visual Arts

**Advertising/Music**
**49** Hand | Student: Tiffany Lui, Jacqueline F. Sendgikoski | Instructor: Frank Anselmo | Department: Advertising & Graphic Design | Department Chair: Richard Wilde | School: School of Visual Arts

**Advertising/Outdoor**
**50** Souloution (top) | Student: Stella Jo Hsin Wang | Instructor: Jack Mariucci | Department: Advertising & Graphic Design | Department Chair: Richard Wilde | School: School of Visual Arts

**50** Ski Lifts (bottom) | Student: Hyojoo Kim | Instructor: Frank Anselmo | Department: Advertising | Department Chair: Richard Wilde | School: School Of Visual Arts

**51** Self Tanning Lotion (top) | Student: Hee Kyung Helen Shin | Instructor: Vinny Tulley | Department: Advertising & Graphic Design | Department Chair: Richard Wilde | School: School of Visual Arts

**51** French Fries (bottom) | Student: Tiffany Hyerim Joung | Instructor: Frank Anselmo | Department: Advertising | Department Chair: Richard Wilde | School: School of Visual Arts

**52** Tire Track | Student: Mariana Castellanos Isaza, Stella Jo Hsin Wang | Instructor: Frank Anselmo | Department: Advertising | Department Chair: Richard Wilde | School: School Of Visual Arts

**53** Cellar Door | Student: Alex Sunyoung Koo, Julissa Ortiz | Instructor: Frank Anselmo | Department: Advertising | Department Chair: Richard Wilde | School: School Of Visual Arts

**54** Slide-Pole | Student: Czarine Yee | Instructor: Frank Anselmo | Department: Advertising | Department Chair: Richard Wilde | School: School Of Visual Arts

**Advertising/Pharmaceuticals**
**55** HairClub | Student: Julissa Ortiz | Instructor: Jack Mariucci | Department: Advertising & Graphic Design | Department Chair: Richard Wilde | School: School of Visual Arts

**Advertising/Products**
**56** Duncan Fun for one | Student: Jonathan Smith, David Taylor, Justin Keoninh, Adam Hook | Instructor: Duncan Stone | Department: Advertising | Department Chair: Eddie Snyder | School: Portfolio Center, Atlanta

**57** Apple Shooter | Student: Kenji Akiyama | Instructor: Jack Mariucci | Department: Advertising & Graphic Design | Department Chair: Richard Wilde | School: School of Visual Arts

**58** Arm Cast | Student: Kenji Akiyama | Instructor: Jack Mariucci | Department: Advertising & Graphic Design | Department Chair: Richard Wilde | School: School of Visual Arts

**59, 60** Only One | Student: Michael Youssef | School: Miami Ad School

**61** Fixodent (top) | Student: Sungkwon Ha | Instructor: Jack Mariucci | Department: Advertising & Graphic Design | Department Chair: Richard Wilde | School: School of Visual Arts

**61** Hamilton Beach Iron Poster (bottom) | Student: Ju Hyun Jung | Instructor: Jeroen Bours | Department: Advertising & Graphic Design | Department Chair: Richard Wilde | School: School of Visual Arts

**62** Miracle Grow | Student: Lisa Gilardi, Itai Inselberg | Instructor: Jack Mariucci | Department: Advertising & Graphic Design | Department Chair: Richard Wilde | School: School of Visual Arts

**63** Graves | Student: Lisa Gilardi, Itai Inselberg | Instructor: Jack Mariucci | Department: Advertising & Graphic Design | Department Chair: Richard Wilde | School: School of Visual Arts

**Advertising/ProfessionalService**
**64** Tattoo | Student: Sara Roderick | Instructor: Jack Mariucci | Department: Advertising & Graphic Design | Department Chair: Richard Wilde | School: School of Visual Arts

**65** e Harmony | Student: Chelsea Cumings, Jane Cronk | Instructor: Jack Mariucci | Department: Advertising & Graphic Design | Department Chair: Richard Wilde | School: School of Visual Arts

**66** Diagrams | Student: Hez Hae Ju Kim | Instructor: Jack Mariucci, Frank Anselmo | Department: Advertising | Department Chair: Richard Wilde | School: School of Visual Arts

**67** Woman (top) | Student: Kenji Akiyama | Instructor: Jack Mariucci | Department: Advertising & Graphic Design | Department Chair: Richard Wilde | School: School of Visual Arts

**67** Weight Watchers (bottom) | Student: Lisa Gilardi, Itai Inselberg | Instructor: Jack Mariucci | Department: Advertising & Graphic Design | Department Chair: Richard Wilde | School: School of Visual Arts

# Credits&Comments

*Description:* People may think talking on the phone while driving is less dangerous than driving drunk, since drivers are at least sober in this case, but it is not. People are easily distracted by conversations on the phone, so they cannot concentrate on their driving. By directly comparing the victims of drunk-driving and cellular phone use while driving, this advertisement intends to indicate the danger of cellular phone use while driving, which is especially aimed at teenage drivers who are young and inexperienced.

*Description:* People know smoking is harmful to our health. It can damage our body like lung, brain, and heart. The poisonous chemicals in a cigarette lead many people to the death. Life is not short. It is a bad idea to hang our lives upon the little sticks, cigarettes. This advertisement intends to convey the message "smoking is harmful to one's health" with telling "life is short," and "it can be even shorter."

*Description:* I designed and hand-sewed the binding for this 50 page-architecture book, which details all kinds of buildings in New York City. I silk-screen printed silver onto black endpaper, and black on a metallic card stock for the cover.

*Description:* Burlesque Magazine is a provocative magazine focused on the racy Burlesque culture. The edgy magazine puts a modern spin on a classic topic.

*Description:* Book of lies was design as final project in Typography III, at California College of the Arts, under professor David Asari. The book chronicles multiple ways for individuals to improve their own ability to detect lies. The greater part of the book focuses on the work of Paul Ekman, and his six universal facial expressions. All photography was shot by me, using HDR techniques. The grid is made up of two parts, the first, a simple grid for the basic text, the second, a grid based on the proportions of the human face which was used for all other content. The book is French fold and hard bound by me.

*Description:* Student produced the actual book.

*Description:* Handmade book.

*Description:* In their own words, "Experience Music Project (EMP) is dedicated to the exploration of creativity and innovation in popular music. By blending interpretative, interactive exhibitions with cutting-edge technology, EMP captures and reflects the essence of rock 'n' roll, its roots in jazz, soul, gospel, country and the blues, as well as rock's influence on hip-hop, punk and other recent genres." My objective with this student project was to rebrand EMP in a way that synergized the music museum's values with a brand that felt smart and unified as whole. The logotype that I designed for EMP is simplistic yet has enough variability to be used in the most complex and the most restrained of applications. Frank Gehry's building that houses EMP is iconic and is known for its energy and elaborate nature. In order to maintain the integrity and originality of the structure it was of utmost importance to have the mark feel compatible but not compete with this building. The type was chosen to reflect the forms of the building unifying the brand as a whole from graphics to architecture. The 'O' is called out in the word 'Project' and has been

# Credits&Comments

designed to be a perfect circle. From CD's to gramophone's, the circle has rich symbolism in the music industry.

The idea that the brand is to portray is one of music, energy, rhythm, color, synergy and timelessness—while still allowing for movement, interpretation, and the feeling of being current.

**114, 115** Bildschone Bucher Branding | Student: Cinthya Lopez | Instructor: Adrian Pulfer | Department: Visual Arts | Department Chair: Linda Sullivan | School: Brigham Young University

**116, 117** Cycle Clothing Branding | Student: Analisa Estrada | Instructor: Adrian Pulfer | Department: Visual Arts | Department Chair: Linda Sullivan | School: Brigham Young University

*Description*: Cycle is a high-end Italian clothing company that borrows from different fashion periods and concepts to create contemporary clothing with a rich heritage.

**Design/Brochures**
**118, 119** Amnesty International Collateral | Student: Sandra Craft | Instructor: Michele Damato | Department: Graphic Design | Department Chair: Diane La Franca | School: The Art Institute of Houston

**Design/Calendars**
**120** NY Flood Risk Map | Student: Joungwon Cha | Instructor: Alex Liebergesell | Department: Communication and Packaging Design | Department Chair: Jeff Bellantoni | School: Pratt Institute

*Description*: This calendar is for warning of rising sea level from global warming.

**121 PLATINUM** YOUR UNIVERS FOR 2009 | Student: Yanghee Kang | Instructor: Eunsun Lee | Department: Communication Design | Department Chair: Jeff Bellantoni | School: Pratt Institute

*Description:* "Your Univers for 2009" is a promotional calendar for Univers. I tried to pull out certain aesthetics in distorted typeface shape. In addition I added three-dimensional depth structure through the folded paper. Eventually I created innovative aesthetics of Univers through breaking the shape & form in common typeface.

**Design/CreativeExploration**
**122** Salon Chair | Student: Kaori Sakai | Instructor: Kevin O'Callaghan | Department: Advertising & Graphic Design | Department Chair: Richard Wilde | School: School of Visual Arts

**123** BBQ Truck Grill | Student: Stephen Park | Photography: Myko | Instructor: Kevin O'Callaghan | Department: Advertising & Graphic Design | Department Chair: Richard Wilde | School: School of Visual Arts

*Description:* OFF ROADING: The Reinvention of the American Gas Guzzler. In an attempt to remove a gas-guzzling vehicle from the streets, redesign a piece of a 1980 Chevy Monster Truck into a functional piece of furniture. Part of an exhibition that featured an entire living room created from every part of one truck. School of Visual Arts Museum, NYC 3/09.

**124** Tirelamp | Student: Kaori Sakai | Instructor: Kevin O'Callaghan | Department: Advertising & Graphic Design | Department Chair: Richard Wilde | School: School of Visual Arts

**Design/Editorial**
**125** Sublime Magazine | Student: Cinthya Lopez | Instructor: Adrian Pulfer | Department: Visual Arts | Department Chair: Linda Sullivan | School: Brigham Young University

**126-129** Architectural Record | Student: Takako Saegusa | Instructor: Michael Ian Kaye | Department: Advertising & Graphic Design | Department Chair: Richard Wilde | School: School of Visual Arts

**130-135 PLATINUM** Editorial: Science Times, The New York Times | Student: Jonathan Han | Instructor: Richard Wilde | Department: Advertising & Graphic Design | Department Chair: Richard Wilde | School: School of Visual Arts

**136** Arena Magazine (top) | Student: John Jensen | Instructor: Adrian Pulfer | Department: Visual Arts | Department Chair: Linda Sullivan | School: Brigham Young University

**136** OPS Magazine, Feature (bottom) | Student: Jeanette Kaczorowski | Instructor: Christopher Austopchuk | Department: Advertising & Graphic Design | Department Chair: Richard Wilde | School: School of Visual Arts

**137, 138** Voz Magazine | Student: Raul Aguilla | Instructor: Jeff Glendenning, Luise Stauss | Department: Advertising & Graphic Design | Department Chair: Richard Wilde | School: School of Visual Arts

**139** Arch Lounge Magazine | Student: Eun Sook Choi | Instructor: Christopher Austopchuk | Department: Advertising & Graphic Design | Department Chair: Richard Wilde | School: School of Visual Arts

**140** Oceania Necklace Fashion Spread | Student: Amy Blumenthal | Instructor: Kristin Sommese | Department: Integrative Arts | Department Chair: William J. Kelly | School: Pennsylvania State University

*Description*: A fashion spread advertising a blue and green necklace. This spread consists of type integration and photographics in which I served as the photographer, Student, Student, stylist, and copywriter. All of the work in the spread is original.

**141** I Am Poison | Student: Lainey Lee | Model: Allison Kershner | Instructor: Kristin Sommese | Department Chair: William J. Kelly | School: Pennsylvania State University

**142** The Innocence Project Ad Campaign | Student: John Jensen, Nathan Wigglesworth | Instructor: Adrian Pulfer | Department: Visual Arts | Department Chair: Linda Sullivan | School: Brigham Young University

**143** Type Pantone | Student: Katia Hakko | Instructor: Joe Marianek | Department: Advertising & Graphic Design | Department Chair: Richard Wilde | School: School of Visual Arts

**144** GIP Magazine Pages | Student: Eun Young Kim | Instructor: Christopher Austopchuk | Department: Advertising & Graphic Design | Department Chair: Richard Wilde | School: School of Visual Arts

**145** Editorial Design | Student: Yeon Hur | Instructor: Robert Best | Department: Advertising & Graphic Design | Department Chair: Richard Wilde | School: School of Visual Arts

**146** Fashion Spread (top) | Student: Chris Rizzo | Instructor: Kristin Sommese | Department: Integrative Arts | Department Chair: William J. Kelly | School: Pennsylvania State University

*Description*: This piece draws ties between the sport of boxing and a corrupt relationship. I feel this spread successfully draws your attention to the issue but subtly draws similarities between the two.

**146** Fashion Spread (middle) | Student: Megan Yanchitis | Instructor: Kristin Sommese | Department: Integrative Arts | Department Chair: William J. Kelly | School: Pennsylvania State University

*Description*: Assigned to create two unconventional fashion spreads that employ a strong type/image relationship, I served as the set Student, stylist, photographer, and graphic Student of this surrealistic scene.

**146** Peahen's Prize (bottom) | Student: Jenny Lubkin | Instructor: Kristin Sommese | Department: Integrative Arts | Department Chair: William J. Kelly | School: Pennsylvania State University

*Description*: I crafted this hat by using a 1950s black cap and manually attaching each peacock feather to create a fan effect. The concept was to design a sleek, yet somewhat mysterious, layout to show the intrigue that will come with anyone that wears this cap.

**Design/Games**
**147** Abstract Playing Cards | Student: Cassandra Barboe | Instructor: T. Koppel | Department: Advertising & Graphic Design | Department Chair: Richard Wilde | School: School of Visual Arts

**Design/Illustration**
**148** The Green Renter Lecture Series | Student: Joshua Winship Carpenter | Instructor: Matthew McGuiness | Department: Advertising & Graphic Design | Department Chair: Richard Wilde | School: School of Visual Arts

**149** The Orkuits Spaceship | Student: Mariana Castellanos Isaza | Instructor: Richard Wilde | Department: Advertising & Graphic Design | Department Chair: Richard Wilde | School: School of Visual Arts

**Design/Interactive**
**150** TYPLTRS | Student: Anthony Cafaro | Instructor: Stacy Drummond | Department: Advertising & Graphic Design | Department Chair: Richard Wilde | School: School of Visual Arts

**Design/Letterhead**
**151** Gizmo Stationery Package | Student: Bo Rum Hur | Instructor: Alice Drueding | Department: Graphic & Interactive Design | Department Chair: Alice Drueding | School: Tyler School of Art, Temple University

*Description*: This stationery package (letterhead, envelope and business card) is for Gizmo, a company that sells gadgets that use the latest microtechnologies and the zaniest thinking of garage inventors.

**152, 153** Obscura | Student: Jeanette Kaczorowski | Instructor: Christopher Austopchuk | Department: Advertising & Graphic Design | Department Chair: Richard Wilde | School: School of Visual Arts

**Design/Logo**
**154** Osprey Brewing Logo and Labels | Student: Sara Alway | Instructor: Kelly Holohan | Department: Graphic Arts & Design | Department Chair: Stephanie Knopp | School: Tyler School of Art, Temple University

*Description*: Logo for West coast brewery and bottled brews.

**155** The Mermaid Inn Menus | Student: Emily Kowzan | Instructor: Louisse Fili | Department: Advertising & Graphic Design | Department Chair: Richard Wilde | School: School of Visual Arts

**156** 2B Viognier | Student: Daniel Meney | Photography: Iwan Tanumijaya | Instructor: Dan Brawner | Department: Graphic Design | Department Chair: Michael Niblett | School: Watkins College of Art, Design & Film

*Description*: Branding for a vinyard entering the quickly expanding viognier market. The graphics relay a sense of sophistication, but not exclusivity. The web banners target a young, urban professional demographic.

**157** Obscura | Student: Jeanette Kaczorowski | Instructor: Christopher Austopchuk | Department: Advertising & Graphic Design | Department Chair: Richard Wilde | School: School of Visual Arts

**158, 159** John Fluevog Shoes | Student: Joshua Winship Carpenter | Instructor: Eric Baker | Department: Advertising & Graphic Design | Department Chair: Richard Wilde | School: School of Visual Arts

**160** Tree People Logo (top) | Student: Bo Rum Hur | Instructor: Alice Drueding | Department: Graphic & Interactive Design | Department Chair: Alice Drueding | School: Tyler School of Art, Temple University

*Description*: Tree People is a nonprofit organization that promotes sustainable solutions to urban ecosystems. A key initiative is training and supporting communities in planting and caring for trees in their neighborhoods.

**160** Untitled Store Branding (2nd from top) | Student: Natalie Davis | Instructor: Adrian Pulfer | Department: Visual Arts | Department Chair: Linda Sullivan | School: Brigham Young University

**160** Raya Branding (middle) | Student: Eric Perez | Instructor: Rachel Donovan | Department: Advertising & Graphic Design | Department Chair: Richard Wilde | School: School of Visual Arts

# SchoolDirectory

**Academy of Art University** www.academyart.edu
79 New Montgomery Street, San Francisco, CA 94105-3410
Tel 800 544 2787

**Art Center College of Design** www.artcenter.edu
Hillside Campus: 1700 Lida Street, Pasadena, CA 91103, United States
Tel 626 396 2200
South Campus: 950 South Raymond Avenue, Pasadena, CA 91105,
United States | Tel 626 396 2200

**Art Institute of Atlanta** www.artinstitutes.edu
6600 Peachtree-Dunwoody Road, N.E. 100 Embassy Row, Atlanta,
GA 30328, United States | Tel 770 394 8300

**The Art Institute of Houston** www.artinstitutes.edu/houston/
1900 Yorktown Street  Houston, TX 77056-4197 United States
Tel 713 623 2040 or 800 275 4244

**Brigham Young University**  www.byu.edu
CES Admissions A-41 ASB, Provo, UT 84602, United States
Tel 801 422 4636 | Fax 801 422

**California College of the Arts** www.cca.edu
San Francisco: 1111 8th Street, San Francisco, CA 94107-2247, United States
Tel 415 703 9500
Oakland: 5212 Broadway, Oakland, CA 94618-1426, United States
Tel 510 594 3600

**Columbia College of Chicago** www.colum.edu
600 S. Michigan Avenue, Chicago, IL 60605, United States | Tel 312 663 1600

**Drexel University, Antoinette Westphal College of Media Arts & Design**
www.drexel.edu/westphal | 3141 Chestnut Street, Philadelphia,
PA 19104, United States | Tel 800 2 DREXEL or 215 895 2400

**Hongik University** www.hongik.ac.kr/english_neo
Seoul Campus: 72-1 Sangsu-Dong, Mapo-Gu, Seoul, 121-791, Korea
Jochiwon Campus: Jochiwon-Eup, Yeongi-Gun, Chungcheonggnam-Do
339-701 Korea | Tel +82 02 320 1114 | Fax +82 02 320 1122

**Miami Ad School** www.miamiadschool.com
955 Alton Road, Miami Beach, FL 33139, United States
Tel 305 538 3193

**Pennsylvania State University** www.psu.edu
201 Shields Building, Box 3000, University Park, PA 16804, United States
Tel 814 865 5471 | Fax 814 863 7590

**Philadelphia University** www.philau.edu
4201 Henry Avenue, Philadelphia, PA 19144, United States
Tel 215 951 2700

**Portfolio Center** www.portfoliocenter.com
125 Bennett Street Atlanta, GA 30309, United States
Tel 404 351 5055 or 800 255 3169 | Fax 404 355 8838

**Pratt Institute** www.pratt.edu
Brooklyn: 200 Willoughby Avenue, Brooklyn, NY 11205, United States
Manhattan: 144 West 14th Street, New York, NY 10011, United States
Tel 718 636 3600 | Fax 718 636 3670

**School of Visual Arts** www.schoolofvisualarts.edu
209 East 23rd Street, New York, NY 10010, United States
Tel 212 592 2000 | Fax 212 725 3587

**Tyler School of Art, Temple University** www.temple.edu/tyler
7725 Penrose Avenue, Elkins Park, PA 19027, United States
Tel 215 782 2875

**University of Arizona Communications** www.comm.arizona.edu
211 Communications Building, University of Arizona, Tucson, AZ 85721,
United States | Tel 520 621 1366 | Fax 520 621 5504

**University of Washington** www.washington.edu
4060 George Washington Lane, Seattle, WA 98195-5502, United States
Tel 206 543 9198 | Fax 206 221 4890

**Watkins College of Art, Design & Film** www.watkins.edu
2298 MetroCenter Boulevard, Nashville, TN 37228, United States
Tel 615 383 4848 | Fax 615 383 4849

# AwardWinningStudents

# AwardWinningSchools

## AwardWinningInstructors

## DepartmentChairs

## PlatinumWinningInstructors

# Two ways to dramatically save on our Books!

**Book Subscriptions (Standing Orders):**

50% off or $35 for a $70 book, plus $10 for shipping & handling
Get our new books at our best deal, long before they arrive in book
stores! A Standing Order is a subscription commitment to the Graphis
books of your choice.

**Pre-Publication Sales:**

35% off or $45 for a $70 book, plus $10 for shipping & handling
Our next best deal. Sign-up today at www.graphis.com to receive our
pre-publication sale invitations! Order early and save!

# Graphis Titles

Poster Annual 2010

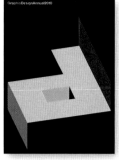
Design Annual 2010

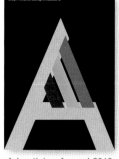
Advertising Annual 2010

Annual Reports 2010

Letterhead 7

The Illustrated Voice

Logo Design 7

Promotion Design 2

Nudes 4

Dana Buckley: Fifty

Tintypes

Photography Annual 2010

12 Japanese Masters

Please visit our store at www.graphis.com/store for more information.